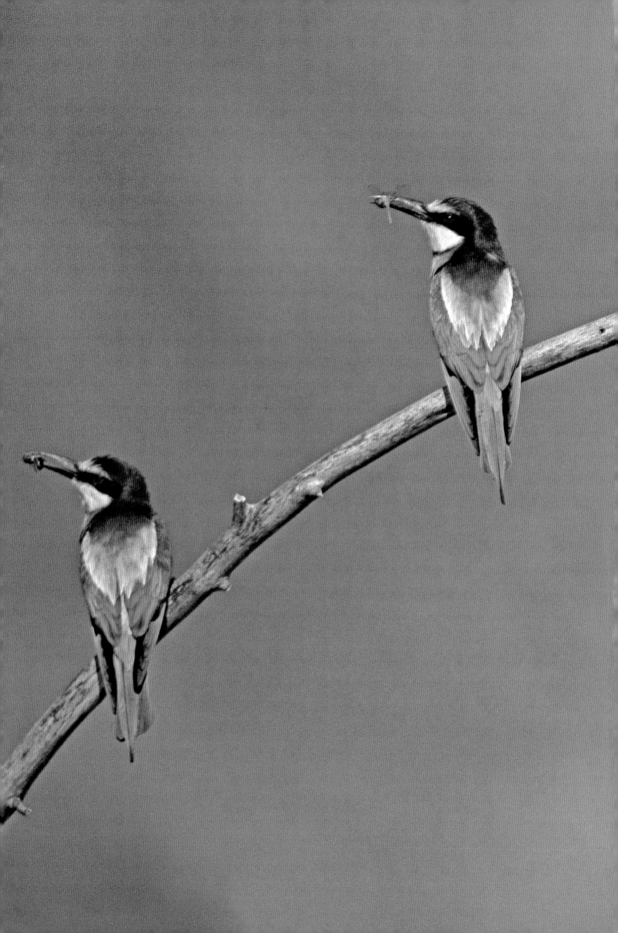

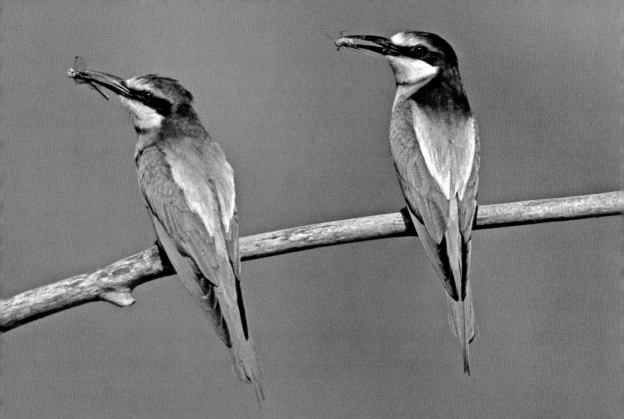

NATIONAL GEOGRAPHIC
BIRD
COLORATION

GEOFFREY E. HILL

NATIONAL GEOGRAPHIC

WASHINGTON, DC

CONTENTS

PAGE 1: Eurasian Hoopoe. **PAGES 2-3:** European Bee-eater *(Hungary)*.
OPPOSITE: Paradise Tanager *(Ecuador)*.

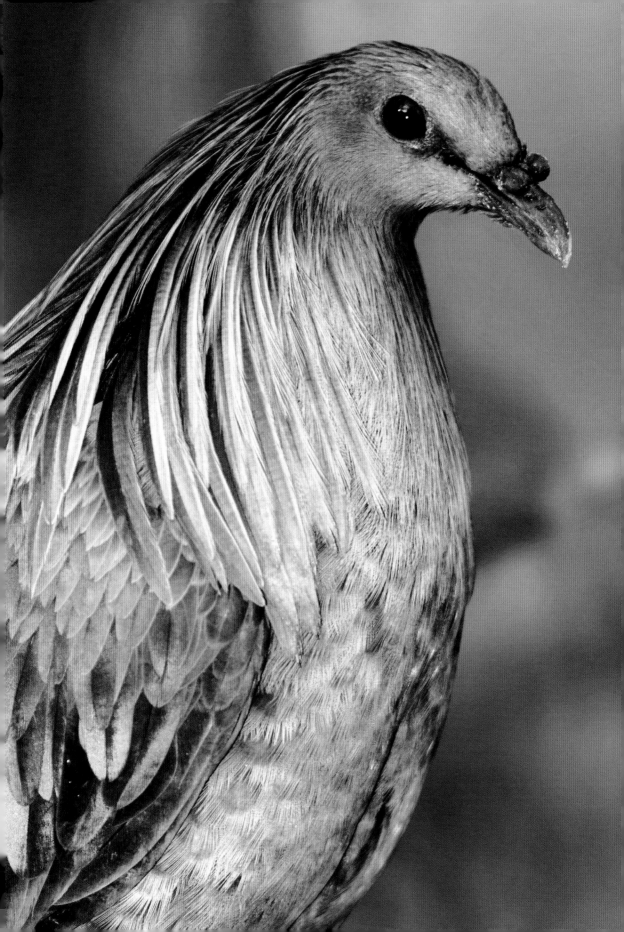

THE BOLD, BRILLIANT, AND VARIED COLORATION OF BIRDS evokes both admiration and curiosity. The striking colors of a species like the Scarlet Macaw with brilliant reds and blues demand attention, but for a birder, subtle coloration can be equally captivating. The mottled brown and gray feathers of a Common Pauraque are a marvel, enabling it to blend in completely with the dry leaves in which it sleeps. The myriad of gray and brown patterns in a flock of gulls is a puzzle, challenging identification skills.

For some it is enough to simply enjoy the kaleidoscope of colors and patterns that birds present. For others there is a need to unravel the mysteries of such coloration. Why do small and vulnerable songbirds have brilliantly colored feathers that make them conspicuous to predators? Why is our own species so drab by comparison? Why do Bald Eagles progress through four years of brown subadult plumages before finally attaining a white head and tail? Why are some Snow Geese white while others are dark? Understanding the colors and patterns of birds is a goal of ornithologists working at universities around the world, and the collective efforts of hundreds of research scientists over the past several decades has enabled us to move toward a comprehensive understanding of bird coloration. My purpose in writing this book is to communicate in prose accessible to nonscientists what scientists know about the coloration of birds.

Birders have a special motivation for understanding the coloration of birds. The pattern and hue of the feathers, eyes, bills, and legs of birds are the primary criteria used to identify them. Birders are adept

There are no orange, green, or blue pigments in the feathers of this **Nicobar Pigeon**. The varied iridescent coloration results from microscopic structures in the feathers. *(captive)*

Red-and-green Macaws are among the most beautiful of birds, combining vivid red pigmentation with striking blue structural coloration. *(Brazil)*

at noting subtle nuances of color. Skilled birders know the likely range of color variation among birds of a given species, the sequence of plumages leading from hatching to full adulthood, the seasonal changes in coloration, the differences in coloration between sexes, and the regional variation in colors. Unless a birder has the time and training to read the technical ornithological literature, there is no way to keep up with scientific discoveries concerning the production of coloration, genetic control of colors, how color functions, and the forces that have shaped the evolution of coloration.

In 2006, with my ornithologist colleague Kevin McGraw, I edited a two-volume compendium also entitled *Bird Coloration*. The topic of those tomes is the same as for this volume, but the content of *Bird Coloration* and *National Geographic Bird Coloration* is distinctly different. *Bird Coloration* was not meant for a broad readership. Our intention in creating those volumes was to compile the vast scientific literature and advance the field of scientific research by summarizing all current knowledge on topics related to the coloration of birds. Accordingly, the tone of *Bird Coloration* is highly technical. It has statistical summaries of data, discussions of mathematical models for light environments and social interactions, and details on the biochemistry of pigments. Without an extensive background in biology, chemistry, and even physics, a reader cannot penetrate the

dense chapters of those books. As I edited that enormous compendium, I could not help but despair at the huge number of fascinating discoveries that were locked away from a broader readership.

After completing work on the *Bird Coloration* volumes, I vowed to write a companion book that would be a readable and accessible account of the major scientific discoveries related to bird coloration. My target audience would be the many birders and nature enthusiasts who are not research biologists but who have a fascination with and a substantial knowledge of birds. *National Geographic Bird Coloration* is my attempt at such a translation.

National Geographic Bird Coloration is meant to be an enjoyable tour of one of the most captivating fields of ornithological research. My goal in writing the book was to put an emphasis on fascinating aspects of bird coloration rather than on the technical details of scientific studies. To keep the volume readable, I refrain from directly referencing the many published studies on which my statements are based. While this approach leaves the text unencumbered with citations, it denies recognition of the scientists whose sweat and imagination expanded our understanding of bird coloration. It is my hope that my colleagues will draw some sense of fulfillment at seeing their studies highlighted as key discoveries in the field. For readers who wish to know the primary sources of information for each chapter, I present a list of sources at the end of the book.

ORGANIZATION

Scientists recognize that a question such as "Why does a Scarlet Ibis have bright red feathers?" can be answered on two fundamentally different levels. One focuses on the mechanism for red coloration—the chemistry of pigments and the factors that affect pigmentation. These explanations address *how* the trait exists. The second views red coloration in terms of its functions and the factors that shaped its evolution. These explanations address *why* the trait exists. Both sets of explanations are necessary for a thorough understanding of the trait. These are not competing levels of explanation; they are entirely complementary.

The *hows* and *whys* of bird coloration represent two major themes in this book. A third theme is a basic description of bird

coloration and topics closely related to bird coloration, such as visual perception, light environment, and measurement of color. I call such descriptions *what* questions. What is the visual range of humans and birds? What techniques do scientists use to measure coloration? What patterns of variation do we see within and among bird species?

Together, these levels of explanation create a series of *what, how,* and *why* questions. I begin by answering *what* questions and then move to *how* questions before finishing with *why* questions.

Information in this book is organized in five formats. Primary information is conveyed in the main text of the book, arranged in fourteen thematic chapters. The early chapters introduce the reader to basic descriptions and terminology before more advanced concepts are presented. I first describe color variation, discuss how birds see colors, and explain how scientists measure coloration. I then provide an overview of the mechanisms of color production and the effects of genes and the environment on coloration. I end with a series of chapters on the functions and evolution of coloration.

The second source of information is sidebars embedded within the text. These sidebars are meant to enhance the main text. Typically, they provide more technical explanations of topics and delve into subjects that are interesting and important but tangential to the central focus of the chapter. For readers who would prefer to sidestep technical aspects of color research, the sidebars provide a convenient way to read around such technicalities.

The third layer of information is the illustrations. Bird coloration is a topic that demands abundant illustration, and color photographs provide an excellent means to document the variety, vibrancy, and fascinating patterns of avian coloration. The photographs in this book were chosen to provide enjoyable and interesting visual accompaniments to the text. When known, the place and season of a photograph are noted parenthetically at the end of each caption. In addition, drawings of birds have been taken from National Geographic field guides and labeled with the sex, age, or plumage of the bird shown. (Sex is labeled only when the sexes differ in plumage.) A reader seeking only an overview of the information can learn the basics of bird coloration just by looking at these illustrations and reading their captions.

Despite an effort to avoid jargon, certain technical words and concepts were unavoidable. But, rather than compiling a glossary of unfamiliar words at the end of the text, I have included marginal notes adjacent to words or concepts that required additional explanation or clarification. And, finally, in each chapter there is a series of birder's notes, which focus on topics and tips to help you fine-tune your observational skills and make sense of what you see in the field.

A RESOURCE FOR BIRDERS

I hope that a book on avian coloration will be attractive to a broad range of readers from fellow scientists to curious naturalists, but my main audience is birders. Birding has become an activity pursued with such enthusiasm and energy that top amateur birders now surpass many professional ornithologists in their skills at field identification and their knowledge of the movements and distributions of birds. Species once considered impossible to separate in the field, such as flycatchers in the genus *Empidonax* and immature *Larus* gulls, are now routinely and accurately identified.

Rose Robin

Such devotion to the study of bird identification leads inevitably to a desire for a deeper understanding of the color variation on which most field identification is based. Knowing the basis of this variation can enable birders to refine their field identification skills and to help drive future scientific investigations of bird coloration.

Beyond identification, a better understanding of birds is itself a worthy pursuit. Birding might focus on identifications and lists, but I have met few birders who are fulfilled simply by listing birds. Birds trump mammals, herps, and fish as a focus of interest by amateur naturalists because they are conspicuous during the day and can be readily observed in their native habitats. For me, it is impossible not to be drawn into the lives of birds while watching their struggles for food, shelter, and reproductive opportunities. The lives of birds play out before our binoculars, but as familiar as they often seem, birds and the avian world of color are foreign to humans. I hope my explanations provide a guidebook for interpreting the role of color in the lives of birds.

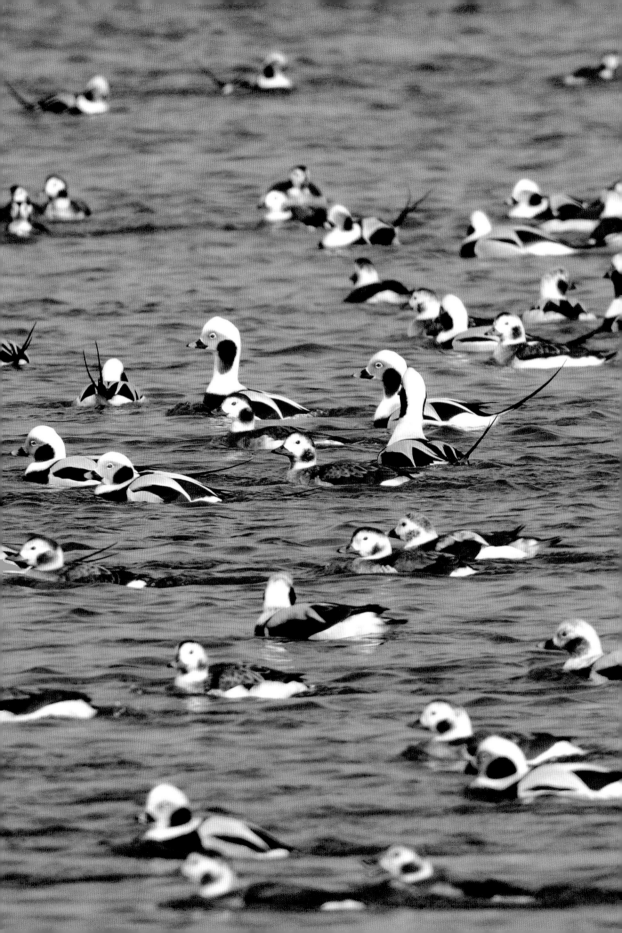

CHAPTER ONE

PATTERNS OF VARIATION

Oreof my duties at Auburn University is teaching ornithology. The laboratory portion of the course focuses on teaching students how to identify birds in the field. Inevitably, some students really take to birding. Some don't. But by the end of the first field trip or two, they all loathe Yellow-rumped Warblers.

Yellow-rumped Warblers are small songbirds that fill the bushes and trees around my home in Auburn, Alabama, in the winter. They flit about in small flocks and sometimes come to the ground to feed like sparrows. They are endearing and harmless. How could students dislike such birds? For novice birders who are struggling with bird identification, winter yellowrumps are a nightmare of variation. Some are boldly marked with yellow patches on the head, flanks, and rump, and black stripes on the undersides. Others are brown and drab with just a small spot of yellow on the rump that is frequently hidden. Between these extremes is endless variation.

I have had almost comical exchanges with students as we worked through a flock of yellowrumps.

"OK, but that one *can't* be a yellowrump," generations of students have told me as they tried to focus their binoculars on a featureless brown bird feeding in the grass in front of us. The previous five birds that I had identified as Yellow-rumped Warblers were much

Yellow-rumped Warbler

basic ♀

In winter flocks of **Long-tailed Ducks,** the boldest individuals with pink bills and long tails are males in definitive plumage. Yearling males are drabber with little or no pink in their bills. Females are drabber still with brown backs and plain bills. *(Ontario, February)*

more boldly patterned in black with conspicuous yellow on their crown, rump, and flanks.

"Sure it is," I'd respond in a voice perhaps too cheerful. "That one is just a bit drab."

"Arghh!" they'd inevitably exclaim as they threw up their hands in frustration.

Students sometimes suspect that I am fooling them when I keep using the same species name for birds that look so different.

Yellow-rumped Warblers encapsulate the variation that is the focus of this chapter. Within any flock of winter yellowrumps, there are likely to be adult males, adult females, and birds born the previous summer. Each age and sex class looks different, although in the case of Yellow-rumped Warblers these age and sex groups are not discretely distinct in coloration in the winter. They blend from the drabbest young female to the brightest old male in continuous variation. Then in April, when the students might just be gaining a handle on yellowrumps in winter plumage, the whole population transforms into birds that look different as they progress through spring molt into their striking black and yellow breeding plumage.

In this chapter I document patterns of color variation that we see within species. Most variation in coloration among individuals within a species is related to differences in sex, age, and season. Descriptions of age classes, molts, and plumages provide critical background for many topics related to bird coloration. Understanding how color patterns vary between the sexes, across seasons, and with age is a worthwhile endeavor in its own right, but such patterns become even more fascinating when we try to deduce how and why they came to be.

Herring Gull

first basic

Ring-billed Gull

first basic

BIRDER'S NOTE

Improve Your Skill Set ›› Understanding the basis for individual variation significantly elevates a birder's identification skills. Being able to sort individuals by age and sex makes the range of color expressions within a species comprehensible and easier to remember. For instance, Herring and Ring-billed Gulls present endless variation related to age, sex, and season. Once you have mastered variation within these abundant species, you will be primed to pick out a vagrant gull that wanders into your birding area.

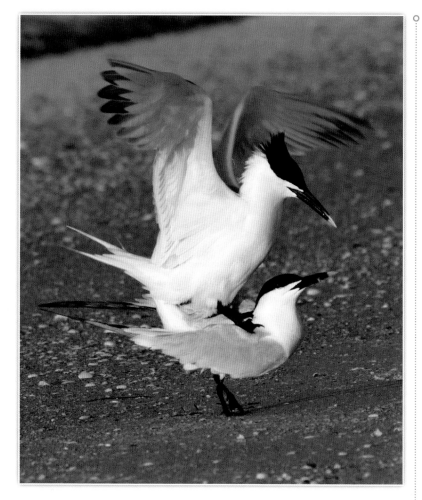

Behavior is often the only way to determine the sex of individuals of monochromatic species like these **Sandwich Terns.** Males are on top during copulation. *(Florida, April)*

SEXUAL VARIATION

The parrot owners whom I know like to give their parrots male names—I think it's because parrots of both sexes tend to be bold and aggressive—but about half of these friends have called to tell me that "Pretty Boy" or "Johnny" laid an egg in "his" cage. As in many species of birds, the plumage coloration of most parrots gives no clue to sex. Such species in which males and females are identically colored are described as being sexually monochromatic.

The sexes are alike in coloration.

Humans tend to think of birds as monochromatic creatures. When cartoon birds are invented, they are rarely imagined as males and females having different plumage. Just look at the birds in the classic Disney movies *Snow White* and *Cinderella*. The sex of the birds is indicated by the clothes they wear or by their expressions; the feathers of

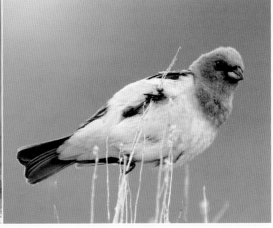

Female (left) and male (right) **Lazuli Buntings** have completely different feather coloration. The female Lazuli looks much more like females of other *Passerina* buntings than like males of their own species. *(California, September; Idaho, May)*

The sexes are different in coloration.

males and females are identical. People also take monochromatism for granted in many of the species they encounter every day. English has a rich vernacular related to Rock Pigeons (pigeonholed, pigeon-toed, squab) yet it includes no special words for male and female pigeons, although there are sex-specific names for many other familiar animals. To a human eye, male and female pigeons are identical.

Among the thousands of species of birds that are sexually monochromatic some are among the most brilliantly colored of all birds, such as the Toco Toucan, Scarlet Macaw, and European Bee-eater. Greater numbers of sexually monochromatic species are drably colored like the tube-nosed seabirds, owls, vultures, and swifts. Most sexually monochromatic species fall between these extremes, having distinctive but not gaudy coloration—for example, Canada Geese, Sandhill Cranes, and Wood Pigeons.

Males and females frequently look alike, but in about half of all species they can be distinguished by plumage coloration. When males and females differ in coloration, the species is described as being **sexually dichromatic.** Sexual dichromatism divides the sexes into two basic appearances.

In some species such as Blue Grosbeak and Williamson's Sapsucker, dichromatism is so extreme that males and females share the same coloration on scarcely a single feather over their entire bodies. The sexes look like different species of birds.

One common pattern that frustrates birders is that across a genus or even an entire family of sexually dichromatic birds, the females of different species look very similar but the males differ completely and dramatically. For instance, almost all female manakins (in the

neotropical family Pipridae) have drab green coloration, and many of these females are so similar that even skilled field ornithologists have difficulty distinguishing the species. The males of these species are strikingly distinct in coloration from one another as well as from females.

Dichromatism does not have to be complete and dramatic. Some species show very subtle sexual dichromatism such as the "yellow-shafted" form of the Northern Flicker, with a black malar spot on the face of males but not females (see page 207 for more on the flicker's malar spot). In many sexually monochromatic species, females have a subdued version of the same plumage as males. This occurs in Western Bluebirds, in which females are orange and blue like males but with much less saturation in the colors, and in Eurasian Bullfinches, in which females replace the red of males with gray but retain the same plumage pattern. It is easy to tell that male and female bluebirds and bullfinches belong to the same species, and it is easy to distinguish males from females. Monochromatism and extreme dichromatism lie at ends of a continuous scale of color differences between males and females, and many species fall between the extremes.

Western Bluebird

♀

♂

MOLT AND SEASONAL VARIATION

People who watch birds are acutely aware of seasons, and not simply because the season will dictate what to wear on field trips and how crowded the local beach might be. A birds' appearance can change dramatically across seasons. Change in feather coloration typically requires the growth of new feathers by a process of programmed feather replacement called molt. In my experience, no topic related to birds is as misunderstood as molt. In truth, molt can be interesting and relatively easy to comprehend. Understanding molt is fundamental for understanding the hows and whys of feather coloration.

Molt is the regular pattern of feather replacement. After birds progress through natal and juvenal plumages, molt becomes a cycle that occurs at the same time each year. Molt may or may not change an individual's appearance, and molt is necessary beyond the need to change feather color. The two primary functions of molt are to replace

The downy feathers covering the body of a bird at hatch are called natal plumage. Some birds hatch naked and have no natal plumage.

When I write about sexual dichromatism, I am almost always referring to species in which males are more colorful than females. In a small minority of bird species, however, females have more brightly colored plumage than males. Ornithologists call such a reversal of the typical bright-male and drab-female pattern **reversed sexual dichromatism.**

A pattern of coloration within a species in which females are more brightly or boldly colored than males.

Reversed sexual dichromatism is invariably associated with a mating system called "polyandry," wherein individual females pair with more than one male. In polyandrous species of birds, females are typically larger than males, and they take on the aggressive and displaying behavior that is typical of males in most bird species. In some species with reversed sexual dichromatism females even have higher levels of the male sex hormone testosterone than males. To a casual observer, females in these species appear to be males, at least until they are observed laying eggs.

Why do such reversals in sex roles occur? In the vast majority of bird species with typical sex roles, females are the sex that invests more in reproduction, beginning with the creation of large and well-provisioned eggs and typically continuing through a greater role in incubation and provisioning of young. Because they invest more in reproduction, females are a resource competed for by males, and competition among males leads to the evolution of ornamental plumage (see chapter 11). In polyandrous species, it is males that invest more in reproduction because males build the nest, incubate, and feed offspring. In polyandrous species, females compete for males, and with competition for mates comes ornamental plumage that aids in such competition. Most birds with reversed sexual dichromatism are shorebirds, and the phalaropes are the most dramatically colored species with reversed sexual dichromatism in North America and Europe.

Wilson's Phalarope

alternate ♀

alternate ♂

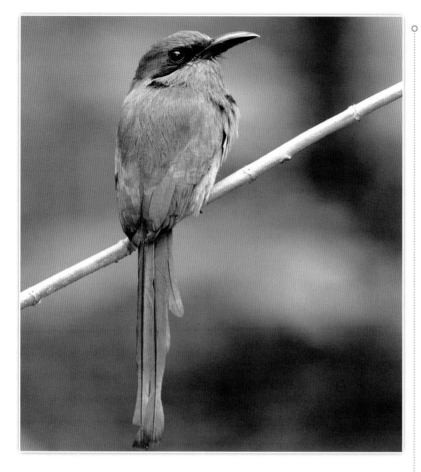

Most birds of wet tropical regions, like this **Broad-billed Motmot,** show no seasonal change in plumage coloration. *(Costa Rica, February)*

worn or immature feathers and, in some species, to change the color of plumage. All birds go through a progression of molts to reach adult (definitive) plumage. When they are mature, they must replace most of their feathers annually because wear and tear destroy the feathers' structures and leave them less efficient for insulation and flight. The sidebar on page 22 summarizes the common patterns of molt and the resulting plumages. It will be useful for readers to refer to the table contained therein as I discuss patterns of molt.

For birds in the temperate zone or in regions with marked wet and dry seasons, molt occurs roughly at the same time each year and proceeds at a relatively rapid pace. A "rapid pace" does not mean that birds drop all their feathers and go naked for a time. All birds have to maintain insulation from plumage and most birds have to retain the ability to fly even when they are molting. So only a portion of the feathers is dropped at any one time, and molt is a process rather subtle to a human observer.

Definitive plumage is worn by the oldest recognizable age class within a population of birds.

Small birds, including all songbirds in temperate areas, rarely molt for longer than 20 percent and often less than 10 percent of the year. Some large species such as hawks and seabirds can be in some stage of molt for much of the year. For species in tropical areas with less seasonality, molt can occur over a longer portion of the year or even throughout the year. Such nonseasonal molt can proceed much more slowly than the seasonal molt of temperate zone birds. For these reasons, seasonally distinct plumages are typically not observed in birds found in the tropics, especially in wet tropical regions.

After birds pass through their immature (subdefinitive) plumages, as described in the next section, they typically adopt one of two patterns of molt. Either they have one complete molt per year, or they have one complete molt per year plus one extensive but incomplete molt. Birds cannot move substances such as pigments into or out of feathers after they are grown, so seasonal color change results from growth of new feathers. A species with one molt per year necessarily has the same color and pattern all year (except for wear and tear on the feathers), but species with two molts per year can have two different plumage appearances.

Seasonal changes in plumage coloration can be dramatic. It is always hard to break the news to my undergraduates that the striking black and yellow coloration of the male American Goldfinch—so prominently illustrated in their field guides—is not what American Goldfinches look like in the fall and winter in Alabama. In the winter, goldfinches are drab brownish yellow birds. Like many other species, American Goldfinches undergo a remarkable transformation twice each year as they change back and forth between seasonal plumages.

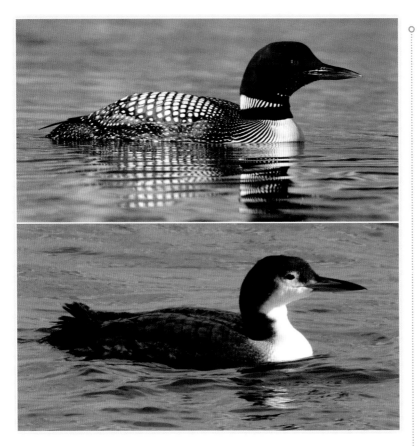

The aspect of molt that most people find difficult is the terminology, but there are really just a few names of molts and plumages that must be learned. In temperate regions, most birds replace all or almost all of their body feathers in a late summer or early fall **prebasic molt** and grow their basic plumage. Birders commonly refer to basic plumage as "winter" or "nonbreeding" plumage. "Basic plumage" is a fundamentally better name, and not just because it is more formal. Many species retain their basic plumage for the entire year. If this is called "winter" plumage or "nonbreeding" plumage, then many birds spend the summer in "winter" plumage, or they breed in "nonbreeding" plumage. The term "basic plumage" engenders no seasonal contradictions. The first one or several basic plumages can be distinct from definitive basic plumage. How age can affect plumage coloration is described in the next section.

For many birds, the prebasic molt is the only molt, and adults of these species have a similar appearance throughout the year (see

The molt that produces basic plumage is called the prebasic molt. It follows the breeding season for sexually mature birds, and occurs after fledging for recently hatched individuals.

Virtually all birds in Europe, North America, and temperate Asia, and many birds in other regions of the world, undergo relatively brief periods of feather replacement called molts. Molts can be complete (involve all the feathers of the body) or partial (involve only some feathers). Ornithologists commonly recognize three molts and four plumages:

PLUMAGE	SEASON	MOLT	EXTENT
Natal down	Spring/summer		
Juvenal plumage	Spring/summer	Prejuvenal molt	Complete
Basic plumage	Fall/winter or year-round	Prebasic molt	Usually complete; wing and tail feathers retained in many juveniles
Alternate plumage	Spring/summer	Prealternate molt	Usually partial; commonly absent

In field guides and casual discussions basic plumage is often called "winter plumage" or "nonbreeding plumage." Alternate plumage is commonly called "breeding plumage" or "nuptial plumage." "Alternate" and "basic" are superior terms (not all birds breed in alternate plumage and many birds wear basic plumage in the summer) and are the terms used in ornithology journals and texts. I will use "alternate" and "basic" throughout this book.

All birds develop a prebasic molt leading to a basic plumage—hence the name "basic" as the baseline for all bird plumages. Prebasic molt is usually complete, but some young birds like Eastern Bluebirds retain a portion of their juvenile plumage as part of their basic plumage. When prebasic molt is not complete, the feathers most typically retained are wing, tail, and wing coverts. Only some birds have a prealternate molt, and in general the prealternate molt is partial, not involving wing or tail feathers. In general, birds that show seasonal variation in plumage coloration achieve the change in coloration through a prealternate molt. Species that look the same throughout the year lack a prealternate molt.

sidebar, page 26). As a general rule, birds that are resident in their breeding areas have only one molt and a more or less constant appearance throughout the year. This group includes such familiar birds as Northern Cardinals, House Finches, and Western Scrub-Jays in North America and European Robins, Eurasian Blackbirds, and Great Tits in Europe.

Other species, especially long-distance migrants, have a second molt each year that is known as the prealternate molt. This occurs in late winter or spring and produces alternate plumage. Birders often call the alternate plumage "breeding" or sometimes "nuptial" plumage. The term "breeding" plumage for alternate plumage is better than "winter" plumage for basic plumage because all birds that have an alternate plumage attain it before the onset of the breeding season and lose it a few months later (although not all individuals in alternate plumage attempt to breed).

Most birds with a prealternate molt look different in basic and alternate plumage, particularly in males. The change in appearance can be dramatic, as in male American Goldfinches, which transform from drab brown and yellow in the winter to brilliant yellow with a striking black cap in the spring and summer. Male Scarlet Tanagers go from greenish and cryptic to blazing scarlet through a prealternate molt. A dramatic difference between basic and alternate plumage is not limited to songbirds. Common Loons go from drab gray to striking green, black, and white between winter and spring.

With some exceptions, the prealternate molt is partial. It involves replacement of the feathers that cover the body but not the large wing and tail feathers, which are costly to create. A careful study of American Goldfinches will show this to be true. Even in their drab winter plumage, male goldfinches have black wings with a bold white stripe at the base of the primaries just as they have in their striking alternate plumage.

Molt rivals breeding as the most energetically demanding event in the lives of birds. Growing new feathers requires a huge investment of protein and energy, and while they are growing feathers, birds are subject to reduced protection from the elements and to diminished flight efficiency. For these reasons, most species have evolved very economical molt patterns. The dark wings and tail of male American

The molt that produces alternate plumage is called the prealternate molt. It entails the replacement of some but rarely all of the feathers of the basic plumage.

SEASONAL COLOR CHANGE

alternate ♂

basic ♂

juvenal

AMERICAN GOLDFINCH

Distinctive juvenal plumage; distinctive winter and summer plumages. American Goldfinches have a moderately distinct juvenal plumage with no yellow pigmentation and buffy edges on their wing coverts. Male goldfinches change appearance dramatically between summer and winter through a complete fall prebasic and partial spring prealternate molt.

definitive alternate ♂

definitive basic ♂

juvenal

first alternate ♂

first basic ♂

SCARLET TANAGER

Indistinct juvenal plumage; distinctive first basic and first alternate plumages; dramatic season change in coloration. The Scarlet Tanager is an example of a songbird with seasonal plumage change and male subadult plumage in the first spring. They have indistinctive juvenile plumage that resembles female plumage. In first-alternate plumage, young males have brown wing and tail feathers that are retained from juvenal plumage, and body plumage that is typically more orange with a few retained green feathers. By their second-alternate plumage, the adult males are brilliant red with striking black wings.

Goldfinches and Scarlet Tanagers are relatively inconspicuous when set against drab brownish or greenish body feathers in the nonbreeding season, but these same feathers are relatively bold and striking when contrasting with brilliant yellow or red body feathers in the breeding season. American Goldfinches and Scarlet Tangers are, therefore, able to achieve dramatic seasonal changes in coloration by molting only their small body feathers while retaining their large wing and tail feathers between seasons.

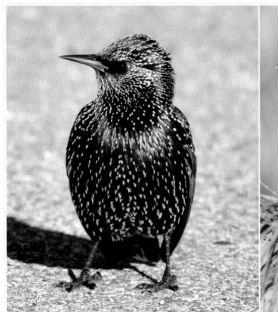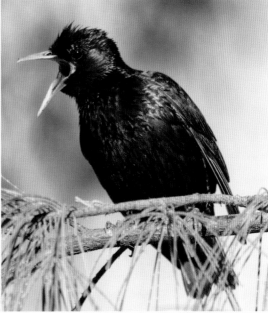

Molt is a complex process, and there is substantial variation among species in which feathers are replaced. The basic patterns of molt that I outline are the most common, but there are numerous exceptions.

The most economical pattern of molt is to skip prealternate molt entirely. This strategy typically limits the potential for seasonal change in plumage coloration, but a few species manage to change the color of their feathers significantly between seasons without molting. Such change comes about when pale feather tips wear away, revealing darker feather coloration underneath. European and North American birders are familiar with the transformation of European Starlings through feather wear, from heavily speckled in the fall and winter to glossy black and unpatterned in the spring. Starlings grow body feathers with light-colored tips, giving them a heavily patterned appearance. Over time, the tips wear off, exposing the glossy black plumage. Feather wear can also cause more subtle changes in appearance and many species brighten from fall to spring as pale feather tips are worn away.

Both of these **European Starlings** are in definitive basic plumage. The bird on the left is in fresh fall plumage while the bird on the right has worn off the white tips its feathers, revealing the glossy purple coloration seen in spring and summer. Bill color has also changed from black to yellow between winter and spring. (Florida, October; Florida, April)

AGE VARIATION

Birds have two basic patterns of growth and development. Precocial species, such as ducks and chickens, are able to run and swim within minutes of hatching. Altricial species, such as songbirds and hawks, are blind and immobile at hatching. Whether they are precocial or

juvenal

definitive basic

TUFTED TITMOUSE

Indistinct juvenal plumage, one adult plumage. From the time they leave the nest, Tufted Titmice have just one plumage pattern. Definitive basic plumage is reached through the first prebasic molt.

TOWNSEND'S SOLITAIRE

Distinct juvenal plumage; one adult plumage. Townsend's Solitaires have a distinctive juvenal plumage but reach definitive plumage through the first prebasic molt and have the same coloration thereafter. The first prebasic molt of Townsend's Solitaires is partial such that some juvenal flight feathers and covert feathers are retained as part of the basic plumage. Because these feathers are nearly identical in juvenal and subsequent plumages, there are not distinct age-related plumages in Townsend's Solitaires after the first prebasic molt.

juvenal

definitive basic

altricial, birds grow and mature much faster than mammals. By the time altricial birds leave the nest, which can be less than two weeks after hatching in some songbirds, they are approximately the same size as their parents. Precocial birds also reach the size of their parents within a few weeks of hatching. In my neighborhood in Alabama, it is common to see immature rabbits and squirrels and, in the nearby farmland, fawns—all small versions of the adult mammals. By the time young mockingbirds, robins, or hawks are flying around my yard, however, they are the same size as their parents. Unless you find a nest, you don't see these species as juveniles in the sense of being miniature versions of their parents, but the plumage of newly fledged birds often gives them away.

Most birds begin life in natal down (a few have bare skin at hatch), which can vary from a few wispy feathers in altricial songbird nestlings to a dense covering of the entire body in the precocial chicks of domestic ducks and chickens. Young birds live in natal down from just a few days in some songbirds to several months in penguins. The natal down of some precocial species is boldly patterned or brightly colored, such as the black and red down of American Coots or the banded pattern of the down of Killdeers. The natal down of many precocial and virtually all altricial species is drab and patternless.

Natal down is replaced by juvenal plumage, the first plumage in which the number, size, and arrangement of feathers is like that of adults. Growth of juvenal feathers coincides with skeletal growth and occurs mostly in the nest for altricial species or soon after hatching for most precocial species. In some species, individuals in juvenal plumage are like adults in appearance; in other species, juvenal plumage has a color and pattern distinct from that of adults.

Juvenal plumage differs most commonly from adult plumage in having bold streaks or spots on the breast where adult plumage is unmarked. For instance, American Robins have unmarked rust colored breasts in basic plumage, but young robins in juvenal plumage have boldly spotted breasts. Many North American sparrows have plain breasts in basic plumage but show vertical streaks on their breasts in juvenal plumage. In other species, juvenal plumage differs from adult plumage in having a scaly appearance created by buff tips on body feathers. Juvenal plumage can differ completely from adult plumage, such as the snowy white juvenal plumage of Little Blue Herons that is so different from the dark blue basic plumage of adults.

When they are in juvenal plumage, birds are immature. For all small birds (less than about 200 grams, or 7 ounces), including all

BIRDER'S NOTE

Shapely Feathers ›› Some of the toughest identifications rely on shape created by feathers, and birders should be aware that molt changes the shape of a bird as well as its coloration. For instance, the extension of primaries past the longest tertial feather is a useful field mark for separating American and Pacific Golden-Plovers, but if tertials are missing or growing, feather shape could be misleading.

Bald Eagle

definitive
plumage

songbirds, individuals in juvenal plumage are no more than a few months old. Some larger birds, including hawks and eagles, retain their juvenal plumage until the next spring or summer after they hatch, and some of those individuals can be sexually mature and can breed in juvenal plumage. In most species, however, individuals in juvenal plumage have yet to develop functional reproductive organs.

An Eastern Bluebird or an American Robin with spots on its breast is a young and inexperienced bird with immature reproductive organs that preclude it from breeding. Sexual immaturity associated with plumage immaturity is an important topic that I will return to when discussing the function of distinct juvenal plumage in chapter 13.

In some species, individuals molt from juvenal plumage into subdefinitive plumages, which are not additional juvenal plumages. I will call these plumages subadult plumages, defining them as plumages that occur subsequent to juvenal plumage and that differ in feather coloration or pattern from that of birds of the same sex in older age classes. This age terminology is not as confusing as it first sounds. Juvenal plumage is the plumage of sexually immature birds. Subadult plumage is the distinct plumage of young birds that can be sexually mature and breed. Subadult plumages can be defined more precisely by simply numbering them in sequence such as first basic, first alternate, and so on, if subadult plumages persist for more than one year.

Definitive plumage appears at the end of the transitional developmental sequence. It is the white head and solid dark body of the Bald Eagle and the bold black-and-white plumage of the Pied

Flycatcher. Birds can reach definitive plumage at the first molt after juvenal plumage, or they can spend years in one or a series of subadult plumages. Except for changes between seasons, once an individual reaches definitive plumage, its general appearance is stable for the rest of its life.

Age-specific plumages account for much of the variation in plumage coloration we see within a species. A Herring Gull does not reach definitive plumage until it completes its fourth prebasic molt after hatching. Consequently, Herring Gulls display a juvenal, a first-year subadult, a second-year subadult, and a third-year subadult plumage before they reach definitive plumage in their fourth winter. In addition, within an age-specific plumage there is seasonal variation. A flock of Herring Gulls in the early fall can look like a mixed flock of five different gull species. To make identification of gulls even more challenging, individuals of the same age class in different species sometimes look more alike than individuals of different age classes within a species. For instance, a Herring Gull in definitive plumage looks more like a Glaucous-winged Gull in definitive plumage than it looks like a Herring Gull in first or second subadult plumage.

Subadult plumage does not occur exclusively in large birds such as gulls and eagles; it commonly occurs in songbirds. In North America most birders are familiar with subadult male American Redstarts in first alternate plumage with yellow rather than red flank and tail patches. Many European birders know that a Pied Flycatcher with the plumage pattern of a male but with brown rather than black feathers is a subadult male in first alternate plumage. Male songbirds in subadult plumage often display conspicuously to attract females or defend territories, are sexually mature, and sometimes breed. Subadult plumages can occur in winter as well as in summer.

Herring Gulls in definitive basic plumage (left) look less like Herring Gulls in first basic plumage (middle) than **Glaucous-winged Gulls** in definitive basic plumage (right). *(New York, April; New York, April; California, December)*

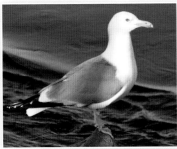
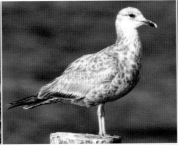
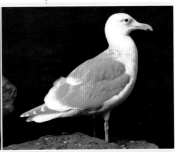

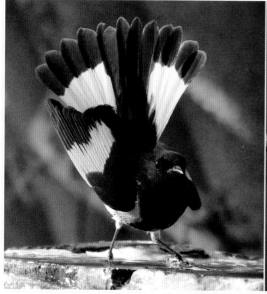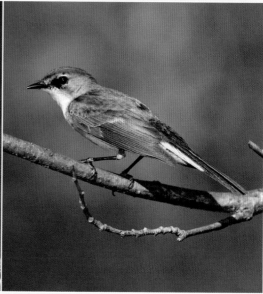

Male **American Redstarts** only attain their bold black and red definitive plumage (left) after a year in much drabber subadult plumage (right). *(Florida, April; Michigan, June)*

Some species of birds such as Common Yellowthroats have a distinctive subadult plumage as their basic plumage, but by their first spring they have molted into definitive alternate plumage.

Eye, bill, and to a lesser extent leg and foot coloration also can change with age. For instance, juvenile White-eyed Vireos are very similar in color and pattern to adults, but a darker iris makes them easily recognizable as immature. Several tropical species of jays retain distinctive pale bills after reaching definitive plumage, and many birds display different bill colors when they are in juvenal and subadult plumage.

SUBSPECIES VARIATION

Along with sex, age, and season, birds can vary in coloration across their geographic ranges. Most populations of species with distinctive plumage coloration are named as subspecies. Often, within a

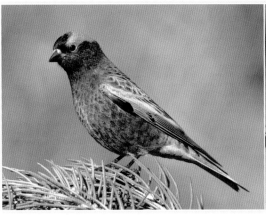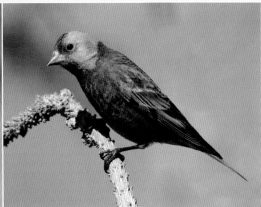

particular location, only one subspecies is present, but there are occasions, especially in the winter, when mixed flocks of different subspecies are encountered.

I opened this chapter with an anecdote about the difficulties of identifying wintering Yellow-rumped Warblers. This species has a distinctive eastern subspecies group ("Myrtle Warbler") and western subspecies group ("Audubon's Warbler"). In breeding plumage, Audubon's Warblers are blacker and have a yellow throat. Myrtle Warblers have a white throat. In basic plumage in the winter, these differences become subtler because the bold markings of alternate plumage are less distinct. In many areas of the West, Myrtle and Audubon's Warblers winter in mixed flocks, and the differences between subspecies add another level of variation to an already confusingly variable species.

Geographic variation tends to interest bird watchers. One of the enjoyable aspects of birding is finding a bird out of its normal range. Most birders keep track primarily of species, but many enjoy keeping track of subspecies as well. To be proficient at finding unusual species or subspecies, birders need to understand color variation due to age, sex, and season. Once a birder is familiar with the full range of variation within a subspecies, he or she will be primed to spot an odd bird that belongs to a different **taxon** worth noting. In this sense, a big part of birding is interpreting individual variation in color and pattern.

Gray-crowned Rosy-Finches are divided into several subspecies including a brown-cheeked subspecies from the interior west (left) and a gray-faced "Hepburn's Rosy-Finch" from northern coastal regions (right). Occasionally these subspecies form mixed flocks in the winter in which case most of the plumage variation in the flock is due to subspecies differences. *(both California, March)*

In this book taxa, or taxonomic groupings, can be subspecies, species, genera, families, or orders.

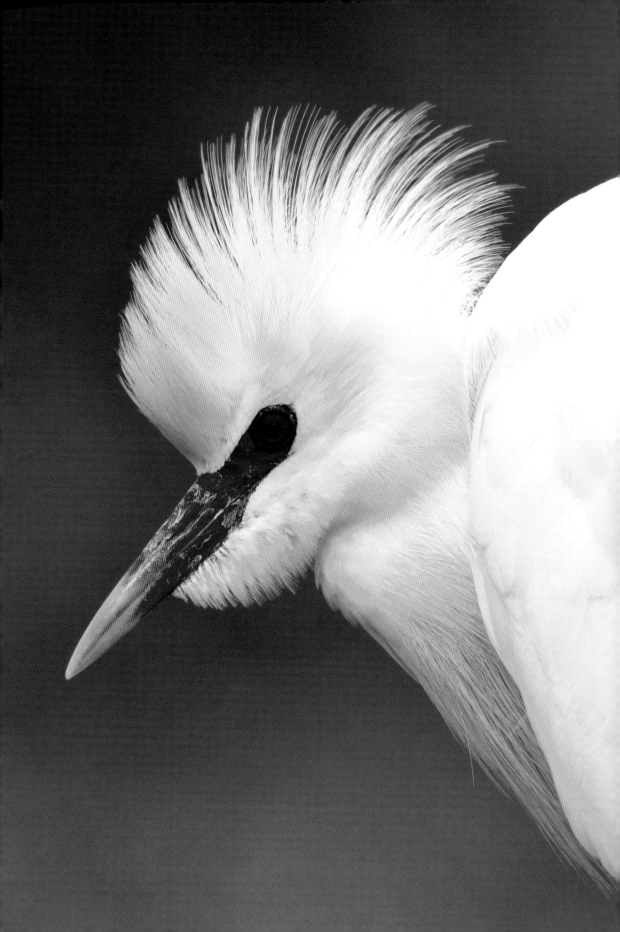

THE VISUAL
WORLD OF BIRDS

S IR JOHN WILLIAM LUBBOCK, BETTER KNOWN TODAY AS LORD
Avebury, was the first scientist to suggest that some animals
might not see the world as humans do. The studies of Lord
Avebury were impressive for the original insights they revealed and
for the fact that he pursued this work on animal vision as a pastime.
By vocation he was a prominent London banker overseeing a large
corporation and an expansive personal estate. He was also a mem-
ber of the British Parliament, authoring a series of influential laws.
Perhaps it was the company he kept (he was a contemporary, friend,
and neighbor of Charles Darwin), but successful careers as a busi-
nessman and politician were not sufficient for Lord Avebury. In his
spare time he was among the leading archeologists of the 19th cen-
tury. He was also the authority of his era on ants, bees, and wasps,
writing the first comprehensive treatise on the social behavior of the
group. His interest in ants led him to establish for the first time,
with a single brilliant and conclusive experiment, that some animals
could perceive ultraviolet light.

Working from the simple observation that ants carry pupae from
lighted areas into dark areas, in 1886 Lord Avebury used a prism to
divide white light into component colors and shined the divided
light onto an ant nursery. He noted that ants moved their pupae
from areas illuminated with blue and violet light to areas of red

Most birds, including this
Cattle Egret, have color
vision that extends into the
ultraviolet portion of the
spectrum. Birds also have
better discrimination than
humans of the colors that
people see. As stunning
as the face of this egret
appears to us, it would be
even more richly colored
through the eyes of a bird.
(Florida, July)

light, from which he correctly concluded that ants cannot perceive red light. The most puzzling thing he observed was that the ants moved their pupae from the dark region adjacent to violet coloration. Lord Avebury concluded that ants could perceive ultraviolet light (beyond violet in the electromagnetic spectrum) and penned a speculation about ants that would apply equally to birds: "The colors of objects and the general aspect of nature must present to them a very different appearance from what it does to us."

Because we share with birds a world of daylight and color, it is natural to assume that birds and people perceive the world in a similar way. But they don't. Most birds see ultraviolet (UV) light, so their visual perception is fundamentally different from the visual perception of human beings. It is not possible to understand the coloration of birds fully without first understanding how birds see the world around them.

COLOR IS LIGHT

Understanding how the visual world of birds differs from that of humans requires a basic grasp of the physics of color. Until the 17th century, the color of an object was generally considered by philosophers to be an inherent property of that object. This view of coloration was challenged by one of the most brilliant intellects in human history, Sir Isaac Newton. As a 29-year-old, Newton conducted a set of original and insightful experiments showing that the color of an object is a consequence of reflected **ambient light**.

The ambient light refers to the available light or the light that illuminates an object.

What is the color of an apple in the dark? Newton showed that this is a nonsense question. An apple has no coloration in the dark. It has a shape; it has a mass; it has a chemical composition; but it has no color when it is not illuminated. The reason is that color is light.

BIRDER'S NOTE

In the Headlights ›› The incandescent headlights of cars produce a red-shifted light lacking short wavelengths. When illuminated by such headlights, as can happen in predawn, male Indigo Buntings look green—much like female Painted Buntings. Beware of headlight identifications based on color.

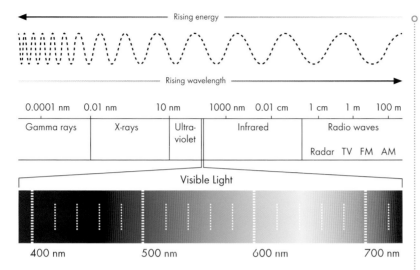

Rising energy

Rising wavelength

0.0001 nm	0.01 nm	10 nm	1000 nm	0.01 cm	1 cm	1 m	100 m
Gamma rays	X-rays	Ultra-violet	Infrared		Radio waves		
					Radar	TV FM AM	

Visible Light

400 nm 500 nm 600 nm 700 nm

The human visible spectrum, highlighted in color, occupies only a small fraction of the total electromagnetic spectrum, which includes wave types from gamma rays to radio waves. Most birds see ultraviolet as well as human-visible light.

Newton demonstrated the relationship between color and light by projecting white light through a prism. He showed that white light is composed of all colors, that these colors cannot be further separated, and that they can be collapsed back into white light by reversing the prism. The series of component colors, which Newton called a spectrum, is always the same: red, orange, yellow, green, blue, indigo, and violet, with the memorable acronym ROY G BIV. Newton used seven colors to describe the visible spectrum, but he recognized that the colors graded into one another and were just a convenient way to describe the continuous spectrum. Newton's insights produced the first great leaps of understanding about the nature of coloration and the relationship between color and light.

Scientists use the same terminology to describe color that they use to describe light or, for that matter, any electromagnetic radiation. Light is propagated as very small waves. The standard descriptor of light is wavelength, which is the distance from one wave crest to the next, typically measured in nanometers. A nanometer (abbreviation nm) is one billionth of a meter—about 100,000 times smaller than the width of a human hair. The scale of light waves becomes especially important for discussion of structural coloration in chapter 5.

The concepts that white light is composed of all colors and that bird coloration results from the interaction of light and the bird's surface are basic themes in the study of avian coloration.

THE VISUAL
WORLD OF BIRDS 35

Black-throated Blue Warblers might be more aptly named Ultraviolet-throated Blue Warblers. The black throat has a distinct UV peak of reflection that would be clearly visible to a bird. Differences in human and avian perception of color are important to consider in studies of avian coloration. *(Ontario, May)*

HUMAN VISION

In Newton's time, no one knew that there could be colors beyond the range of human perception. The human eye is sensitive to wavelengths of light between about 400 nm (violet) and 700 nm (red), which spans the seven colors of the rainbow described by Newton. Above 700 nm lies infrared radiation, which we cannot detect with our visual system but which we can detect in rudimentary fashion with our skin, such as when we feel warmth emanating from the burner of a stove. Below 400 nm lies ultraviolet (UV) light, which is imperceptible to humans. A hundred years after Newton, James Maxwell discovered that the bounds of human visual perception are more or less arbitrary bounds within a larger electromagnetic spectrum. The sun produces a wide range of electromagnetic radiation from gamma rays (one thousandth of a nanometer) to radio waves (about one billion nanometers), but the Earth's atmosphere filters out most wavelengths and allows primarily UV and visible light to reach Earth's surface. The anatomical and visual systems of vertebrates, including humans and birds, have evolved over time to capitalize on this available electromagnetic radiation.

Scientists call the portion of the spectrum between about 400 nm and 700 nm the visible spectrum, but really it should be called the spectrum visible *to humans*. This distinction is not a picky point. What humans perceive versus what other animals perceive can be very different. Birds can see light in the UV range, which is completely invisible to humans.

THE RICHNESS OF AVIAN VISION

Ultraviolet light was described before Lord Avebury made his observations of UV perception in ants, but until Lord Avebury's study, no one had proposed that animals could see in the UV range. The discovery of UV perception in ants, however, did not immediately lead to a reconsideration of UV vision in vertebrates. For a century after Lord Avebury published his observations of ants, it was almost universally assumed that birds were blind to UV light. In fact, for a while in the 20th century, some researchers speculated that UV light represented a special communication channel of insects that was invisible to their vertebrate predators, including birds.

Not until the 1970s did scientists show that most birds, fish, and reptiles had UV vision. The UV-insensitive vision of humans and other mammals, it turns out, is far from typical among vertebrates. Birds perceive light across the full spectrum that humans perceive, but many birds and other vertebrates also perceive light between 315 nm and 400 nm. As such, human vision is a poor model onto which to project the visual world of birds.

SENSITIVE AVIAN EYES

Bird eyes are more discriminating than human eyes in part because birds have droplets of colored oil associated with their cone cells that are lacking in human eyes. Oil droplets act to sharpen the color vision of birds. Each droplet in the eye of a bird is positioned so that light has to pass through it before it stimulates a cone cell. The oil droplet absorbs much of the incoming light, leaving a narrower band of light to stimulate the cone cell. The result is that bird species with colored oil droplets can discriminate among different hues better than humans. Even within the spectrum visible to humans, birds see more colors than humans do. This gives birds the capacity to make more subtle discriminations of color displays, and color discrimination can affect a host of visual activities from females' assessing the plumage coloration of potential mates to warblers' spotting green caterpillars on green leaves.

The light-absorbing pigments in oil droplets are carotenoids.

The primary species that cannot perceive UV light are those that live in light-deficient environments, such as caves or deep ocean habitats, and those that are nocturnal. Mammals as a group are generally nocturnal and have the poorest color vision and the least UV perception of any vertebrate class. The mammalian line leading to humans shifted into a diurnal, visually oriented lifestyle relatively recently in an evolutionary sense, and in our constrained color vision we carry the vestige of our recent nocturnal ancestry. The visual world of humans is, sadly, not nearly so rich as the visual world of birds.

FOUR PRIMARY COLORS

The differences in color perception of humans and birds are a result of differences in color receptor cells. The retina (back surface) of the human eye has three types of color-sensitive cone cells: a long-wavelength sensitive cone, a medium-wavelength sensitive cone, and a short-wavelength sensitive cone, more simply termed red, green, and blue cones. Think of these as tiny switches that will only turn on and send an impulse to the brain when light within a certain range of wavelengths shines on them. Each cone type is sensitive over a fairly broad portion of the spectrum so that the three cones together cover the entire visible spectrum. The retina is blanketed with millions of these light-sensitive cells, and the relative stimulation by light of the three cone types gives us our range of color vision. For instance, light reflecting from the red paint on a toy fire engine stimulates the long-wavelength (red) cones of a human eye much more than the short (blue) or medium (green) wavelength cones. Red cones send signals while blue and green cones do not, and the result is a sensation of red in the human brain. Light reflected from the skin of a lemon, in contrast, equally stimulates both long-wavelength and medium-wavelength cones, creating the sensation of yellow. A perception of yellow, then, is the brain's interpretation of simultaneous signals from red and green cones.

Tri-stimulus color vision, as our three-cone visual system is called, is the reason we recognize three primary colors that can be mixed to create the rainbow of colors. It is also why there are three colors of toner in your color printer and why televisions and computer screens

Cone cells in the retina of the eye are stimulated by light.

The three primary colors of the human visual system, corresponding to the three types of cones in the retina. Birds have a fourth cone type and hence a fourth primary color.

project three colors of light at a viewer. The combinations of these three primary colors is sufficient to give humans their full range of color perception and the ability to distinguish millions of colors.

Birds have the full range of color vision found in humans plus a fourth color dimension. One way to think of this is that the brains of birds recognize four instead of three primary colors. In addition to three cones that are more or less equivalent to the three cones in a human eye, birds have a fourth cone type that is sensitive to ultraviolet light. Birds' UV perception is not simply spillover or trivial perception. They perceive ultraviolet light as clearly as humans perceive red or green light.

UV AND VIOLET VISION

Not all birds perceive UV light. Owl species tested to date have no perception of UV light. Owls, of course, are primarily nocturnal, living in low-light environments. We would expect owls to have poor color vision in favor of better high-contrast, black-and-white vision. The vision of other nocturnal birds like nightjars has yet to be studied. Most birds are diurnal, and all diurnal birds tested to date perceive UV light.

Not all bird species exhibit the same range of UV light perception. Some have a shortest-wavelength cone maximally sensitive between 355 and 370 nm. Species with this retinal cone are called *ultraviolet-sensitive* species, and this group includes most songbirds and parrots. Other groups of birds probably have ultraviolet-sensitive vision, but most orders and families of birds remain to be tested. The other type of shortest-wavelength retinal cone is maximally stimulated by light between 405 and 420 nm, which is actually at the lower edge of the human visible spectrum. Species with this retinal cone are called *violet-sensitive* species, although birds in this group have perception of light into the UV portion of the spectrum. Orders of birds that have been found to have only "violet-sensitive" vision include waterfowl, gallinaceous birds, woodpeckers, jacamars, hoopoes, kingfishers, trogons, pigeons, cranes, and rails.

Eurasian Hoopoe

○ COLORS IN THE BRAIN

It is important to emphasize that birds not only have perception of UV light but also have a fourth cone type lacking in humans that gives them a dimension of color perception beyond human experience. For birds, it is as if a totally new primary color has been added to the three primary colors that are familiar to us. Not only is the color itself new, but there are new combinations to be made with each of the other three primary colors. It takes an animal with a three-cone visual system such

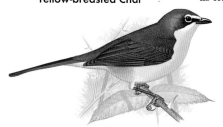

Yellow-breasted Chat

as humans to appreciate the color purple, which results from the interaction of blue and red. One can only imagine what colors birds perceive from the simultaneous stimulation of their UV and other cones. For instance, the breast coloration of the Yellow-breasted Chat has a prominent UV peak as well as a yellow peak of light reflection (see page 51). Humans perceive only the yellow. To a bird's eyes, however, the light reflected from the breast feathers of a chat would stimulate both UV and long-wavelength cones. For birds, the breast feathers of a chat would be a bright color totally beyond our experience.

The perception of ultraviolet light by birds adds a serious wrinkle to studies of the function of coloration. We have to consider the ultraviolet portion of the spectrum as well as the spectrum visible to humans if we want to fully understand how color functions in the lives of birds. We cannot simply rely on the color variation we perceive with our human eyes.

NO HIDDEN PATTERNS

When it was discovered in the mid-20th century that honeybees perceive ultraviolet light, scientists looked for and found hidden UV patterns in the petals of some flowers that directed bees toward nectar and pollen. For a color pattern to be visible to an animal with UV-sensitive cones but invisible to a human, light must be reflected or absorbed exclusively in the UV range.

Color patterns that are visible to some people but invisible to other people have been documented in all human populations for many decades. I first became aware of the potential for color blindness in

humans in my seventh-grade health class. In our textbook was a picture composed of large dots of different colors. Within the matrix of dots, I could see the number 74 formed with green dots among the more abundant orange dots. The text explained that if a person had protanopia (lacked red-sensitive cones), he or she would not discern any numbers among the dots. I remember feeling bad for anyone who couldn't see the numbers and at the same time quite content that I could see the world in all its glory. Imagine my disappointment when years later I found out that from a bird's perspective, all humans are partially color blind. We all lack UV color perception, an entire dimension of avian color vision. In a vision test, dots colored UV that could form a pattern easily perceived by a bird's eye would not be visible to human eyes.

Do the feathers of birds hold invisible patterns? A search using UV-sensitive equipment of bird specimens in museum collections revealed almost no such invisible patterns in birds. Only a few species of whistling-thrushes from Southeast Asia had a strong hidden UV pattern. These whistling-thrushes have patches of feathers on their breasts and crowns that reflect exclusively in the UV range, forming a crown patch, eye strip, and flank spots that are largely imperceptible to a human observer. Most other birds (by one estimate 90 percent) have some UV reflection from their feathers, but in these species the UV component is blended with other color components and there are no patterns invisible to humans.

The failure to find more than a single example of hidden color patterns in bird plumages might lead to a mixed response by birders.

Anyone with normal vision perceives a 74 among the dots in this test for color-blindness. The same people, however, would fail a test for perception of UV coloration. Typical humans lack perception of ultraviolet light because the cornea of the human eye acts as a UV filter. Some humans can perceive UV light when their corneas are removed, but the human brain is not set up to process UV light like the brain of a bird.

It is reassuring to know that humans are not missing out on lots of interesting color patterns. On the other hand, this means that there are no hidden, but simple, UV markers of look-alike species—no UV chest streak on Fish Crows that is lacking in American Crows.

Though few invisible plumage patterns such as spots, stripes, and bars are created by UV coloration, UV makes a large contribution to the visual world of birds in the same way that red, green, or blue adds profoundly to human color vision. The importance of each dimension of color in our view of the world becomes obvious if you disconnect the red input from a color television. The picture would still be in color, but the view presented would be an odd and diminished yellow, green, and blue world. Ignoring the UV component of coloration when considering the visual world of birds is analogous to leaving the red input disconnected when you watch television.

The UV component of bird coloration plays a key role in how color functions. It is often an important factor in mate choice. UV coloration can make birds more or less conspicuous against green leaves in a forest canopy. UV vision also plays a key role in enabling birds to find cryptic prey in their environment.

LIGHTING MATTERS

If color is reflected light, then it follows that the light illuminating an object can have a large effect on the object's coloration. Previous sections of this chapter emphasized that to understand the visual world of birds, it is critical to take into account the broad range of color perception of birds. It is equally important in studies of

To a human eye, the flower of the narrow-leaved arnica appears uniform yellow (right). In the UV portion of the spectrum, as revealed by UV photography (left), however, there is a clear bull's eye pattern that is completely invisible to humans but clearly visible to animals with UV-sensitive vision.

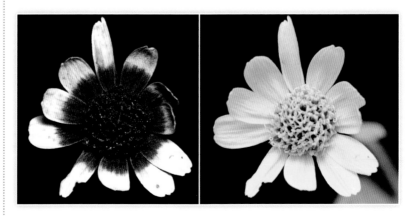

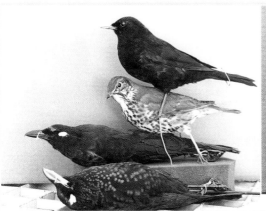

coloration to take into account the lighting environment in which the bird typically dwells. For instance, when afternoon sunlight is streaming into a window, portions of a wall that are brightly lit will appear starkly different from parts of the wall that lie in shadows, even when the paint is exactly the same. In the same way, a bird will look different under different light conditions.

Light conditions can change substantially and rapidly. Just before sunrise, daylight is rich in short-wavelength light (blue and UV) and deficient in long-wavelength light (red). Hence, the pre-dawn world has a blue cast to a human eye, and it would have a UV-and-blue cast to a bird's eye. It follows that color displays of birds will look bluer in pre-dawn light. Conditions change dramatically when the world is illuminated by direct sunlight. As the sun breaks the horizon, the red portion of the spectrum instantly becomes as prominent as the blue portion, and the colors of birds appear to change. Shade further complicates lighting. Light filtering through a forest canopy loses more of its long- and short-wavelength components compared to middle wavelengths, and this forest-shade light takes on a green cast.

Variations in ambient light under different circumstances have played a role in shaping what color displays different birds have and where and when birds display their feather or skin patches. For instance, male Bluethroats have a bright blue and UV chest patch, which they display most actively in the long periods before sunrise on their subartic breeding grounds in Eurasia and Alaska. In this light, their blue feathers have the greatest saturation and are most impressive to females.

Many bird species strategize how to display their plumage coloration not only with regard to time of day but also with respect to the

The whistling-thrushes of Southeast Asia are the only birds known to have color patterns that are invisible to humans. Pictured are the same four stuffed birds (top to bottom: **Eurasian Blackbird, Song Thrush, Taiwan Whistling-Thrush,** and **Blue Whistling-Thrush**) photographed with conventional black-and-white film (left) and with UV-sensitive film (right). The blackbird and Song Thrush look the same, but both whistling-thrushes show a crown patch and breast spots in UV that are not present in visible light.

The light environment refers to the lighting conditions created by ambient light, the background, and impurities in the air.

most flattering light within the local environment. The interaction of **light environment** and display of coloration has been best studied in tropical forest birds. In the Guianan Cock-of-the-rock, spectacular orange males gather at favored spots in their neotropical forest habitat and try to attract a brownish female. Male cocks-of-the-rock don't just pick any random spot in the forest to establish their display perches; they pick a spot where the light coming through the trees is near optimal for accentuating their beautiful orange feathers. Within this larger patch of ideal light, males seek out the scarce shafts of direct sunlight that give their feathers the greatest color saturation.

BACKGROUND MATTERS

How a color display is perceived also depends on how it contrasts against the background. The yellow feathers of the male Golden-collared Manakin stand out much better against a uniform brown background of the forest soil than against a complex background composed of leaf litter. So male manakins clear all leaf litter from the forest floor below their display site and prune green leaves from the branches surrounding the site. No ornithologist would propose that manakins understand color contrast and light environments or think about what conditions would make their feathers most attractive. These behaviors have been shaped by natural selection, and the birds simply have an urge to remove green leaves from their display courts. The result is that when a male manakin displays in front of a potential mate, his feathers are optimally illuminated and presented against a background that achieves the best color display.

Female Golden-collared Manakins have plumage coloration strikingly different from males. The goal of female manakins is not to attract other individuals but to be as inconspicuous as possible to predators. Female coloration achieves this goal very well. The drab olive green plumage of female manakins is not highly reflective in forest shade, and it produces little contrast against the green background of the forest. Because of their drab coloration, female manakins are hard for human or bird eyes to spot in their forest home.

An appreciation of the effects of light on coloration is important not just for ornithologists trying to understand the function of color

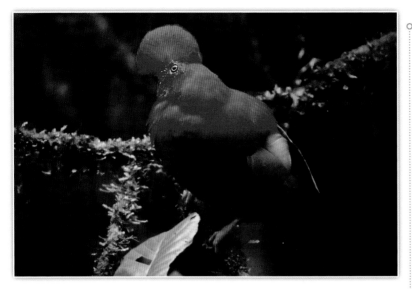

displays, but also for birders trying to make tough identifications. For instance, female Blue-winged Teal and Cinnamon Teal differ subtly in facial pattern and bill size and shape, but the reddish cast to the brown plumage of female Cinnamon Teal plumage is often used as a key field mark by birders. In reddish late-day light, the plumage of female Blue-winged Teal will look much redder than at pre-dawn or in midday, and more than one birder has been tricked into calling a female Blue-winged Teal, viewed in reddish light, a Cinnamon Teal.

WHAT COLOR IS UV?

When I give presentations on bird coloration, I am frequently asked, "So what color is UV? What does it look like?" After I've made a point stressing the importance of UV to some bird displays and how birds really pay attention to variation in UV coloration, it is natural to want to know exactly what birds see that we can't. The rather disappointing answer is that there is no way for us to comprehend coloration based on four rather than three primary colors. We can no more appreciate what such color looks like in the brain of a bird than we can appreciate how a world perceived by ecolocation appears in the brain of a bat. Not only do we lack the retinal cones to respond fully to UV, but more importantly, we lack the computational ability in our brain to interpret the colors that result from the interactive effects of stimulation from four cone types.

MEASURING COLOR

BEFORE I WAS A SCIENTIST OR EVEN A BIRDER, I WAS A CHILD with a box of crayons and a coloring book. Crayons taught me how to put names to the colors I saw in the world around me. I remember being fascinated by the differences between burnt orange and burnt sienna or between pine green and forest green in my 64-color box of Crayola crayons. When I started graduate school in the early 1980s and decided I wanted to study bird coloration, I found that the techniques ornithologists and birders used to record the colors of birds weren't much different from the way I had described colors as a child with my box of crayons.

From the late 19th through the late 20th century, the state of the art in describing colors of birds was direct comparison with color chips in books. The first standard volume describing and naming birds' colors was published by Robert Ridgway in 1886. In 1975, Frank Smithe published a much smaller, field-portable reference of named colors and, for a brief period, his *Naturalist's Color Guide* became the standard. There was nothing particularly sophisticated about either Ridgway's or Smithe's approach to quantifying colors. They both wanted to produce a common language of coloration, but neither took a very systematic approach to the problem. When either of these ornithologists encountered a patch of feathers or a region of skin with a color that didn't match their existing color swatches,

Measuring avian coloration requires a variety of tools and techniques. For a bird with a complex plumage pattern like this **Masked Trogon,** a researcher might pluck red and green feathers for analysis of color quality with a spectrometer, use digital photography to record bill and eye-ring color, and measure the size of the tail spots and the chest band using imaging software on a computer. *(Ecuador, January)*

Smithe's *Naturalist's Color Guide* is a collection of named swatches, little different from the collection of named colors in a box of Crayola crayons.

Color references based on the Munsell system, such as the *Methuen Handbook of Color,* describe color systematically along three axes. Two scales of variation—saturation and brightness—within a red hue are shown.

they would create a new swatch and give it a name. Each book is a collection of hundreds of color chips with names like "Paris Green" and "Pratt's Ruby." Smithe's guide is still useful for birders who want to describe colors verbally as a human sees them. For scientists who wanted to collect data on bird coloration for study and analysis, these books took the study of bird coloration down the wrong path.

THE MUNSELL SYSTEM

As explained in chapter 2, humans have three types of cones in their retinas, each of which is sensitive to a different range of wavelengths of light. Because human vision is based on a three-cone sensory system, it takes three variables to describe coloration completely for a human observer. The system for describing colors in three dimensions that is most commonly used by contemporary ornithologists studying bird coloration was devised in the early 20th century not by a scientist but by an artist, Alfred Henry Munsell. He constructed his systematic notation around the informal language of color description that already existed. Munsell started with hue, the descriptor that is often simply called "color" in casual language, and he divided the colors of the rainbow into ten even portions from red to violet. The second color variable that he described is purity or saturation. Munsell recognized that within a hue such as red, coloration can vary from vivid to washed out (scarlet to pink). He ranked saturation on a seven-point scale with white at 0 and fully saturated coloration at 6. Finally, Munsell recognized that a color could also vary by the amount of black it contains. He called this variable tone—easy to remember for anyone who uses a copier or printer with black toner. In most current color literature, the amount of black in a color is called brightness instead of tone. Munsell divided brightness into eleven levels with black at 0 and pure coloration with no black given a 10. With his hue, saturation, and brightness scores, he could fully describe a color display as a human sees it. Hue, saturation, and brightness are now typically measured on continuous scales. The units are different from those first devised by Munsell, but core aspects of color descriptions based on his terminology have not changed.

Munsell Color System

In the Munsell system, a patch of color is ranked along three axes: brightness, illustrated as the axle, ranges from pure black to pure white; saturation, illustrated as the spokes, varies from pale to vivid; and hue, the color wheel at the end of the spokes, encompasses the colors of the rainbow.

For ornithologists studying coloration, there are critical advantages of Munsell's system compared to Ridgway's or Smithe's. Ridgway and Smithe created a bunch of color chips, each of which stood alone with no clear connection to any other chips. In the Munsell system, however, color chips are arranged on plates in a logical sequence with variation progressing along three axes. For instance, a person would be able to understand the color differences between two birds when told that their feathers had the same hue but differed by two points in saturation. The numbers would indicate that the bird with the lower saturation score has less intensely pigmented feathers than the bird with the higher score. This scaled and logical system allowed statistical tests to be applied to color data and made the study of coloration a much more rigorous field of research than it had been previously.

In the 1980s and the early 1990s most research on bird coloration proceeded by comparing patches of feathers or skin to chips in standard color references based on the Munsell system and recording their hue, saturation, and brightness. This approach essentially used the human visual system as a spectrometer to measure coloration. Despite variation in different observers' color perception, comparison to chips was reasonably accurate within the range of colors visible to humans. The real problem with using human eyes to measure color is that such an approach excludes UV coloration. As I explained in detail in the last chapter, birds perceive UV coloration. To ignore the ultraviolet portion of bird coloration is to ignore a large portion of relevant color information.

BIRDER'S NOTE

Talking Color ›› Birders rarely attempt to use standard color terminology when documenting an unusual bird, but it could make the difference when color is a key to identification. The more precise the documentation, the more likely a record is to stand up to scrutiny. Unfortunately, Smithe's *Naturalist's Color Guide* is out of print and hard to obtain.

Birders use an informal language when describing color. A birder friend recently described to me "the bill of a **Western Grebe** (left) is greener and not as bright. The bill of a **Clark's Grebe** (right) is orangish and more intense." I understood the gist of the differences, but scientists need a better means to quantify coloration than such narratives. *(South Dakota, June)*

MACHINES THAT MEASURE COLOR

Quantifying the coloration of birds using color chips arranged according to the Munsell system allowed for the first rigorous studies of coloration variation within and across populations of birds as well as for better and more detailed studies of the functions of color. But the inability of human visual assessment to include UV variation and a growing demand for techniques that were more sensitive, accurate, and repeatable led ornithologists to switch to machine measurements of coloration.

Most analysis is now done using a machine called a reflectance spectrophotometer (or spectrometer). This type of spectrophotometer bounces a known quantity of light off an object and measures how much light returns to a sensor. Spectrophotometers track the amount of light reflected across the visible and the ultraviolet portions of the spectrum. The information allows a researcher to create a pictorial representation—a **spectral curve**—of the light reflection off the object. From the spectral curve, a researcher can derive hue, saturation, and brightness and include UV light in these calculations.

A spectral curve is a graph showing the proportion of light reflected from a surface at different wavelengths.

A reflectance spectrophotometer consists of a light source and a light receiver. The light source emits a known quantity of light spanning wavelengths from the UV to the infrared range. A receiver measures how much light is reflected from the surface of an object at each wavelength. The data generated can be plotted as a curve of reflected light (*y* axis) versus wavelength (*x* axis). These spectral curves can tell a researcher a lot about the color properties of the object. For instance, examination of a spectral curve reveals whether there is a significant UV component and whether there is one peak of reflection or more than one.

Some spectral curves are straightforward to interpret. For instance, if there is a distinct peak crowded to the left (short-wavelength) side of the curve, then the object will appear blue or violet to a human observer, as in the blue back feathers of Long-tailed Manakins and Eastern Bluebirds. If the reflected light peaks on the opposite, long-wavelength side, then the object will appear red, as in the crown feathers of the Long-tailed Manakin. The far left peak of a Yellow-breasted Chat is not perceived at all by humans. In the brain of a chat, stimulation from this UV peak interacts with stimulation from the yellow peak to produce a color that humans cannot experience.

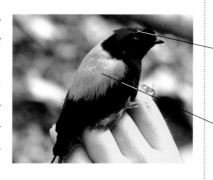

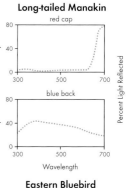

Long-tailed Manakin

red cap

blue back

Wavelength

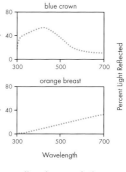

Eastern Bluebird

blue crown

orange breast

Wavelength

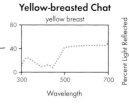

Yellow-breasted Chat

yellow breast

Wavelength

Carolina Chickadee

black cap

white cheek

Percent Light Reflected

Wavelength

Achromatic color refers to coloration that falls on a gray scale from pure white through all shades of gray to pure black. The spectral curve of such gray-scale colors is really not curvy at all. It appears approximately as a flat line. If the flat line lies near zero, the object looks black. If it lies near 100 percent reflectance, the object looks white. If it lies between these extremes, it looks gray.

Chromatic coloration, in contrast, is any color display with a hue, which deviates from black/gray/white. Such coloration won't show as a flat line; rather, it will have higher and lower points. See the previous sidebar for how ornithologists interpret the shapes of reflectance curves.

DESCRIBING COLOR

Hue, saturation, and brightness are three of the most common variables used to describe color as perceived by humans.

Earlier I described what are referred to as **tri-stimulus color variables**—hue, saturation, and brightness—as appropriate and meaningful for describing bird coloration for a human observer. I then stated that ornithologists have stopped using their own eyes to assess color and now use spectrophotometers, which record coloration in the form of reflectance curves. How have researchers integrated these approaches?

Fortunately, it is straightforward to calculate hue, saturation, and brightness values from a reflectance curve. Brightness is the total area under the reflectance curve. This area can be calculated for just the spectrum portion visible to humans, but more commonly in studies of bird coloration, brightness is calculated as the area under a curve within the spectrum visible to birds, including the UV portion. Brighter coloration has more reflected light. You can visualize brightness as the component of coloration captured in black-and-white photography.

Hue is the position of the peak reflection of light. If peak reflectance is at the short-wavelength or left side of the spectrum, the object is blue. If the peak is at the opposite end, the hue is red. Color researchers distinguish between achromatic coloration, which includes black, white, and gray tones, and chromatic coloration, which is color that has hue.

Saturation is a measure of how much of the total reflected light is concentrated in one part of the curve, usually around the peak reflectance. Relatively pure coloration, like brilliant blue on a Blue Jay feather, shows a steep curve with much of the reflected light concentrated around the peak. More washed out coloration, like the powder blue of a Mountain Bluebird feather, shows a more gentle curve with less reflected light concentrated closely around the peak.

PATCH SIZE

Northern Cardinal

Ruby-crowned Kinglet

Color displays vary not only in hue, saturation, and brightness—their color quality—but also in their distribution across the surface of the bird. The tiny patch of red on the crown of a Ruby-crowned Kinglet is clearly a different sort of color display than the extensive red of a Northern Cardinal. The extent of a color display is called patch size or badge size. Patch size varies not only among species but also among individuals of the same species. Like color quality, it can be a key component of color signaling.

Measuring patch size is much less complicated than measuring color quality. One need only find a means to measure the area of colored feathers. Patch size is most accurately measured as the total area of the colored patch. Computer software programs now allow researchers to calculate the area of a patch of coloration easily just by tracing the outline from digital photographic images.

Variation in color quality and in patch size are fundamentally different aspects of bird coloration. Differences in color quality arise from differences in the type or concentration of pigments or from differences in feather microstructure, whereas differences in

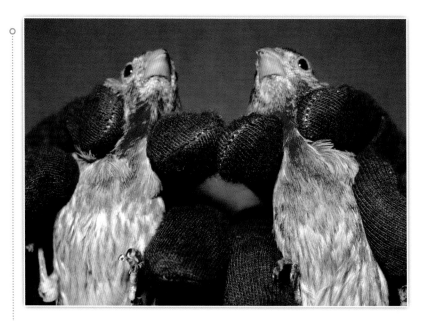

Two male **House Finches** from the same population and age cohort. Both have a similar hue, saturation, and brightness of breast color, but the bird on the left has a smaller red patch than the bird on the right.

patch size result from *which* feathers are colored. Studies indicate that these components of coloration can be under different environmental and genetic controls, and that they can serve distinctly different functions. I will make a point of distinguishing between color quality and patch size when I discuss functions of coloration such as mate choice and status signaling in later chapters.

COLLECTING DATA

In most studies of bird coloration, birds in the study population are captured in nets or traps, and data on coloration is taken in the hand. Reflectance spectrophotometers can be field-portable, running from laptop computers, so color data can be derived directly from the bird in the field. Collecting accurate color measurements in the field while keeping the equipment clean and dry is challenging.

In addition, it is very hard to take accurate color measurements in bright sunshine. Bright ambient light invariably leaks into the spectral measurements. For these reasons, most ornithologists bring a sample of their study birds back to the lab for analysis. This doesn't mean that they kill or harm the bird. For studies of plumage coloration, researchers commonly pluck about a dozen feathers (from the thousands of feathers on the bird's body) for analysis. These feathers are affixed to a black card making it easier to record color data. The cards with feathers create a permanent record.

Some studies of bird coloration are conducted on skins of dead birds in museums, where a reflectance spectrophotometer can be used to take color measurements directly from the specimen. Museum collections are invaluable resources because most of the diversity of the world's birds is represented. A few hours of work in a major collection like the American Museum in New York can enable a researcher to measure the coloration of birds from Madagascar, Borneo, Afghanistan, and Bolivia and to make comparisons that otherwise would not be possible.

There are drawbacks and limitations to studies based on museum skins. Research has shown that feather coloration can change over time in museums, although the changes are usually subtle and major features hold up very well even after a century of storage.

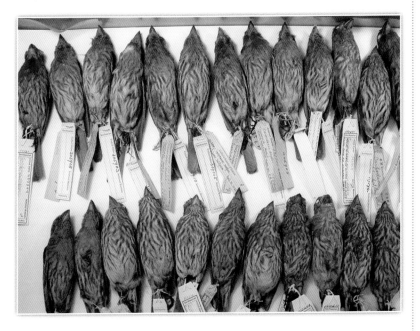

A tray of **House Finch** museum skins in the research collection at the Smithsonian Institution. Such stuffed bird skins retain feather coloration and are a valuable reference for studies of bird coloration.

Coloration, such as the yellow plumage and orange bill of this **American Goldfinch** specimen, can be recorded with a digital photograph, especially if a standard color reference is included. For studies of feather coloration, most researchers pluck a small sample of colored feathers, which are affixed to a black card and measured with a spectrophotometer.

EE2073A
By Candle Li[...]

EE2073B
Luminary

S=60
F=3.2

More importantly, a sample of specimens collected from many different locations over many decades is not the same as a sample of individuals living at one location in one season. Museum specimens are the foundation of many important studies of bird coloration, but field studies of wild bird populations are the basis for much accumulated knowledge regarding the functions of coloration.

Bills and legs presents a challenge for recording coloration because there is no benign way to take a piece of a bill or a leg back to the lab. Some researchers studying bill or leg coloration use portable reflectance spectrometers or even the old-fashioned method of comparing colored tissue to color chips. Another common method to record coloration of birds' nonfeathered bare parts is digital photography. Digital photographs must be interpreted cautiously because, under most settings, digital cameras correct the color of the image. Photographs taken under standardized lighting and with a color standard in the picture can provide an accurate record of coloration within the spectrum visible to humans.

Bare parts are non-feathered surfaces of a bird including bill, legs, feet, eyes, and bare skin on the head.

Coloration fulfills its functions in a specific light environment
and with a particular background. The orange feathers of a male
Guianan Cock-of-the-rock look quite different in deep forest shade
than they do in direct midday sun. A Chuck-will's-widow may
be invisible when it sleeps on a pile of dry oak

leaves, but it is conspicuous when it chooses
to rest in the middle of a light gray sidewalk.
Over the past decade, there has been a growing
realization among ornithologists that to really
understand the color display of a bird, one has
to measure more than just the color on the bird. It
is also critical to measure the light environment in which the color is
displayed and the background against which the color is presented.

Measuring a bird's background simply entails using a reflectance
spectrophotometer to measure the light reflected from the forest
floor, a grassy field, or a tree trunk against which a bird is typically
viewed. Measuring light environment requires a slightly different
device because instead of measuring reflected light, the researcher
records the spectrum of light illuminating a particular spot.

COLOR DESCRIPTIONS FOR BIRDERS

Much of what I present in this chapter is a prelude to my discussions
of studies of coloration conducted by ornithologists. The techniques
that I present in this chapter are, for the most part, not methods
that birders can employ. Most birders rarely or never have birds, or
even feathers, in their hands for examination. Even if birders did
have access to feathers, spectrometric analysis would not be much
of an aid to identification in most cases.

Nevertheless, birding could benefit from more careful, standard-
ized, and rigorous *descriptions* of coloration. If more birders were
familiar with how to describe color in terms of hue, saturation, and
brightness, the outcome would be more accurate and less ambigu-
ous documentation of coloration.

CHAPTER FOUR

PIGMENTARY COLORATION

Around 1863, Arthur H. Church, a chemist at the British Royal Agricultural College with a special interest in pigments, heard an account from a friend that he found hard to believe. He was told that the brilliant scarlet feathers of turacos, a group of birds endemic to sub-Saharan Africa, would leach red into water. Church knew enough about feather pigments to know that they are notoriously hard to release from the feather to which they are bound. They certainly do not just float off a feather when it is put into water. But, when he obtained his own red turaco feathers, Church found the account to be true. Some red pigments were released from a turaco feather submerged in water. Making the water more basic (less acidic) such as by adding soap, however, caused more of the feather pigment to be released into the solution.

Working with the red extract, Church used his skills as a chemist to conduct the first chemical characterization of a feather pigment. He named the red pigment "turacoporphyrin" now called turacin, and he showed that the pigment molecule was constructed around a copper atom—one of very few copper-based bird pigments.

Church's studies were the first to answer a fundamental question: What makes a bird's feathers red? It would be decades after his studies of turaco feathers before this question could be answered for a majority of bird species, but scientists had started down the path toward understanding feather coloration.

Yellow Wagtail

The beautiful pink bill and feathers of a **American Flamingo** result from carotenoid pigments. The black tip of the bill derives from eumelanin. *(captive)*

PIGMENTARY
COLORATION

59

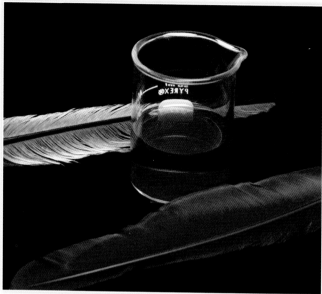

In the photograph on the left, the foreground feather is an untreated feather from a **Ross' Turaco**. The back feather had most of its pigment leached away after two minutes in a basic solution. The beaker holds the leached red pigments. A **White-cheeked Turaco** (right) has two copper-based pigments in its feathers that are unique to turacos—red turacin and green turacoverdin. (captive)

Common Redpoll
basic ♂

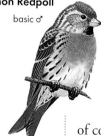

PIGMENTARY COLORATION

The flaming orange throat of a Blackburnian Warbler, the banana-yellow belly of a Great Kiskadee, the deep rust-red tail of a Red-tailed Hawk, the midnight-black cap of a Coal Tit—pigments are a large part of what we see when we view a bird.

An understanding of the pigmentary basis for coloration provides answers to fundamental questions about the appearance of birds. How can the feathers of some birds have the brilliant red hue of a freshly painted wagon when human hair cannot? Is the red of a Red-masked Parakeet in the canopy of a Costa Rican rain forest produced by the same pigments as the red of a Common Redpoll clinging to stubble on a frozen farmfield in Ohio? Do the black feathers of an ostrich striding across the plains of the Serengeti have the same pigments as the black feathers of a House Sparrow picking an insect from the grille of my car? Understanding which pigments produce what colors can be an end unto itself, but it can also be a beginning. The mechanisms by which color displays are created dictates whether the display is physiologically inexpensive or costly to produce, the extent to which genes influence color variation, and how coloration is affected by environmental factors. These characteristics of different types of pigmentation, in turn, influence the functions and evolution of coloration.

MELANIN

Stand on a street corner in a city with a diverse population and note the hair color of the people who pass by—auburn, golden, gray, rust, brown, black. You are looking at the same range of colors that melanin creates in the feathers of birds. This similarity in coloration is not a coincidence. The melanin that colors human hair is in the same family of molecules as the melanin that colors feathers and bare parts of birds.

Melanin is nearly universal as an animal colorant. It is the primary pigment of humans, giving us both our skin tone and our hair color, and it is present in the plumage of nearly every bird species and in the skin of most birds. There are two classes of melanin: eumelanin and phaeomelanin. Though chemically similar, these two types impart different coloration to feathers. Eumelanin produces black and gray. Phaeomelanin produces earth tones such as rufous, chestnut, golden, and yellowish hues.

Melanin is deposited as huge molecules called a polymers made of thousands of repeated subunits. Eumelanin and phaeomelanin have different subunits.

EUMELANIN

Eumelanin is a widespread colorant in bird feathers and bare parts. It is the pigment that gives Red-winged Blackbirds the velvety black plumage that contrasts so beautifully with their brilliant scarlet epaulets. It makes Black Vultures black and Sooty Terns sooty. Eumelanin colors the bills, legs, and patches of bare skin of many bird species.

The relationship between eumelanin and the colors it produces is the same as the relationship between black toner pigments and the colors that these substances produce on sheets of paper. Just as the shade of gray on a printed page gets blacker as more toner particles are applied, so does the color of bills, legs, or feathers become blacker as more melanin is deposited. If no melanin is present, the tissue will appear white. A very low concentration of black eumelanin produces a pale gray appearance. When eumelanin is densely deposited, deep black coloration is the result.

To use some examples, the white secondary feathers of an Arctic Tern in alternate plumage have no eumelanin, but the breast feathers, with a pale gray wash, have a

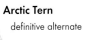

Arctic Tern
definitive alternate

low concentration of eumelanin. The feathers of the slate gray breast of a Gray Catbird have a greater concentration. And crown feathers forming the jet black caps of both the tern and the catbird have dense concentrations. One pigment, eumelanin, can produce the full range of gray tones from the palest gray to midnight black as pigment concentration is raised.

PHAEOMELANIN

Phaeomelanin creates a range of color displays in feathers. At one extreme, it produces relatively bright gold, auburn, or rust as on the hackles and back feathers of the wild-type domestic rooster (Red Junglefowl) and on the body plumage of a male Cinnamon Teal. More typically, phaeomelanins are deposited in combination with eumelanin, and various mixes of phaeomelanin and eumelanin produce every shade of brown from the deep chocolate of an adult Golden Eagle to the rusty red of a Brown Thrasher. This range of coloration results from the density at which phaeomelanin is deposited as well as the mix of eumelanin and phaeomelanin. Phaeomelanin probably occurs along with eumelanin in tans, buffs, and horn-colored legs and bills, but researchers have never isolated it

from these structures. No bird has a rusty bill or legs that would suggest pure phaeomelanin pigmentation.

Deposition of both eumelanin and phaeomelanin in feathers is precisely controlled. Typically, melanin is responsible for the caps, bibs, masks, bars, spots, and stripes that create the characteristic appearance of many birds. Some birds have an intricate pattern of melanin deposition within each feather, and such intricate patterns become stunning whole-plumage patterns when they combine across large patches of feathers. Melanin never forms intricate patterns on bare parts, but it produces dark tips and rings on bills.

CAROTENOIDS

Vivid red, orange, and yellow create memorable images of birds, from the brilliant red-and-yellow bills of Common Moorhens, to the flaming orange feathers of Baltimore Orioles, to the striking yellow legs of Lesser Yellowlegs. The primary source of bright red, orange, and yellow in thousands of bird species is carotenoids, the second most common class of avian pigments behind melanins. Carotenoids are responsible for some of the best-known feather displays including the pink of American Flamingos, the scarlet of Scarlet Rosefinches, and the gold of American Goldfinches.

Phaeomelanin produces brown, rust, and golden plumage coloration, as in the plumages of (clockwise from upper left) **Red Knot, Cinnamon Teal, Horned Grebe,** and **Green Kingfisher**. (Florida, May; Texas, February; Ontario, April; Texas, February)

Although the basic details of feather growth were described in the late 19th century, the tubular nature of feathers was not commonly appreciated for most of the 20th century. Richard Prum, an ornithologist at Yale University, described a new developmental model of feather growth that revolutionized the way ornithologists think about feather development and feather evolution. But how do we know that Prum's model for feather growth is right, and what does this have to do with coloration?

LEFT TO RIGHT: feathers of the **Vulturine Guineafowl, Collared Trogon, Red-tailed Tropicbird, Northern Flicker,** and **Pileated Woodpecker.**

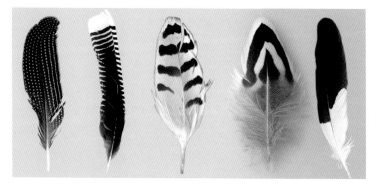

Strong support for the correctness of Prum's model of feather development comes from the model's ability to predict, with startling accuracy, the within-feather patterns of melanin pigmentation. On first consideration, the patterns within feathers—spots, stripes, bars, eyespots, bands—can seem infinite and beyond explanation. But Prum's research shows the value of applying computational models to biological phenomena. Basically, in Prum's **model**, melanin-producing cells associated with growing feathers are turned on and turned off at points in time during feather development. The results were stunning. From his simple model, Prum was able to simulate many patterns of feather pigmentation in living birds.

A model is a mathematical description of a natural phenomenon.

The implications for this developmental model are important. It provides insights into how genes can control feather coloration and what sort of patterns are and are not likely to evolve. It took a set of observations that seemed disconnected and impossible to explain and united them under one simple developmental model.

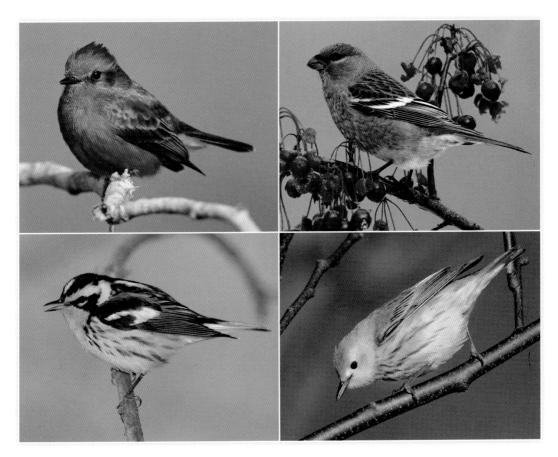

Yellow is the most common carotenoid-based color. Red is widespread but less common. Carotenoid coloration frequently varies among age and sex classes within a species. A common pattern is red plumage in males and yellow or yellow-green plumage in females and juveniles, such as Summer Tanagers. The reverse, yellow in males and red in females and juveniles, is never observed. Carotenoid-based orange is less common than either yellow or red, although it is widespread among New World orioles.

Unlike melanins, which come in only two general forms, carotenoids in the feathers and skin of birds can be any one of more than a dozen different types. The carotenoid pigments of birds are either red or yellow in pure forms. Hue—the shade of yellow, orange, or red—of a bird part is determined by the mix of red and yellow carotenoids. Saturation is determined by how densely carotenoids are deposited. Thus, brilliant red results from dense deposition of mostly red carotenoids. Drab yellow results from diffuse deposition of primarily yellow carotenoids. Bright orange results from dense deposition of an approximately equal mix of red and yellow carotenoids.

Carotenoid pigments in feathers produce red, yellow, and orange coloration as in the plumages of (clockwise from upper left) the **Vermilion Flycatcher**, **Pine Grosbeak**, **Yellow Warbler**, and **Blackburnian Warbler**. *(Texas, February; Ontario, December; Ontario, May; Ontario, May)*

The beautiful red coloration of a **Roseate Spoonbill** in definitive plumage grades from weakly saturated pink on the outer wings and tail to highly saturated scarlet on the shoulders. This change in coloration across the plumage is due primarily to a change in concentration of the same carotenoid pigments. (*Florida, April*)

In general, because there are fewer carotenoids involved in their color displays, species with characteristic yellow coloration will not vary much in hue. For instance, in the yellow plumage of Nashville Warblers and Blue Tits, there is only one carotenoid pigment, and hue does not vary among males; variation in color in these species is restricted to variation in saturation and brightness. In contrast, in species that are typically red or pink there will usually be variation in hue as well as in saturation and brightness. For instance, in the feathers of birds such as the Red Crossbill and the Scarlet Tanager, there is a mix of yellow and red carotenoids. Individuals in these species vary from yellow and orange to red as the ratio of yellow to red pigments differs.

When combined with blue structural coloration (to be discussed in the next chapter), yellow carotenoids produce myriad greens that help to camouflage many birds that live in foliage. Carotenoids also produce striking colors in bills, legs, and feet, as in the red bills of White Ibises, the yellow wattles of Yellow-wattled Lapwings, and the orange bill sheath of Tufted Puffins.

Carotenoids tend to be deposited across relatively large patches of feathers such as the rump, crown, and breast. No bird shows an intricate within-feather pattern of red or yellow, a circumstance

suggesting that fine control of carotenoid deposition in feathers is not possible. Most patterns are created by carotenoid pigmentation when entire feathers are either pigmented or not pigmented. Patterned feathers typically are large, such as those of wings and tails, and have large parts of the feather pigmented or unpigmented. An example is the Pine Siskin, which has a flashy yellow wing stripe created by carotenoids in the inner half of the flight feathers and dark melanin in the outer half.

SOURCES OF PIGMENTS

The sources of pigments are critically important to the functions and displays of coloration. Birds acquire pigments by two means: They can build them from simple compounds available in the body, such as amino acids and fatty acids, or they can eat them and move them intact to feathers, bills, or skin. Think of these sources as options for acquiring a house. You either start from scratch with boards, bricks, and mortar, or you purchase an existing house. This metaphor can be extended further. There are really *three* distinct approaches to acquiring a house: build it from components, move into an existing house without changing it, or renovate it using the framework of an old house but substantially changing its appearance. All birds use one of these three strategies for acquiring pigments.

Melanin is like the new house built from scratch. It is manufactured in a bird's body from the building blocks of proteins called amino acids. Amino acids are found in relative abundance in the diet of all birds, so there are few dietary restrictions on production of melanin.

Carotenoids, in contrast, cannot be synthesized by birds. Acquiring carotenoids is like acquiring the existing house. Carotenoids must be eaten and then moved as complete molecules through the circulatory system to the site where they are needed. To construct and

Because birds cannot make their own carotenoids, they have to ingest every carotenoid pigment used to color feathers and bare parts.

BIRDER'S NOTE

Most Variable Coloration ›› Carotenoid pigmentation is the most variable avian coloration. Birders should be wary of using subtle variation in hue or brightness of carotenoid pigmentation as the sole or primary basis for identification of a rare bird.

Most pigmentary coloration is deposited in growing feathers. Pigments and colored substances can also be applied to feathers *externally*, and sometimes such cosmetic coloration can be a conspicuous part of a bird's coloration.

Most external coloration added to feathers is by accidental soiling. Rock Pigeons and House Sparrows living in big cities have much darker feathers than their counterparts in farmland or suburbs because they wear the soot of combustion engines. Species that feed in tannin-rich wetlands such as Sandhill Cranes and Snow Geese often become stained brown. Male Rock Ptarmigan purposely soil their feathers to reduce their conspiciousness to Gyrfalcons. Lammergeiers (below right) apply patches of iron-rich red mud to their breast feathers, tinting them reddish brown.

Rarely, pigments can be excreted and then applied to feathers. Knobbed Hornbills (above left) secrete a yellow pigment from their uropygial (preen) gland that they rub on patches of white feathers as well as their bill and casque to give them a distinctive golden yellow coloration. Some gull species show a pink cast to their breast plumage, which was thought to be applied externally with the bill, but recent studies show that the pink is due to carotenoid pigmentation internally deposited in feathers during molt.

maintain the machinery for carotenoid transport requires energy and resources. Disruption of carotenoid transport (or mechanisms for the absorption or deposition of carotenoids) can disrupt pigmentation of feathers, bills, or skin, leading to drabber colors. The potential for carotenoid pigmentation to be disrupted by environmental circumstances makes carotenoid coloration an important signal of health and vitality. It is the most variable color display in most groups of birds.

In some species, carotenoids are eaten and moved unchanged to feathers, bills, or skin, the equivalent to purchasing a house and moving in without changing it. Great Tits and Yellow-breasted Chats are examples of birds that follow this simple mode of pigmentation. All species that color their feathers exclusively with unmodified dietary pigments have yellow feathers. Some species of wading birds have abundant shrimp and other shellfish in their diets, which are sources of dietary red pigments. Birds such as Roseate Spoonbills and American Flamingos derive much of their red color by using red dietary pigments unaltered, but they can also produce red feather pigments by chemically altering yellow dietary pigments.

Just as an old house can be remodeled to look very different, carotenoids can be changed in ways that alter a bird's appearance. Such chemical tinkering with carotenoid structure is the primary source of

red in the bills, skin, and feathers. In nature, yellow carotenoids are much more common in the foods eaten by most birds—seeds, buds, insects, and fruits—than are red carotenoids. Entire families of birds with many red species like cardueline finches (family Fringillidae) could not display red feathers if they could not chemically modify their dietary pigments, because these birds eat few or no red pigments.

Across class Aves, there are two types of modifications of carotenoids. In the first, birds chemically modify dietary carotenoids but do not dramatically change the characteristic hue (color) of the pigment. In other words, birds eat yellow carotenoids and then modify these dietary pigments into different yellow pigments that are deposited into their feathers. This yellow-to-yellow conversion occurs in some familiar birds such as American Goldfinches and canaries. Casual inspection suggests no differences in feather coloration between species that use dietary yellow carotenoids and those that undertake the yellow-to-yellow conversion. Detailed study of feather coloration with a spectrometer, however, shows that the latter group has a brighter coloration.

A second and important type of chemical conversion of carotenoids changes yellow pigments to red or orange pigments. These are one-way transformations; red or orange carotenoids are never modified to yellow carotenoids. Yellow-to-red pigment conversions are responsible for the red plumage of species such as male Siberian Rubythroats, Northern Cardinals, and Scarlet Tanagers. Such conversions of yellow carotenoids to red carotenoids are likely the source of most of the red color in birds' feathers, bills, and legs.

UNCOMMON PIGMENTS

Although most pigment-based feather, bill, and skin coloration results from melanin and carotenoids, there are other sources of avian pigmentation. These other classes of pigments are each restricted to one or a few orders of birds, so they account for much less of the diversity of avian coloration than melanins and carotenoids.

As mentioned previously, the brilliant red coloration of turacos results from the copper-based pigment turacin. Interestingly, the bright green color of these same turacos results from deposition

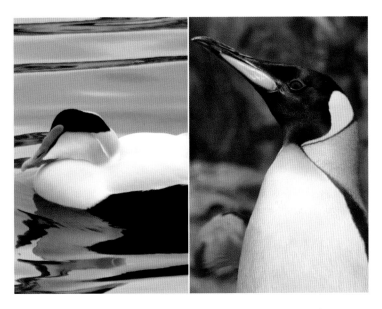

Science has progressed so rapidly, and the volume of accumulated knowledge is now so vast, that it is natural to think there are no real discoveries left to be made in a field of study like animal coloration. But, to quote former Secretary of Defense Donald Rumsfeld, "We know there are some things we do not know. But there are also unknown unknowns—the ones we don't know we don't know."

As for what we know we don't know, the most familiar bird in the world is the domestic chicken, whose young are covered in yellow down when they hatch. Amazingly, the pigments that give chicks their yellow color remain undescribed. Similarly, the orange and yellow colors on the breasts of King Penguins (above right) is produced by a combination of melanins and an undescribed fluorescent yellow pigment. The green head plumage of adult male Common Eiders (above left) is produced by a green pigment that may be the same as the green turacoverdin in the feathers of turacos, but it has not been described biochemically.

These are just the known unknowns. Only a small fraction of the colored feathers of birds have been tested, and it is likely that novel pigments remain to be discovered.

of another copper-based pigment, turacoverdin; thus, two unique pigments are found only in this one rather obscure order of birds (Muscophagiformes) restricted in distribution to sub-Saharan Africa. Turacoverdin is one of very few green pigments found in birds. Most green plumage colors—and all of the green feather colors of songbirds—result from a combination of yellow carotenoids and blue structural coloration.

Parrots have their own unique pigments for producing yellow and red, which are known, appropriately enough, as psittacofulvins. (The order of parrots is Psittaciformes.) Psittacofulvins can produce vibrant yellow and red colors and, when combined with blue structural coloration, brilliant green. Unlike red and yellow carotenoids, psittacofulvins are manufactured within the bodies of parrots. Within a species, psittacofulvin-based pigmentation is less variable in expression among individuals than is carotenoid-based pigmentation.

The brilliant red and yellow colors of parrots, as on this **Rainbow Lorikeet,** result from psittacofulvins, a pigment unique to parrots. *(captive)*

Porphyrins are perhaps the least known of all feather pigments that have been biochemically characterized. The red and green pigments of turacos belong to a class of porphyrins known as metalloporphyrins, but there are also brown porphyrins sometimes referred to as natural porphyrins. Despite being isolated from feathers in 1925, these substances have received remarkably little attention from scientists over the past 80 years.

White-tailed Kite

juvenal

Natural porphyrins are featured most prominently as the pigments in avian egg shells. They are the primary pigments responsible for brown and reddish spots on eggs. They also occur in the feathers of species in at least 13 avian orders including owls, goatsuckers, and bustards. All birds with natural porphyrins in their feathers also have melanins in their feathers. The relative contributions of natural porphyrin and melanin to the overall coloration of feathers has been studied only in the Black-shouldered Kite. In juvenal plumage, Black-shouldered Kites and the closely related White-tailed Kites have distinct reddish brown feathers in their otherwise gray plumage. The color of these reddish brown feathers derives from natural porphyrins. Interestingly, the reddish brown of juvenile kites fades away completely within a few weeks without the birds replacing their feathers. The natural porphyrin pigmentation of kite feathers is degraded by sunlight and persists for only a brief period.

definitive

EYE COLORATION

Eyes have the most complex and least understood mechanisms of coloration of any part of a bird. The coloration of bird eyes is often a result of both pigmentation and crystalline deposits of pigments that

BIRDER'S NOTE

Invisible Parrots ›› The brilliant psittacofulvin pigments that are so conspicuous on caged parrots are not so easy to spot in the canopy of tropical forests. One of the great frustrations of tropical birding is to hear the cries of parrots as they move around the forest, but to be unable to locate them once they are perched.

Acorn Woodpecker

♀

♂

create structural coloration. Dark brown and black eye colors are due to melanins. The yellow eyes of diving ducks and Great Blue Herons are produced by carotenoids. A much more common source of red, yellow, and orange eye coloration is pterin, a class of pigments completely unrelated to red and yellow carotenoids. Unlike carotenoids, pterins are manufactured in the bodies of birds. Pterins produce much of the red and yellow skin coloration in fish and lizards, but in birds they are found only in eyes. They are widespread sources of birds' yellow, orange, and red eye colors, accounting for the striking red eyes of hawks and doves and the deep yellow eyes of many owl species. Pterins also account for the yellow eyes of songbirds such as Brewer's Blackbirds. Hemoglobin, the same molecule that makes blood red, creates the bright red eyes of birds such as Bronzed Cowbirds and Phainopeplas.

Another source of eye coloration is purines, a class of pigment used in the synthesis of pterins and another type of pigment that birds manufacture. Purines are the source of white eyes in birds. Purine-based coloration can be striking, as in the white eyes of Acorn Woodpeckers or Crested Auklets. When combined with pterins, purines also increase the brilliance of some red, orange, and yellow eye colors. The sources of eye coloration in most species of birds remain to be tested.

Mechanisms for color production in eyes are more diverse and less understood than mechanisms for coloration in any other part of birds' bodies. Sources of eye coloration have been studied in less than 200 species of birds, but carotenoids, melanins, pterins, purines, and microstructures have been identified as mechanisms

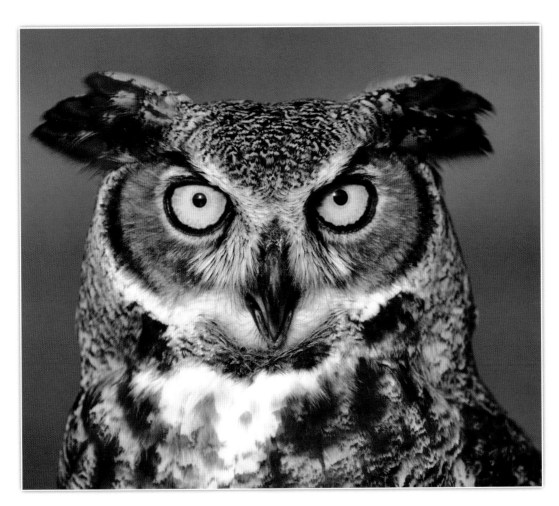

that produce eye color. Much more work has been conducted on feather color than eye color, but a growing interest in eye color among ornithologists should start to close the knowledge gaps.

A FOUNDATION FOR UNDERSTANDING

Understanding how pigments create colors in birds can be of great use to birders intent on making correct identifications in the field. Some forms of pigmentation are more likely to vary among individuals than others, creating odd colors and making identification more difficult. For scientists, knowing the pigmentary basis for coloration provides a critical foundation for studies of function and evolution of the coloration of birds. Whether pigments are ingested or synthesized, what they are constructed from and how they are deposited and displayed are among the most important factors that determine the sort of coloration that evolves in birds.

Great Horned Owls have porphyrins in their feathers, but how much these pigments affect coloration is unknown. The intense yellow of the eyes results from pterin pigments. *(Florida, April)*

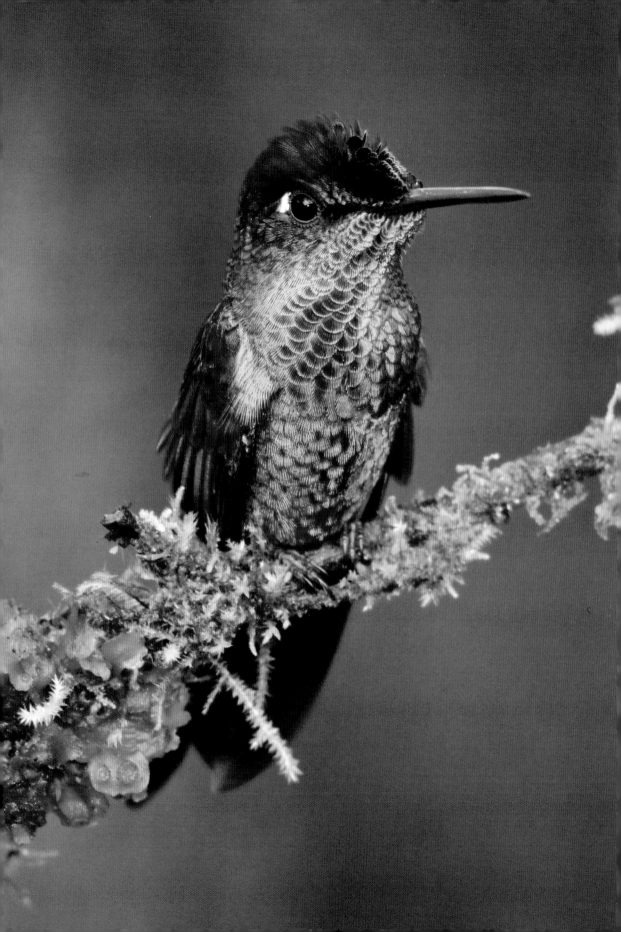

STRUCTURAL COLORATION

H OW WOULD YOU REMOVE THE COLORATION FROM EACH of these feathers?" I once asked a graduate student during a candidacy exam—an oral exam that would determine whether or not the student continued with her graduate studies. I placed on the table before her a red tail feather of a Scarlet Ibis and a blue secondary of a Blue-bellied Roller.

"The red feather is pigmented with carotenoids," she answered correctly through a nervous smile. "You could partially digest the feather to release the red pigments."

"Good," I responded. "So you could separate the redness from the feather of an ibis. What about the blue feather? Could you separate the blueness from the feather?"

"No," she answered, still nervous but gaining momentum and confidence. "The blueness is a consequence of light interacting with the structures of the feather itself. The blueness of the feather could not exist separately from the feather any more than the shape of the feather could exist separately from the feather."

"Very good," I replied, and then I leaned forward in my chair and went for the answer that I really wanted. "So how would you remove the coloration?"

She paused for just a second and then responded: "I would hit it with a hammer."

Scarlet Ibis (left) and **Blue-bellied Roller** (right).

The bright green color in the plumage of the **Violet-fronted Brilliant,** a hummingbird of cloud forests in Ecuador, results from the interaction of light with feather microstructures. (Ecuador, May)

Ornithologists call color such as the blue in a Blue-bellied Roller's feather structural coloration. It results from an interplay between light and the fine structures of a feather. These structures are built at the scale of wavelengths of light, so small that they are called **microstructures.** Stated more precisely, structural coloration results when various wavelengths of light are reflected, amplified, interfered with, or absorbed to differing degrees by microstructures in feathers and skin. To remove this sort of coloration from a feather, one has to destroy the structures. Crushing a feather with a blow from a hammer would likely do the trick.

Any microscopic structure is a microstructure. Microstructures at the scale of nanometers are called nanostructures.

Light interacting with feather microstructures can create three basic types of structural coloration: white, non-iridescent, and iridescent. Together, these different forms account for a wide range of colors in birds from the brilliant white flight feathers of a Red-headed Woodpecker, to the metallic green plumage of a male Elegant Trogon, to the soft pastel blue on the back of a Mountain Bluebird. Although the color in each example results from feather microstructures, the mechanisms that produce these different colors are distinct. Just as it is with pigment-based colors, understanding the mechanisms that create structural coloration is fundamental to understanding how it may have evolved and how it currently functions.

Elegant Trogon ♂

MICROSCOPIC STRUCTURE OF FEATHERS

To explain how feather structures can produce coloration, it is necessary to introduce the names and arrangement of the microscopic layers in a feather. The good news is that there aren't many layers, and they don't have unintelligible Latin names as is true for some anatomical features.

The large and clearly visible parts of a feather are familiar to anyone with an interest in birds, even if the technical names for the parts are not. A typical feather has a central shaft called the *rachis* from which a vane extends. The vane is essentially a flat sheet that forms a covering over the body, something like shingles on the roof of a house. The vane is made of thousands of parallel branches called *barbs,* which are held in place by even smaller cross-links called *barbules.* Because the

Feathers are highly structured objects from their precise shape at the scale of centimeters to their microstructure at the scale of nanometers (1/10,000,000th of a centimeter). The vane of the feather is made of thousands of parallel barbs that are held in place by interconnecting barbules.

As seen in cross-section, barbs have a tough outer layer of keratin, called the cortex, that overlays a layer of keratin particles and air spaces called the spongy layer. Beneath the spongy layer lies a layer of melanin granules if the feather is colored. If the feather is white, the layer of melanin granules is lacking (see page 81). At the center of the barb are hollow air vacuoles. The microstructure of barbs creates the non-iridescent coloration of feathers.

Barbules are the smaller side-branches extending from barbs, and they have a simpler internal structure than barbs. Barbules have a tough outer cortex that overlays a solid mass of keratin— essentially one layer of solid keratin overlaying an interior of solid keratin. Melanin granules can be interspersed within the inner mass of keratin. The microstructure of barbules creates the iridescent coloration of feathers.

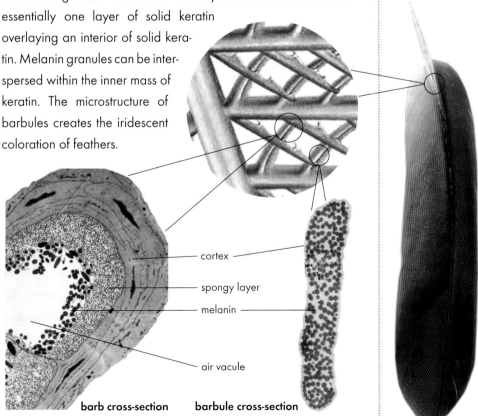

cortex

spongy layer

melanin

air vacule

barb cross-section **barbule cross-section**

different layers of material inside both barbs and barbules play critical roles in producing structural coloration, it is important to understand what these parts are and how they fit together.

The main building block of feathers is keratin, a protein that is hard, strong, and largely transparent to light. It is the same substance from which human fingernails are constructed. The outermost microscopic layer of a feather barb is the cortex, a dense layer of keratin that forms a protective covering. A typical cortex is about 300 nanometers thick, which means that a human hair is roughly one thousand times thicker. These are very small structures. Below the cortex lies the spongy layer, a three-dimensional matrix of keratin with abundant air spaces. Beneath the spongy layer is a layer of black melanin granules.

For a crude sense of how these microscopic parts of a barb fit together, imagine a kitchen sponge sandwiched between an inner layer of black velvet and an outer layer of clear plastic. The plastic represents the cortex. The sponge is the spongy layer. The velvet is the underlying melanin layer. This is the anatomical structure of the blue feathers of many birds in North America and Europe. In some tropical groups of birds such as cotingas and tanagers, the spongy layer is more highly structured. Rather than resembling a sponge, it resembles Swiss cheese, but with more and smaller bubbles. For this type of feather arrangement, think of an outer layer of clear plastic over a layer of Swiss cheese, with black velvet again as a bottom layer. White feathers lack the layer of melanin granules.

The microstructure of barbules is simpler than that of barbs. A cortex surrounds a clear, solid layer of keratin. If melanin granules are present in a barbule, they are suspended in the central keratin layer. Think of a solid tube of clear plastic wrapped in another layer of plastic and with black marbles interspersed through the tube.

WHITE

When considering how colors are produced and what function they serve in birds, observers tend to overlook white. White seems like the default coloration of objects—color that exists without pigments or specialized microstructures. Albinos, individuals lacking melanin pigmentation, are typically snowy white. In this sense, white *is* the

In the summer of 2004, a Steller's Jay in a backyard in Boulder, Colorado, molted from typical blue-black to stark white plumage. Fortuitously, the jay lost one of its new white feathers, which was picked up by the homeowners and sent to my lab at Auburn University. Matt Shawkey, then a graduate student and now an ornithology professor, analyzed

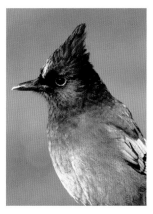

the white feather and compared it to the blue-black feathers of a typical Steller's Jay. There was a single difference in feather anatomy: The white feather lacked a layer of melanin at the center of each barb.

Lack of black melanin would obviously cause a loss of black coloration, but why did it also cause a loss of blue? The answer was proof of a hypothesized but untested idea that melanin at the center of a barb is necessary for non-iridescent color production. The small structures in the spongy layer of barbs reflect short-wavelength light but not longer wavelengths of light, which pass through it. Critically, there must be a light-absorbing backstop to capture the light that passes through the spongy layer, or it will reflect off the back of the feather and wash out the light reflected from the spongy layer.

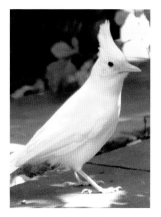

In a normal Steller's Jay, melanin captures the light that is not reflected and a brilliant blue display results. In the white Steller's Jay, all the microstructural mechanisms for blue coloration were fully intact. Without the melanin backstop, the blue was overwhelmed by light scattering off the back of the feather and the result was brilliant white.

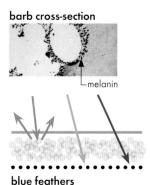

barb cross-section

— melanin

blue feathers

The feather barb of the white Steller's Jay (bottom) lacks the layer of black melanin granules, conspicuous in the feather of the dark jay (top), that absorbs medium- and long-wavelength light (as shown in the diagram below each cross-section).

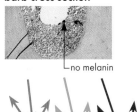

barb cross-section

— no melanin

white feathers

default color of bird feathers, but like blue and violet coloration white is a form of structural coloration.

White plumage results when the microstructures of feather barbs scatter light of all wavelengths equally. Such random scattering is the basis for all white in feathers and bare parts (as well as the white of snow and clouds). Species such as Great Egrets and Fairy Terns have entirely white plumage, while others such as White Ibises and White Pelicans are white except for black areas in their flight feathers. White feathers are most commonly found on birds' underparts. Relatively few birds have white feathers on their back. White or pale underparts combined with dark upperparts create a countershading effect—a type of camouflage that is very common in birds.

Many birds have feathers with white patches in their wings and tail that create distinctive flashes when they fly. Willets are drab gray shorebirds when they stand on a beach or mudflat, but in flight they flash a bold black-and-white wing pattern that makes them conspicuous and easy to identify. Sorting through flocks of wintering sparrows in North America is challenging, but bold flashes created by white outer tail feathers make Vesper Sparrows, Lark Sparrows, and Dark-eyed Juncos stand out in flocks composed mostly of species with all-dark tails.

Individual feathers commonly have both pigment-based coloration and white structural coloration, and typically the base of otherwise colorful feathers is white. The white bases are hidden by colored portions of adjacent and overlapping feathers. Pale or white feather bases are particularly common in brightly colored species such as American Goldfinches and Baltimore Orioles. Species with darker coloration such as Blue Grosbeaks and Red-winged Blackbirds tend to have feathers with gray bases.

A few birds such as American Coots have white bills and white bare parts on their head, which are created by the same basic mechanism as white feather coloration: chaotic scattering of all wavelengths of light by microstructures. White eyes are produced by white purine pigments that act as structural elements in the eye, randomly scattering all wavelengths. No bird has white legs created by skin microstructures, although several species of vultures and the vulture-like Marabou Stork defecate on their legs, coloring them white.

NON-IRIDESCENT COLORATION

Blue Jays are among the most common and conspicuous birds in eastern North America. It is easy for birders to take Blue Jays for granted because they are so familiar, but they are stunning birds. In daylight, from all angles, the feathers on a Blue Jay's back are rich cobalt blue. Such soft, unglossy structural coloration is called non-iridescent coloration, as opposed to iridescent coloration, in which the hue changes with viewing angle.

Non-iridescent structural coloration is restricted to short-wavelength coloration (violet, indigo, blue and ultraviolet) and is responsible for the blue color in such species as Indigo Buntings, Eastern Bluebirds, and Cerulean Warblers. A few birds also have blue bare parts including the feet of Blue-footed Boobies and the faces of Reddish Egrets and Little Blue Herons. Blue in bare parts is produced by essentially the same mechanism as in blue feathers except that in place of keratin, a matrix of collagen in the skin coherently scatters light.

Non-iridescent structural coloration combines with yellow carotenoid pigments to produce most green and olive plumage coloration,

Non-iridescent structural coloration remains relatively constant regardless of viewing angle. It is the mechanism for blue coloration in the feathers of (clockwise from upper left) **Florida Scrub-Jay, Shining Honeycreeper, Ringed Kingfisher,** and **Cerulean Warbler.** (Florida, December; Costa Rica, November; Ecuador, May; Ontario, May)

Only a few birds such as turacos have green feather pigments. Most green plumage results from a combination of blue structural coloration and yellow pigments, which can be yellow psittacofulvins in the case of **Cobalt-winged Parakeets** (left) or yellow carotenoids in the back feathers of **Tennessee Warblers** (right). *(Ecuador, May; Costa Rica, November)*

such as in the feathers of Tennessee Warblers and female Painted Buntings. Blue structural coloration combined with yellow psittacofulvin pigment produces the familiar brilliant green of many parrot species.

Non-iridescent coloration is produced by microstructures in feather barbs. The mechanism of this production was proposed more than 100 years ago by John Tyndall and in more detail by Lord Rayleigh (John William Strutt), his successor as professor of natural philosophy at the Royal Institution of Great Britain. The mechanism they proposed came to be known as Tyndall scattering and Rayleigh scattering. Unfortunately, although their mechanism correctly explains the blue color of a clear sky, they were both incomplete in describing the processes that give rise to non-iridescent feather coloration.

To produce a display like the blue hue of a Blue Jay's body, feather microstructures must differentially reflect and absorb short and long wavelengths of light so that only a portion of the daylight that reaches the feathers is bounced back to an observer. If there is no differential scattering of wavelengths, white coloration is produced. This sounds complicated, but it is really quite simple. White light is a blend of all colors. If feather tissue "traps" some of the component wavelengths of white light and reflects only a certain range of wavelengths, then white light becomes colored light.

Differential scattering is achieved when materials in the spongy layer of barbs are the correct size to reflect short wavelengths (blue and violet) but too small to reflect longer wavelengths (green, yellow, orange, red), which pass through the layer unimpeded. The longer wavelengths not reflected by the spongy layer are absorbed by the melanin that underlies the spongy layer.

Blue-footed Booby
adult

The result is that only short wavelengths are reflected to an observer, and blue or violet is perceived.

Tyndall and Lord Rayleigh got this critical part of the process of structural feather coloration correct: Some wavelengths are absorbed, and others are reflected back at the observer. What they failed to appreciate, and what has only recently been demonstrated, is that the microstructures don't simply reflect short wavelengths and absorb longer wavelengths—they actually amplify certain wavelengths. Such amplification results because the structures of the spongy layer that appear so chaotic when viewed under a microscope are actually arranged very precisely. This precise arrangement of material results in **constructive interference** of reflected light. Through the amplification that results from constructive interference, microstructure in the barbs can turn white light into bright plumage coloration that does not change with viewing angle. The color that is achieved depends on the size and spacing of the feather microstructures.

> Constructive interference is the interaction of light waves such that they are matched peak to peak, with the result that they become amplified.

IRIDESCENT COLORATION

Every birder has watched the sheen on the breast of a breeding European Starling change from black to purple to green depending on the bird's orientation. The gloss on the head of a male Greater Scaup is typically green and that of a male Lesser Scaup is typically purple, but field guides warn birders not to rely entirely on the head color because it can change depending on the angle at which it is illuminated and viewed. This is called iridescent coloration.

In contrast to non-iridescent coloration, which is produced by microstructures in feather barbs, iridescent coloration is produced by thin layers of light-transmitting substances within the barbules.

Lesser Scaup

♂

Greater Scaup

♂

BIRDER'S NOTE

**Head Case ›› ** Scaup head coloration is often dismissed as a misleading character, but it is actually a good field mark for distinguishing Greater and Lesser Scaup. Under most viewing conditions, male Greater Scaup have green heads and male Lesser Scaup purple heads. Rarely, one can perceive the wrong color, so head color should always be used in combination with other field marks—Greater Scaup has more white in the wing and a smoothly rounded head. But there is no reason to completely ignore this generally reliable clue.

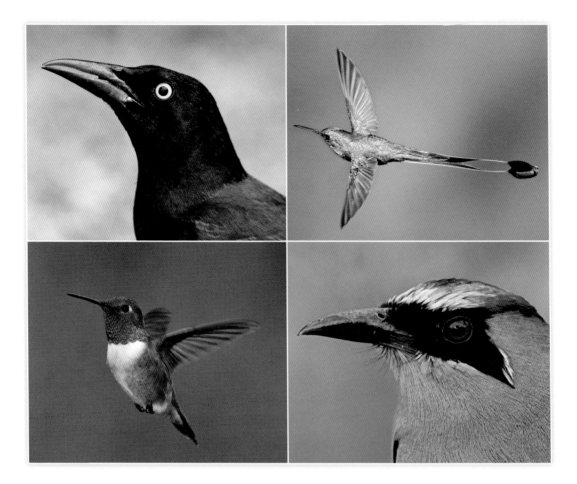

Some of the most striking feather displays are iridescent colors, as in (clockwise from upper left) the **Common Grackle, Booted Racket-tail, Blue-crowned Motmot,** and **Rufous Hummingbird.** *(Florida, March; Ecuador, May; Costa Rica, November; California, March)*

The refractive index is the speed at which light moves through a substance compared with the speed of light in a vacuum.

Thin layers of material that produce iridescent coloration are certainly not restricted to feathers. The most familiar iridescent coloration is the shifting rainbow of colors frequently seen in oily puddles in parking lots. As a matter of fact, iridescent coloration is so strongly associated with films of oil that birds with highly reflective, iridescent feathers are often described as looking oily.

How can a thin film of clear oil on clear water produce brilliant iridescent coloration? The answer is the key to understanding how the feathers of birds produce iridescence. As daylight reaches the surface of the oil, some of the light is reflected from the surface and some light passes into the oil. Light that passes into the oil becomes compressed and slows down because oil has a higher density (called refractive index by scientists) than air. Some light then reflects off the bottom of the oil layer and moves back to the surface of the oil. At the surface, light reflected from the base of the oil meets light reflected from the surface. Because light reflected from the surface will have moved a different distance and at a different speed than

light that bounced off the bottom of the oil layer, most of the wavelengths of light that meet will be **out of phase**, canceling each other out. A few wavelengths, however, will be **in phase** when they meet, and these wavelengths will be amplified.

Through this process of cancellation and amplification, some wavelengths of daylight are subtracted while others are amplified. The result is a brilliant color display. The color produced by a film of oil on water changes with angle of viewing because viewing angle changes the distance that light travels through the oil layer. Different distances mean that different wavelengths of light will be canceled or amplified as the angle of observation changes, hence different colors will be produced.

Feathers also produce iridescent coloration by means of very thin films made of alternating layers of material. The simplest of these iridescent colors result from the cortex (the transparent outer layer) of a feather barbule acting like a layer of oil on water. Light either reflects from the surface of the cortex or penetrates the cortex and reflects from the base. Just as with oil on water, the two types of reflected light meet with most wavelengths out of phase. Wavelengths that are not canceled create bright coloration.

A critical aspect of the production of iridescent coloration in feathers is that the cortex only works as a thin film when a layer of black melanin creates a boundary at its base. Without the defining effects of such a melanin layer, light passes through the cortex without reflecting back to the surface and there is no iridescence. What does this mean in terms of bird coloration? How much could the arrangement of a few melanin granules matter? It actually changes the color of a bird entirely. Red-winged Blackbirds lack a melanin layer below the cortex—they have melanin dispersed throughout

> Out of phase is the condition when wavelengths of light are matched peak to trough, such that they cancel out. In phase is the condition when wavelengths of light are matched peak to peak, such that they amplify one another.

BIRDER'S NOTE

Sheen or No Sheen? ›› The presence or absence of a glossy sheen can be a useful and reliable field mark. For instance, during Christmas Bird Count season in the Southeast, Brewer's and Rusty Blackbirds sometimes join large flocks of Red-winged Blackbirds. In December only male Brewer's Blackbirds, among these three species, have an all-dark plumage with a distinctive gloss. Scanning for such glossy birds and then noting additional field marks is an excellent way to find scarce Brewer's Blackbirds in these flocks.

Shiny Cowbird ♂

The blue of the **Shiny Cowbird** (above) results from the cortex of the barbule (shown in cross-section) acting as a single reflective layer when bounded by a layer of melanin granules. The purple gorget of a male **Black-chinned Hummingbird** (below) results from multiple layers of keratin and melanin in the barbules (shown in cross-section).

Black-chinned Hummingbird

♂

the keratin of the barb—and they have no hint of iridescence; their feathers are a deep, velvety black. In contrast, Shiny Cowbirds have the same amount of melanin in their breast feathers as in Red-winged Blackbird feathers, but it is arranged into a discrete layer at the base of the cortex. As a result, Shiny Cowbirds have bright iridescence.

Depending on the thickness of the cortex, the color produced by this simple mechanism can have a characteristic bronze, purple, blue, or green hue. Species with feather coloration resulting from single thin layers in the barbules include European Starling, Brewer's Blackbird, and Glossy Ibis. Just as with oil on water, the hue of the iridescent coloration of these species changes with viewing angle, so that the color of any given feather can shift from green to purple to bronze.

As a general rule, the more thin layers that are involved in the production of an iridescent color display, the more brilliant the color display will be. Many of the most intense color displays of feathers, for instance the brilliant gorgets of hummingbirds, involve multiple thin layers within the feather barbules. The same materials are repeated over and over, so that light bouncing off the different layers repeatedly amplifies the some colors and cancels others. Color resulting from multiple layers, such as in the purple cap and green throat of Magnificent Hummingbirds is more brilliant than color created by single thin layers.

Because iridescent coloration changes with viewing angle, it is dynamic coloration. At least some species of birds take advantage of this dynamic effect and flash their color displays. For instance, male Anna's Hummingbirds, a species with a brilliant red gorget, engage in a courtship display during which they rapidly move their head back and forth in front of a female. The result is flashes of bright red, like a light that can be turned on and off. It has also been suggested that

BIRDER'S NOTE

Viewing Position ›› The best angle for viewing and photographing structural coloration is typically when there is a 45-degree angle between the sun, the bird, and the observer. Positioning yourself at hummingbird feeders in such a manner can maximize your chances of seeing and photographing gorgets in full brilliance.

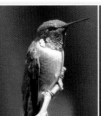

flashing iridescence, as on the back of a Tree Swallow darting away from a predator in the sun, may confuse the predator and aid escape.

FROM STRUCTURES TO COLORS

Blue, violet, and indigo are safely assumed to be structural colors. No blue pigments have ever been discovered in the feathers or skin of birds. As mentioned previously, most non-iridescent structural coloration is short-wavelength—UV, violet, blue—but iridescent colors can be any hue from violet to ruby red.

The avian group with the greatest range of structural coloration is undoubtedly the hummingbirds. They display no carotenoid pigmentation, yet they present a rainbow of colors. In the western U.S. a birder can observe throat colors that range from rose red on Broad-tailed Hummingbirds, to fiery orange on Rufous Humming-birds, to indigo blue on Blue-throated Hummingbirds, to violet and black (mostly UV) on Black-chinned Hummingbirds—all produced by microstructures in the feather barbules. Most green colors result from structural blue combined with yellow pigmentation, but some greens are produced entirely by feather microstructures, as on a male Mallard's head and on metallic green hummingbirds, fruit pigeons, jacamars, todies, bee-eaters, motmots, rollers, and cuckoo rollers.

The previous chapter explained in detail how the pigments in feathers create different color displays. No such detailed explanation is possible for how feather microstructures translate into color display. The basic mechanisms have been worked out recently, but what makes one feather with structural coloration a bit less brilliant blue than another feather with similar structures is not well understood. Structural coloration in birds and other animals is an active area of research uniting the skills of biologists, physicists, and mathematicians.

Iridescent coloration is dynamic coloration, changing with lighting conditions and viewing angle. As this **Ruby-throated Hummingbird** swings its head, the color of its gorget transitions from black to red to black. *(Florida, April)*

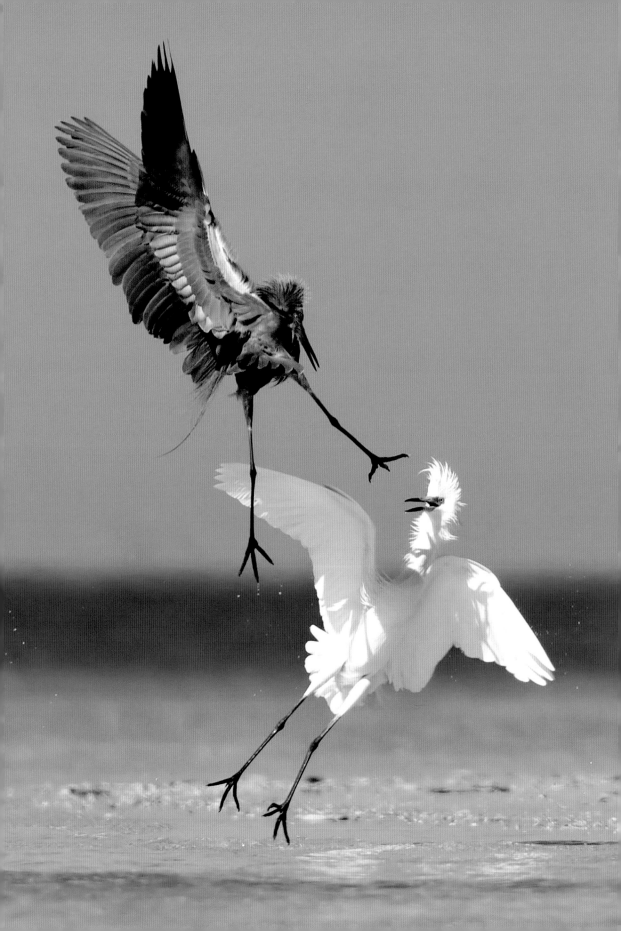

THE GENETICS OF COLORATION

BEFORE WORLD WAR II, AVICULTURE—THE RAISING AND BREED-ing of pet birds—was a popular hobby in Germany, pursued by some with nearly fanatical zeal. Domesticated canaries were among the most popular caged birds, and a long-held dream for breeders was to develop a canary with red instead of yellow plumage. The idea was not far fetched. Color mutants occur in virtually every species of animal, and canaries with pure white feather coloration had already been bred more than a century earlier. Why not a red canary? Despite the lure of the fame and fortune that a red canary would bring, canary fanciers waited in vain for a red mutant to appear.

Finally, breeders grew impatient waiting for nature to provide a red bird and looked for a means to engineer their own. In 1921 geneticist Hans Duncker teamed with a local canary fancier, Karl Reich, in Bremen, Germany, and together they crossed canaries with Red Siskins, a not-closely-related cardueline finch from South America with brilliant red body feathers. The result of the cross was a hybrid offspring with red feathers.

Duncker and Reich wanted red canaries, not red hybrids, so they selectively backcrossed their hybrids with pure canaries to eliminate all of the siskin traits except for red plumage. Voilà! They created a strain of canaries with bright red feathers. "Red factor" canaries, some of them descendants of the original birds bred by Duncker

Two **Reddish Egrets** skirmish over a favored feeding spot. The top bird is a dark morph and the bottom bird is a light morph. The striking color differences result from a two forms of a single gene. Morphs such as these coexist in the same population, and even siblings can be different morphs. *(Florida, March)*

and Reich, can now be seen in pet stores and at bird shows all over the world. But what, exactly, transpired in this breeding experiment? How did Duncker and Reich transfer the red coloration of Red Siskins to canaries?

THE CODE OF LIFE

DNA encodes the blueprint for all life forms, and genes are the segments of DNA that code for specific traits. The reason an experienced birder can venture into the field and identify virtually every individual bird viewed clearly is that birds have species-typical coloration and color patterns. These traits are controlled by sets of genes inherited from one generation to the next. Genes contain essentially all the genetic information that is required to construct the bodies of birds, including growth of feathers and production of feather coloration.

Birds carry two copies of each gene except genes on sex chromosomes, and it is common for more than one version of a particular gene—called alleles—to exist within a population. Variation for a trait like coloration results from the actions of different genes as well as the actions of different alleles for particular genes. The particular set of genes and alleles carried by an individual is called its **genotype**. Most color traits in birds are influenced by multiple genes.

A genotype is the genetic blueprint encoded in DNA, whereas a phenotype is the collection of expressed traits, the manifestation of genotype in an environment.

Although genes govern the basic appearance of all birds, the information encoded within genes has to be translated into the observable characteristics of an individual (called a phenotype) within a given environment. The environment can have a substantial impact on how genes are decoded and, hence, have a large influence on coloration and color pattern in birds. Environmentally induced variation in coloration is the topic of chapter 7.

COLOR MORPHS

Color polymorphisms, often referred to by birders as morphs, are two or more discrete plumage color types that occur in the same population of birds and are not specifically related to age, sex, or season. Color morphs provide the clearest examples of genetic control of bird coloration. In a bird population with polymorphic coloration, individuals have one of two or three distinct appearances. For instance, Short-tailed Hawks have either a white or a black breast. There are no intermediates. Color morphs are under the control of one or a small set of genes, so there is little or no blending of traits.

Short-tailed Hawk

light morph

dark morph

Discrete, polymorphic variation is fundamentally different from the continuous variation in plumage coloration described elsewhere, such as the red-to-yellow variation of House Finches or the small-to-large throat-patch variation in House Sparrows. In these species, color variation does not fall into discrete types. Instead, continuous variation typically reflects a complex interaction of genetic and environmental influences.

Plumage polymorphisms occur in about 3.5 percent of birds, and morphs typically differ in melanin pigmentation. The most frequent morphs are dark brown instead of white, tan, or gray coloration as in many seabirds and raptors. Rusty and gray morphs occur in cuckoos and owls, and blue-gray and white morphs occur in herons. Color polymorphisms typically do not involve carotenoid pigmentation and they are rare in songbirds. Two exceptions to these rules are among the best-studied morphs in birds: the black-or-yellow

BIRDER'S NOTE

Identifying Morphs ›› Color morphs can help or can hinder identification, depending on which species are involved. For instance, the Herald Petrel has three morphs. Distinguishing light-morph and intermediate-morph Heralds from Fea's Petrels can be challenging at long distances—but only the Herald Petrel has a dark morph, making these individuals easy to separate from Fea's. Oppositely, a dark-morph Herald can cause an identification problem. In distant views, it could be confused with the more-common Sooty Shearwater, which is similarly dark.

In birds, a male and a female parent each contribute one copy of each gene to their offspring. If there are two alleles for a particular gene, then depending on the genotype of the parents, there will be predictable combinations of the two alleles in offspring and a predictable ratio of appearances among offspring.

Geneticists use a simple tabulation method called a Punnett square to track possible combinations of genes and appearances of offspring. Standard shorthand is to use a capital letter to symbolize the dominant allele and a lower case letter to symbolize the recessive allele. For instance, B is typically used to symbolize the allele for brown eyes and b for the allele for blue eyes in humans. The genotype of each parent is recorded and then the two alleles from each parent are used as column and row headers. Combining the alleles in the columns and rows throughout the table gives the combinations of alleles that will occur in offspring and their expected ratios. For instance, the ratio of color morphs of a cross between two intermediate-plumaged Parasitic Jaegers could be estimated as follows.

Incomplete Dominance

Parasitic Jaeger
2 alleles for color:
D= Dark
d= Light

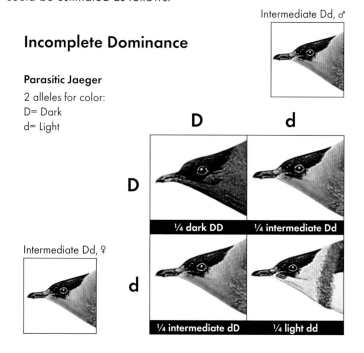

Intermediate Dd, ♂

Intermediate Dd, ♀

	D	d
D	¼ dark DD	¼ intermediate Dd
d	¼ intermediate dD	¼ light dd

Ratio of offspring: ¼ dark; ½ intermediate; ¼ light

polymorphism in Bananaquits and the black- or red-cheek polymorphism in Gouldian Finches.

SIMPLE INHERITANCE

The influence of genes on coloration is easiest to understand when variation is controlled by a single gene with alternate alleles for coloration. Blue and brown eye color in humans is a familiar example of a color trait that is the result of two alternate alleles at a single locus. If a person inherits two blue-eye alleles, the person will have blue eyes. On the other hand, if a person inherits either two brown-eye alleles or one brown-eye and one blue-eye allele, the person will have brown eyes. (There is a second gene for human eye color that can add a greenish tint, but the blue/brown gene determines primary eye coloration). In this example the allele for brown eyes is genetically dominant to the allele for blue eyes, which is genetically recessive. When there is complete dominance, the dominant allele will be the only allele expressed whenever it is present. Recessive alleles like blue eye coloration will not be expressed except when they are the only allele present. When there is incomplete dominance, in contrast, both alleles will be partially expressed. Biologists call inheritance of traits that have just a few discrete appearances "Mendelian inheritance" after the 19th-century Austrian monk Gregor Mendel, the father of modern genetics. Any color trait in birds that shows Mendelian inheritance is designated as a morph.

One of the best examples of Mendelian inheritance in the color patterning of birds is the "bridle" on the face of Common Murres, an abundant seabird of northern oceans. A Common Murre's face either is plain blackish brown or has a distinct pattern with white around the eyes that extends back as a white slash across the cheek. There are no intermediates among adult murres; birds are either fully bridled or plain. This pattern is controlled by one of two alleles for a single gene. The plain-face allele is dominant, and the bridled allele is recessive. The dominant plain-face morph outnumbers the recessive bridled morph.

Examples of species with two plumage morphs and no intermediates, as in the Common Murre, are scarce. In most birds with

Locus is the position of a gene on a particular chromosome.

Dominant is the allele that is expressed when two different alleles are present. Recessive is the allele that is masked when two different alleles are present. Incomplete dominance is when both alleles of a pair are partially expressed.

Common Murre

bridled morph

plain morph

Snow Geese come in two distinct morphs: white (lower right) and blue (second from bottom lower left). Because of incomplete dominance of the blue allele, birds that carry both a white and blue allele (immediately above and in front of white-morph bird) are intermediate in coloration between pure blue and pure white morphs. (Alabama, November)

recognizable morphs, intermediates occur. For instance, field guides typically recognize two distinct morphs of Parasitic Jaegers (known as Arctic Skua in Europe)—a light morph with a white upper breast and belly and a dark band across the upper chest and a dark morph with uniformly dark brown plumage.

While these extreme plumage types certainly occur, many jaegers show a mix of dark and light characteristics. Decades of observations of nesting Parasitic Jaegers in Scotland yielded evidence that overall plumage darkness is determined by a single gene with two alleles: a dark-morph allele and a light-morph allele. However, unlike the simple case of bridling in the Common Murre, in the Parasitic Jaeger there is incomplete dominance such that birds carrying both a dark and a light allele are intermediate in coloration (see page 94).

The Snow Goose and the Common Buzzard are two other well-studied bird species with color polymorphisms determined by a two-allele Mendelian inheritance system. Both of these species have distinctive light and dark morphs but, as in the jaeger example, display intermediate plumage colorations resulting from incomplete dominance of the dark morph.

The reason that intermediate morphs are so variable in coloration, instead of showing a single intermediate appearance, is not completely understood. Very likely other genes interact with the

primary gene involved in controlling morph type, modifying the appearance of plumage in the same way that a green-eye gene interacts with the blue/brown genes to complicate human eye color. The environment in which feathers are grown might also affect plumage coloration.

INHERITANCE RELATED TO SEX

Genetic control of coloration is most straightforward when the genes for coloration are positioned on autosomal chromosomes, which are any chromosomes other than a **sex chromosome**. The genes for bridling in Common Murres and for eye color in humans are examples of genes that lie on autosomal chromosomes and have the same expression and pattern of inheritance in males and females. Many of the genes involved in coloration of birds, however, are found on the sex chromosomes.

Sex chromosome: a chromosome that determines the sex of an individual.

As their name implies, sex chromosomes determine the sex of an individual, and these chromosomes are of two distinct types. One is a full-sized chromosome with a complete complement of genes: the X chromosome in humans. The other is smaller and has a different set of genes: the Y chromosome in humans. The inheritance patterns of genes carried on the sex chromosomes are different in males and females.

Geneticists distinguish between two sorts of genes found on sex chromosomes. Sex-limited traits are expressed only in one sex (usually males), whereas **sex-linked traits** are expressed in both males and females but show different patterns of inheritance in the two sexes. A familiar sex-limited trait in humans is male baldness. Men lose hair by age 40 when they inherit an allele for male-pattern baldness, but women do not typically express the trait by age 40 even when they carry baldness alleles.

A sex-linked trait is a trait coded for by genes on the sex chromosomes leading to different patterns of inheritance in males and females.

A sex-linked trait in humans is red-green color blindness. The allele for color blindness is recessive to an allele for normal color vision, and the gene for these traits is on the X chromosome. Men have one X chromosome and one Y chromosome, so the gene for color blindness is expressed in men whenever it is present and dominance interactions become irrelevant. Women, in contrast, have two

Gouldian Finches commonly have two cheek-color morphs— black (male on the left) and red (male on the right). Cheek color in Gouldian Finches is a sex-linked polymorphic trait, meaning that the genes for the trait are carried on the sex chromosomes. Traits coded for by genes on the sex chromosomes show different patterns of inheritance in males and females. *(captive)*

X chromosomes and, therefore, two copies of the color-vision gene. Women have red-green color blindness only when they carry two recessive alleles for color blindness. Because a woman must have two rare alleles, whereas a man needs to inherit only one, color blindness is uncommon in women relative to men.

There are many sex-limited color traits in birds, and they are responsible for creating sexual dichromatism, which is widespread across Class Aves. Sex-linked color traits are uncommon in birds, but an excellent example is cheek color in the Gouldian Finch, a beautiful little seed-eating songbird of the Australian Outback. The cheek feathers of most Gouldian Finches are either jet black or crimson red. There is also a rare yellow-cheek morph, but adding that morph to an explanation of Gouldian Finch genetics unnecessarily complicates the description.

Because the gene for cheek-color morph is on the sex chromosomes, the inheritance of this morph is different for males and females. Instead of the XY sex chromosomes of mammals, birds have Z and W sex chromosomes. In birds, females have one Z sex chromosome and one W sex chromosome. Males have two Zs. Whichever allele females inherit on their single Z chromosome determines color expression: black if the allele is for black and red if the allele is for red coloration. Because males have two Z chromosomes, in males the trait is inherited following patterns of simple dominance.

Most plumage polymorphisms in birds occur in both males and females, but in some Old World cuckoos (family Cuculidae), females show a rufous (hepatic) morph that does not occur in males. The function of this rufous morph is unknown, and, in general, ornithologists have a poor understanding of why color morphs persist in populations.

HYBRIDIZATION

The discussion of Mendelian inheritance is restricted to plumage polymorphisms, but most bird species lack distinct morphs. In such species, all individuals of the same sex in definitive plumage share the same species-typical plumage pattern. For instance, all Little Blue Herons in definitive plumage have a dark, blue-gray coloration—there are no white morphs as seen in Reddish Egrets. In species such as the Little Blue Heron, all individuals in a population carry the same alleles for the species-typical plumage pattern.

Blue-winged Warblers (top left) and **Golden-winged Warblers** (top right) hybridize frequently in northeastern North America producing two types of hybrids. All first-generation hybrids are of the "**Brewster's Warbler**" type (lower left), with a Blue-winged head pattern. Some second-generation hybrids show a Golden-winged head pattern and are called "**Lawrence's Warblers**" (lower right). *(all Ontario, May, except Golden-winged, June)*

○ If there is no variation in expression of the overall plumage pattern, what evidence is there that genes provide the blueprint for the appearance of these birds?

Hybridization provides one of the most dramatic means to examine the effects of genes on species-typical color patterns. One of the best-studied cases of avian hybridization is between Blue-winged and Golden-winged Warblers, and the inheritance of plumage elements in hybrids of these birds provides important insights into the general inheritance of plumage color patterns. Male Blue-winged Warblers have yellow breast and head plumage with a sharp black line through their eyes. Male Golden-winged Warblers, in contrast, have a golden cap with large black patches on the throat and cheek. Blue-winged and Golden-winged Warblers hybridize frequently in the northeastern U.S. and Canada, and first-generation hybrid offspring invariably have a black eye-line, as in pure Blue-winged Warblers. Second-generation hybrids and backcrosses often show the eye and throat patch of Golden-winged Warblers.

Different alleles of the same gene apparently control this facial pattern in both species. The eye-line of Blue-winged Warblers is dominant to the throat and cheek patch of Golden-winged Warblers. Because all first-generation hybrids carry a dominant allele from their bluewing parent and a recessive allele from their goldenwing parent, all offspring of pure goldenwing and bluewing parents show the dominant pattern. Hybrids with this dominant, eye-line pattern are called "Brewster's Warblers." Second-generation crosses, which are crosses between birds that carry both allele types, produce some hybrids that carry two recessive alleles for the face pattern, and these birds show the throat and cheek patches of Golden-winged Warblers. Hybrids with a goldenwing face pattern are called "Lawrence's Warblers." Other aspects of coloration such as that of the breast show more continuous gradations within hybrids, indicating that these other color traits are influenced by multiple genes.

Face-color patterns are also inherited as simple Mendelian traits when Hermit and Townsend's Warblers hybridize in a zone in the Pacific Northwest. Hybrid offspring have either the bold black cheek patch of a Townsend's Warbler or the plain yellow face of a

Townsend's Warbler ♂

Townsend's x Hermit hybrid ♂

Hermit Warbler ♂

Hermit Warbler, with few intermediates. The yellow face predominates in hybrids and appears to be dominant. Other plumage elements, including back color, breast color, and wing barring, show continuous variation in hybrids, suggesting complex genetic and environmental controls.

Some ornithologists speculate that color polymorphisms arise through the merging of two species or subspecies that have different alleles for feather coloration, as in the cases of Blue-winged and Golden-winged Warblers and Townsend's and Hermit Warblers. In the Snow Goose, for instance, some evidence suggests that until about a century ago, blue-morph birds and white-morph birds lived as isolated populations with no polymorphism for coloration within either population. The merging of these populations, this theory suggests, created the blue/white polymorphism seen in Snow Geese today.

COMPLEX INHERITANCE

Most coloration shows continuous rather than discrete variation, and a particular appearance such as bright-red breast feathers or a large throat patch is not passed from parents to offspring in a simple and easily predicted pattern. Most coloration in birds is coded by numerous genes that interact in complex ways with one another and with the environment. Biologists call such traits **quantitative traits**.

Everyone is intuitively familiar with quantitative human traits, such as height. There are no discrete height morphs within human populations. If a tall person marries a short person they don't produce children in just two (tall and short) or three (tall, medium, short) distinct height classes. Height varies continuously among humans, and

Quantitative traits are traits that show continuous variation in expression and that are coded for by multiple genes.

inheritance of height in humans is not simple or entirely predictable. Nevertheless, everyone also knows intuitively that there is a genetic basis to height. Tall parents tend to have tall children and short parents tend to have short children. Height is also significantly affected by childhood diseases and nutrition, so the environment has important effects on the height a person attains. Variation in human height provides a good model for the sort of variation seen in many color traits of birds.

One well-studied quantitative plumage color trait is the white forehead spot of Collared Flycatchers. The size of the spot varies substantially within populations. To determine whether there is a genetic basis for this variation, biologists compared the size of parents' spots to the size of those on their offspring. They also compared the size of spots between brothers. These sorts of parent-offspring and sibling-sibling comparisons are the basis for deducing whether or not genetic variation contributes to color variation. To conduct these comparisons in the most convincing manner, the young birds are swapped between nests to control for effects of the rearing environment. The researchers found that offspring looked more like their parents and siblings looked more like each other than they looked like random birds in the population. These familial similarities were taken as evidence that some of the variation in the size of the white forehead was due to the shared genes of the related birds.

Variation within species-typical color patterns is invariably the result of some combination of the effects of genes, the environment, and gene/environment interactions. Some quantitative traits

Male **Collared Flycatchers,** such as the two birds pictured, show substantial differences in the size of their white forehead patches. In these Old World flycatchers, forehead patch is a quantitative trait, meaning that it shows continuous variation from small to large. Expression of quantitative traits is controlled by multiple genes. (both Cyprus, April)

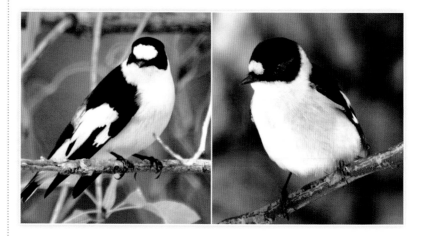

of special interest to researchers studying coloration in birds include the hue of carotenoid pigmentation, the brightness of structural coloration, and the size of patches of melanin. Deducing what portion of the variation in these traits is due to environmental effects and to genetic effects is technically very difficult. Scientists have reasonable estimates of gene and environmental effects for only a few color traits in only a handful of bird species, and these are from populations of birds that lend themselves to long-term banding programs in which many parents and offspring can be measured. For instance, the width of the melanin breast band of Great Tits was studied for years in Wytham Woods, a field station of Oxford University, as was the extent of melanin plumage pigmentation on the breasts of Large Ground-Finches in the Galápagos Islands. In both populations, it was shown that sons resembled fathers in melanin pigmentation more than expected by chance, establishing that genetic variation is responsible for some color variation in these species.

MUTATIONS IN CAGE BIRDS

In studies of laboratory animals such as fruit flies and mice, **knock-out mutations** are one of the most powerful tools for studying the action of genes. A knock-out mutation disables a specific gene so that biologists can observe how losing that particular gene affects the animal. There is often no better way to deduce the actions of a gene than by knocking it out.

Although they don't call them "knock-out mutations," pet bird fanciers have found and bred strains of common cage birds that have color mutations resulting from loss of the action of particular genes. As in laboratory studies, important insights into the actions of specific genes can be derived from studying the effects of such color mutations.

Budgerigars—often called budgies—are a small species of parrot native to the Australian Outback that for the past hundred years has been one of the most common cage birds in the world. In the wild, budgies have bright green body plumage and yellow heads that result from a combination of blue structural coloration and yellow psittacofulvin pigments. They also have bold black barring from

Knock-out mutations in laboratory studies target specific genes and stop them from functioning. They are a primary method for deducing gene function.

Budgerigars, or "budgies," are the most commonly kept cage bird in the world, and blue and green are the most common color varieties. Green is the color of wild birds. Blue results from a genetic mutation that causes the loss of yellow psittacofulvin pigmentation of feathers. *(captive)*

the top of the head back to the nape, which results from eumelanin pigmentation.

The most common color of domestic budgies besides wild-type green is blue, the result of a mutation that eliminates yellow psittacofulvin. Plumage that is yellow in wild budgies is white in these mutant blue budgies. Plumage that is green in a wild budgie is blue in these mutants. The inheritance of this knock-out gene is simple; it acts like a recessive allele. In crosses between blue and green individuals, green is dominant and blue is recessive. This artificial variation in budgie coloration is under control of a single gene.

Another knock-out mutation results in the loss of melanin in budgies, leaving birds with plumage that is yellow where wild birds' plumage is green. This mutation removes all the barring and pattern (as well as eye color), and it eliminates blue coloration. The mechanism by which loss of melanin eliminates blue coloration in a budgie is probably the same mechanism that causes the loss of blue structural coloration in a Steller's Jay (see sidebar, page 81).

These mutations not only show that gross color production is under genetic control, they also reveal that structural coloration and

psittacofulvin coloration can be under independent genetic control. Although these were studies of caged birds in artificial environments, it is not hard to imagine that a polymorphism in color expression could evolve in a wild population of birds through mutations like those seen in budgies.

FROM GENES TO COLOR

The impact of a falling apple may not have been the true inspiration for Isaac Newton's Universal Law of Gravitation, but real eureka moments do occur in science. One of the most significant flashes of insight for understanding how genes code for bird coloration came not to an ornithologist but rather to a cell biologist and geneticist working on the evolutionary relationships of primates. Nicholas Mundy monitored the technical literature on mammalian genomics as part of his job as a research scientist at the University of California at San Diego. In 2000, he read with particular interest a series of papers on a gene that codes for melanin-based coat coloration in mice. This melanin-controlling gene is called the melanocortin-1 receptor, typically shortened to MC1R. In basic terms, this gene was found to stimulate melanin synthesis in cells, and some alleles of the gene stimulated more melanin synthesis and produced darker fur.

Mundy is not a field ornithologist, but he is an avid birder. Like most birders, he knew that morphs in various species differ strikingly in the amount of melanin in their feathers. The eureka moment came when Mundy speculated that the same genes that control fur color in mice might control feather coloration in birds. Such common mechanisms of genetic control across different classes of vertebrates are not completely far-fetched. If vertebrates share common elements of melanin use, Mundy speculated, then maybe they also share genes that control expression of melanin.

BIRDER'S NOTE

Identifying Mutants ›› Rare mutations can cause the loss of pigmentation in any species of wild bird. When such an oddly colored bird has a common body form such as a sparrow or a warbler, a birder is challenged to use clues such as song, size, shape, and behavior to correctly identify it.

Mundy's test of the idea exceeded his most optimistic expectation. Working with ornithologist colleagues, he looked at the distribution of MC1R alleles across individuals in bird populations relative to the darkness of their plumage. To Mundy's elation, variation in the MC1R alleles predicted almost perfectly the dark, light, and intermediate morphs in three unrelated species of birds: the Bananaquit, the Parasitic Jaeger, and the Snow Goose. Mundy found that dark birds of all species had the same MC1R allele while light birds carried an alternative MC1R allele. Intermediate birds carried one dark and one light allele. In the Bananaquit, there is simple dominance of one MC1R allele over the other, with no intermediates, hence only yellow and black Bananaquits with no intermediates.

Parasitic Jaeger

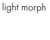

light morph

The discovery that MC1R is the main gene that controls expression of plumage polymorphism in diverse species of birds was a huge step toward understanding the mechanisms by which genes affect birds' coloration. Instead of using abstract symbols to represent the unknown dominant and subordinate genes controlling the trait, scientists now have a specific gene with a known action linked to one conspicuous type of color variation.

What about other forms of coloration, such as that of carotenoids? For their genetically engineered canaries, Duncker and Reich used hybridization as a means to transfer genes for red plumage from the Red Siskin to canaries. In effect, they created a **transgenic** canary. But what sort of genes code for red carotenoid pigmentation? What *specifically* was transferred from the siskin to the canary?

An organism that has had its genome altered through the transfer of genes from another organism is transgenic.

Songbirds such as canaries ingest only yellow carotenoid pigments. Unless they can biochemically modify these yellow dietary pigments into red pigments, they will have yellow rather than red plumage. The conversions of yellow dietary carotenoids to red feather pigments are facilitated by enzymes. Thus, what was transferred from Red Siskins to canaries through hybridization was likely a gene or a set of genes that coded an enzyme needed to convert yellow carotenoid pigments to red pigments. The specific enzyme that codes for such a yellow-to-red transformation in songbirds has yet to be identified by physiologists, let alone genetically mapped, but only an enzyme system could facilitate the transformation of yellow carotenoids to red carotenoids.

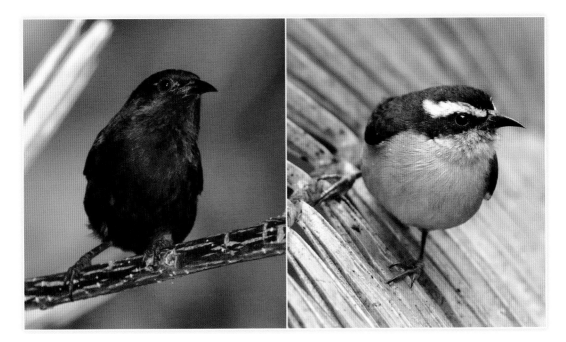

The initial result of the siskin-canary cross was a hybrid with a mixture of Red Siskin and canary traits. The original hybrids produced by the breeding experiments of Duncker and Reich were intermediate between Red Siskins and canaries in size, shape, behavior and plumage characteristics. To derive a bird that had no siskin traits except red plumage, Duncker and Reich had to continue crossing hybrid offspring with pure canaries and selecting resulting offspring that retained red plumage. In this way, over a series of crosses, they essentially isolated the genes for red coloration and eliminated all other Red Siskin traits from their breeding line. The result was a bird that had the appearance of a typical canary except for red coloration.

HORMONES

Up to this point, the focus has been on how genes control color patterns in adult birds. For the most part, sex, age, and season have been ignored. In the first chapter of this book, an array of color variation was described that is primarily related to just these factors. Most of these sexual, age-related and seasonal variations in plumage coloration are controlled, at least in part, by genes.

How can the same set of genes in, for instance, an individual Red-necked Grebe cause it to grow a harlequin pattern in juvenal plumage when it is a few weeks old, a gray basic plumage in the

Bananaquits are common birds in many locations around the Caribbean. Most Bananaquits have yellow breast coloration, but on a few islands, including Grenada, there is also a black morph, with all-black plumage. Genetic analysis shows that a small difference in a single melanin-coding gene causes this dramatic difference in appearance. (Grenada, April; Brazil, August)

fall, and striking rusty-and-slate alternate plumage in the spring? What controls different gene expression within the same plumage patch during different developmental stages, in different seasons, and between the sexes? The simple answer is hormones.

During the development of an individual and then across seasons, levels of circulating hormones show dramatic cycles of change. These hormonal changes cause changes in behavior—breeding in the spring, migration in the fall, and so forth. They regulate the physiology of the bird. Reproductive organs enlarge and become functional in the spring, and then they regress and become non-functional in the fall and winter. Further, hormones direct the timing of molt and the pigmentation of feathers during molt.

The effects of hormones on coloration have been studied primarily with regard to pigment-based coloration. Hormones shape developmental, seasonal, and sexual variation in color by affecting the deposition and withdrawal of pigments from tissues or by altering pigment production. Endocrinology, the study of hormones, is an enormous topic. In this book it is only possible to highlight a few of the mechanisms by which hormones, under the control of genes, regulate coloration.

Experiments provide evidence that sexual dichromatism of birds is under hormonal control. The manner in which hormones control sexual dichromatism differs across different groups of birds. In the flightless ratites, the ostrich relatives, as well as gallinaceous birds such as Gambel's Quail and waterfowl, male coloration is the default state. Drabber female coloration results only when ovarian (female) hormones are present. In these avian groups, female hormones turn off the genes for male coloration; castration and loss of male hormones causes no loss of bright coloration in males. In other birds, including shorebirds and some passerines, drab female plumage is the default state and

Gambel's Quail

♂

♀

the presence of male hormones induces bright male coloration. Individuals that are genetically female can be induced to look like a male by implanting them with the male sex hormone testosterone. Conversely, males can be given a permanent female appearance through castration. In some passerine birds with seasonal changes in plumage color, high levels of a pituitary hormone induce a prealternate molt in males that females skip, making the sexes dichromatic during the breeding season. This sex-specific molt pattern has been documented in detail in weavers (family Ploceidae) including the Orange Bishop.

Orange Bishop

alternate ♂

Although there are different mechanisms by which hormones induce sexual dichromatism, in all dichromatic bird species studied to date, expression of sexual dichromatism is under physiological control. In turn, it must be presumed that these physiological mechanisms are under genetic control.

Hormones, as directed by genes, undoubtedly also control age-specific and seasonal coloration. The same hormones that control sexual dichromatism regulate developmental transitions in color from hatch to definitive plumage as well as seasonal changes when alternate and basic plumages are distinct. For most birds, the specific mechanisms for plumage change and how genes control change in plumage coloration have yet to be studied in detail.

SOURCES OF VARIATION

Birds develop following the blueprint in their DNA. Sexual reproduction ensures that genes are recombined in new arrangements between generations so that each individual in each population of birds is unique. The uniqueness of individuals is constrained within the boundaries of species-typical coloration.

Genes do not account for all variation in birds' coloration. In some species, the effects of environmental factors like nutrition and health generate most of the variation. The next chapter will present what is known about environmental effects on coloration. A recurrent theme through the remainder of the book will be the implications of genetic and environmental color variation for different types of signaling.

ENVIRONMENTAL INFLUENCES

SOMETIMES IT TAKES AN UNBIASED EYE TO HELP SCIENTISTS grasp how nature works. Bird keepers certainly appreciated the importance of the environment on bird coloration long before zoologists did. For hundreds of years in Europe and North America, and perhaps thousands of years in China and Indochina, people who kept birds as pets knew that the yellow and red colors of many species could be maintained only if the birds were "color fed" during molt. By supplementing birds with colorful foods such as leafy greens, peppers, and even ground crustacean shells, feather color can be maintained in captivity. Without color feeding, some red birds faded to pink, yellow, or gray. At the same time, poultry farmers knew only too well that sickness in their flocks could cause the skins of birds to lose their yellow cast and become less marketable. Poultry farmers called this "pale bird syndrome."

By the time biologists began systematic studies of the functions of color in birds after the publication of Darwin's *Origin of Species,* these basic facts about the effects of diet and parasites on color expression were well established among breeders. Such observations should have provided the foundation for scientific studies of avian coloration. Remarkably, though, zoologists largely ignored the observations of zookeepers and aviculturists.

A male **House Finch** with drab yellow breast and crown coloration. House Finches become less red and more yellow as they ingest fewer carotenoid pigments, suffer from poor nutrition, and become infected by parasites. One or a combination of these environmental influences may have caused this bird to grow yellow rather than red feathers. (*California, April*)

Darwin revolutionized how biologists viewed variation, although it took a while for his insights to penetrate all facets of ornithology. He pointed out that organisms exist as populations of individuals. No single individual typifies a species. Most importantly, variation is not a nuisance to be ignored and corrected for; it is a fundamental feature of all species. Variation among individuals allows species to adapt to changes in the environment and to deal with new pathogens. Genetic variation is the raw material for evolution and speciation. Environmental variation is a fundamental feature of the traits of organisms, including color displays, but some color traits are much more sensitive to environmental challenges than other traits.

By the mid-20th century, ornithologists were embracing the importance of variation in traits such as plumage coloration and working to understand the genetic and environmental basis for variation. Much of the research on environmental control of coloration that my ornithologist colleagues and I conducted in the past 20 years has simply been a verification, using controlled studies, of what the poultry farmers and aviculturalists had discovered hundreds of years ago. It took the open mind of Charles Darwin to help the scientific community appreciate what the bird fanciers and farmers knew all along. A large share of the thought devoted to bird coloration now focuses on variation, particularly on how different types of plumage color vary with environmental conditions.

COLORFUL FOOD, COLORFUL FEATHERS

"We are what we eat," so the saying goes, and this expression is just as apt for birds as it is for people. All of the components that make up a bird (except for nutrients that it receives from the egg in which it begins life) pass through its mouth. Despite the variety of the foods that birds eat—from monkeys to algae and from salmon to seeds— all food is constructed almost entirely from the same few basic types of molecules: protein, fat, and carbohydrates. These substances are big molecules composed of repeated subunits. When birds digest their food they break these large molecules down into basic units: proteins into amino acids, fats into fatty acids and glycerol, carbohydrates into sugars, and DNA and RNA into nucleic acids.

These basic building blocks of life are then absorbed through the gut and moved to cells within the body. From these components derived from food, birds build their own proteins, fats, carbohydrates, DNA, and RNA. They use these and other basic components to construct their own melanin, psittacofulvin, turacin, and turacoverdin pigments (see chapter 4 for a description of all these pigment types).

Carotenoid pigments are different. In the 1920s and 1930s, physiologists conducted experimental studies to show that, as a group, birds cannot synthesize their own carotenoid pigments. Birds have to eat carotenoids and move the pigments intact to their feathers, bills, eyes, or skin to achieve a color display. The need to find and eat carotenoids to achieve coloration suggested that carotenoid pigmentation could be linked to the carotenoid content of diet and, hence, to foraging ability. The key question is how much of the variation in color in a population of wild birds such as Northern Cardinals, House Finches, or Great Tits is due to carotenoids in the diet?

It is not unreasonable to speculate that all birds have access to plenty of carotenoid pigments. These pigments are widespread in nature. They occur abundantly in green leaves; they are often densely deposited in colorful fruits; and they are present in seeds and in many insects. The question is: Are any wild birds constrained

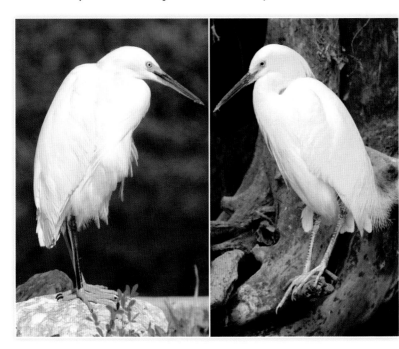

Like many birds, **Snowy Egrets** show diminished carotenoid coloration when they are held in captivity and fed artificial diets. The bird on the right was photographed at the Chattanooga Aquarium. It was healthy and in breeding condition with nuptial plumes but had a very drab yellow face and feet. A typically pigmented Snowy Egret has much brighter yellow coloration (left). (Florida, April)

in their abilities to produce color displays by insufficient carotenoids in their food? Or are carotenoid pigments sufficiently abundant in all natural environments to meet the needs of birds? The degree to which carotenoids in food affects bird coloration remains an area of active ornithological research, but there is now good evidence that insufficient carotenoids in food can diminish the color displays of at least some wild birds.

In captivity, the amount of carotenoids that a bird eats can have a big affect on expression of carotenoid coloration. If during fall molt captive male House Finches are fed a seed diet, which has a low carotenoid content, they will grow pale yellow feathers and look as drab as the drabbest wild male in any population. On the other hand, if male House Finches are provided with abundant red pigments in their water, all individuals will grow bright red feathers when they molt. These carotenoid-feeding experiments show the potential for pigment intake to drastically change feather coloration.

Bohemian Waxwing

Similar, if a bit less dramatic, effects of carotenoid access on plumage color have been observed in other captive birds including flamingos, ibises, spoonbills, quetzals, woodpeckers, barbets, cotingas, waxwings, tanagers, and African weaver finches. Reduced access to carotenoids in captivity can also affect bill coloration in species such as Zebra Finches and Red-billed Queleas. Such observations of birds in cages have to be interpreted cautiously because they concern captive animals on artificial diets, but there can be no doubt that the quantity of carotenoids that are eaten can change the coloration of a bird.

To understand the effects of dietary intake of carotenoids on the coloration of birds living in the wild, researchers have to track carotenoids from food to feathers. It is challenging to measure carotenoid intake in free-living birds, and to date only two such studies have been published. In Sweden, yellow carotenoids called lutein were tracked from the leaves of trees through leaf-eating caterpillars to feathers of Great Tits in both rural and urban environments. Compared to trees in rural environments, trees in urban environments produced leaves with less lutein. A consequence of reduced carotenoids in leaves is

Lutein is among the most common carotenoids in green plant matter.

that caterpillars in urban environments have less lutein in their bodies and that the urban Great Tits that eat the caterpillars, in turn, have less lutein in their feathers. The end result is that because they ingest lower levels of carotenoids, Great Tits in urban areas have drabber yellow breast feathers than those in rural areas.

Tracking carotenoids from a primary source, such as leaves, to feathers is the best way to understand the effects of pigment access on a color display. As a practical shortcut, researchers can also compare the carotenoid content of food in the gut to the color of feathers. Some colleagues and I undertook such a study of House Finches, and we found that male House Finches growing more saturated and redder breast feathers had a higher concentration of carotenoid pigments in the food in their guts compared to finches growing drabber feathers. These studies of Great Tits and House

Caterpillars eat green leaves rich in the yellow carotenoid lutein, which in turn passes to **Great Tits** when they eat caterpillars. Great Tits use the yellow lutein to color their breast feathers. *(Scotland, May)*

The tail feathers of typical **Cedar Waxwings** have yellow tips. Individuals with orange-tipped tails make up a few percent of eastern populations, and this novel tail color results when birds eat honeysuckle fruits containing orange carotenoid pigments.

Finches provide direct evidence that the amount of carotenoids in food affects feather coloration in wild birds.

Egyptian Vultures in Spain provide one of the most bizarre examples of dietary carotenoids affecting a coloration. Egyptian Vultures are beautiful white birds with yellow facial skin (see page 118). Researchers noted that they displayed the odd behavior of eating not only the flesh of dead sheep but also fecal matter from the intestines. It was further noted that vultures that fed in green pastures had yellower faces than vultures that fed in brown, dry pastures. These researchers proposed that Egyptian Vultures consume feces as an important source of carotenoids for coloring their faces, and that the amount of carotenoids available in the grass in the guts of sheep carcasses dictated facial coloration. (If we truly are what we eat, I'm glad that I am not a vulture.)

Sometimes new sources of pigments can actually change the characteristic coloration of a species. The most dramatic example of such a shift in color display is the change in tail color observed in Cedar Waxwings in the latter decades of the 20th century. Until the mid-1960s, all adult Cedar Waxwings had yellow bands on the ends of their tail. Around 1964, however, birders and museum biologists noticed that a few waxwings had orange rather than yellow tail bands. At first it was thought that this change represented a mutation—a change in the genes coding for tail coloration. A group of astute ornithologists investigated and learned that a new, non-native species of honeysuckle (Morrow's Honeysuckle) was widely planted in the midwestern United States in the early 1960s as wildlife food and for erosion control. This invasive plant produced orange fruit that attracted waxwings in the fall when they were growing their tail feathers. The story became complete when biochemical analysis showed that the same pigment that made waxwing tail feathers orange was

Geographic Variation ›› Several North American species with extensive carotenoid pigmentation show distinct regional variation in coloration. For instance, Summer Tanagers in the Southwest are paler red in comparison to eastern birds. The opposite pattern occurs in Northern Cardinals, with western populations brighter than eastern populations. Whether these differences reflect consistent differences in diet or differences in the genetic makeup of the populations remains unexplored.

BIRDER'S NOTE

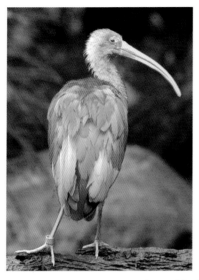

Feather coloration is unique among vertebrate coloration because it is, by and large, a static trait. In many birds, feathers are grown extremely rapidly during one or two short periods of molt. During this feather-growth period, pigments must be procured or synthesized, moved to the growing feather, and deposited. Once a feather hardens at the end of its development, no pigments can be added or removed. Because it is fixed in the dead tissue of mature feathers, plumage color represents a snapshot of a bird's ability to pigment the feather and to create microstructures during its previous period of molt. Just because feather coloration is a reflection of the past does not mean that it is irrelevant in the present. The challenge of pigmenting feathers during the brief molt period means that feather pigmentation can signal fundamental features of the bird that are not likely to change.

Females should also benefit by assessing more immediate signals of a male's health and vitality. Song and courtship displays provide information about the current condition of a male, but so can the coloration of bills, legs, and other bare parts. Unlike mature feathers, the bill and skin of a bird is living tissue, and pigments and other components can be moved in and out. Thus, bill coloration can respond rapidly to the immediate condition of the individual. If a Zebra Finch becomes ill from a parasite, bill color will decrease within a few days. Likewise, if carotenoids are withdrawn from food, bill color will begin to fade within days. Hence, if a bird has ornamental colors that involve both feathers and the bill, information about both past and current condition is on display.

The feathers, bill, and legs of the **Scarlet Ibis** are pigmented with carotenoids. After molt, its feather coloration cannot be altered except through feather wear, but its leg and bill color can change with the condition and health of the bird. *(captive)*

Egyptian Vultures have bright yellow facial skin that is pigmented with carotenoids. To get the carotenoids needed for facial coloration, these vultures eat the gut contents of dead sheep. (France)

also the dominant type of carotenoid in honeysuckle fruit. The proportion of birds with orange tails climbed through the latter decades of the 20th century with the spread of Morrow's Honeysuckle, and waxwings with orange rather than yellow tail bands are now routinely observed throughout the eastern range of the species.

These studies of carotenoid access are somewhat limited, but it seems reasonable to conclude that the amount of carotenoids in food can play an important role in carotenoid-based coloration. Pigment access as an environmental factor that affects coloration is limited to carotenoid pigmentation. All other avian pigments are synthesized from basic biological building blocks such as amino acids within the bodies of birds. Having the ability to synthesize pigments like melanins means that melanin pigmentation will not be affected by how much melanin a bird ingests. However, the ability to synthesize pigments or to create structural coloration does not mean that other environmental factors do not affect the expression of these types of color displays.

THE INFLUENCE OF DIET

Access to carotenoid pigments is one specific component of bird nutrition. Can more general aspects of nutrition, such as the protein

or fat content of food or access to specific minerals or vitamins also affect coloration? The answer is yes. General nutrition has been shown to affect the expression of structural coloration as well as carotenoid pigmentation.

It is challenging to study the nutrition of animals in the wild. A scientist either has to record what birds are eating as they are foraging, which is surprisingly hard to do comprehensively for most species during molt, or has to assess what is in the crop and stomach of a bird, which is also not easy with wild birds.

Fortuitously for ornithologists, birds create a record of their daily nutritional state as they grow their feathers. This record occurs in the form of growth bars—faint alternating dark and light bands in the vane of a feather. These are not the bold bands of melanin pigmentation such as on many tail feathers. Rather, they are very faint bands present even on feathers that appear to be uniformly colored unless they are inspected very closely. One dark bar plus one light bar equals 24 hours of growth, so if a scientist measures the width of growth bars, the rate of feather growth can be calculated. Various experiments have shown that, up to a point, the better a bird's nutrition, the faster it grows its feathers. Thus, the width of growth bars can be used as a record of nutrition during feather growth.

If nutrition determines the width of growth bars and if nutrition also affects expression of coloration, then there should be a positive relationship between the width of growth bars and the intensity of coloration. This predicted pattern was confirmed both for the carotenoid-based coloration of House Finches and Great Tits and for the structural blue coloration of Blue Grosbeaks, Blue-black Grassquits, and Satin Bowerbirds. In the same study that found the predicted relationship between the width of feather growth bars and yellow breast coloration in Great Tits, there was no relationship between melanin pigmentation and growth-bar width. Even for carotenoid coloration, the predicted relationship has not been found in every study. Researchers studying Northern Cardinals found no relationship between growth bars and either red carotenoid or black melanin pigmentation. Overall, these studies indicate that quality of nutrition at the time feathers are grown can affect carotenoid and structural coloration in *some* species. Melanin pigmentation does

The tail feather of a **Ross' Turaco** showing faint but still distinct growth bars.

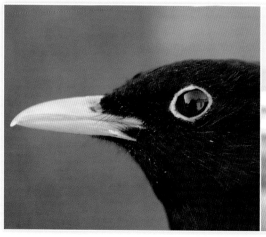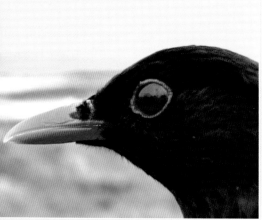

The carotenoid-based bill and eye-ring color of **Eurasian Blackbirds** varies from yellow to red. Blackbirds that were immunized to challenge their immune system lost bill color compared to untreated birds. It has been proposed that birds trade off deposition of carotenoids for display versus use of carotenoids to bolster their immune systems. The blackbird study supports this idea. (France, March; France, February)

not relate to growth-bar width and does not seem very sensitive to nutrition during feather growth.

Food deprivation studies with captive birds have also shown that expression of carotenoid color in House Finches and American Goldfinches and structural color in Eastern Bluebirds and Brown-headed Cowbirds can be affected by nutrition. Individuals of these species that were subjected to periods of fasting during molt grew feathers that were less bright, less saturated, or had altered hues compared to feathers grown by birds that had unrestricted access to food. Again, melanin pigmentation was not affected by modest periods of food deprivation.

Why is melanin pigmentation less sensitive to the effects of poor nutrition than either carotenoid or structural coloration? Birds manufacture their own melanin from amino acids, which are the building blocks of protein. Nutritional deprivation severe enough to slow the growth of feathers may still provide sufficient amino acids for the synthesis of black melanin pigments. A diet stringent enough to affect feather coloration through amino acid restriction may be lethal. It is possible, however, that more specific nutritional restriction—restriction of the specific amino acids needed for melanin synthesis—might affect melanin coloration.

HEALTH AND COLOR

It seems logical that parasites would diminish the coloration of birds. Parasites sap the energy of their host, and in extreme cases make their hosts ill. Humans are well aware that illness can affect color. We routinely assess each other's health by looking at complexion. If I am sick or exhausted, it is easy for my friends and family to see it in the loss of pink color in my cheeks. We associate more colorful cheeks, at least to a point, with health and vitality.

Might the same principle of color as a signal of health apply to bird coloration? The details differ from those of human complexion because most bird species lack extensive areas of exposed skin, but the general relationship is the same. The coloration of birds can reflect the degree to which they are parasitized.

This chapter opened with an anecdote about loss of yellow in the skin of chickens when they are ill. This condition in chickens is typically caused by coccidia, a group of single-celled parasites that can infect the guts of many different vertebrates. In Wild Turkeys, infection with coccidia causes males to grow feathers with less brilliant iridescence compared to turkeys that are not infected. Coccidial infection in House Finches and American Goldfinches causes males to grow paler and yellower (as opposed to more orange) feathers. These studies with coccidia provide some of the cleanest experimental evidence that structural and carotenoid-based coloration is diminished when a bird is infected with parasites. Other studies with viruses, bacteria, malaria-like blood parasites, lice, and fleas also show that a range of infections and parasites has a negative effect on carotenoid and structural coloration. In short, birds can signal their health through the carotenoid and structural colors of their plumage.

The story regarding parasites seems to be different for melanin coloration. In an experimental study of American Goldfinches, a group of birds infected with coccidia became ill by the end of the study. The body feathers grown by infected goldfinches were pale,

Coccidia are protozoans, the same group of organisms that cause such well-known human diseases as malaria, dysentery, and giardiasis.

Wild Turkey

definitive ♂

White-cheeked Turacos have green body feathers colored with the copper-based pigment turacoverdin. How environmental factors, such as parasites and particularly copper access, affect this green coloration has not yet been studied. *(captive)*

Virtually all published research related to the effects of parasites and nutrition on feather color has focused on structural coloration or on the two widespread avian pigment types melanin and carotenoids. Other feather pigments are virtually unstudied in this regard. There is, at least, abundant anecdotal information about the red and yellow psittacofulvin pigments of parrots, because millions of people keep parrots as pets. In general, plumage coloration resulting from psittacofulvin does not seem to be very sensitive to diet or parasites. There is no tradition of color-feeding parrots, and even the most ill-treated parrot will grow bright red and yellow feathers.

Almost nothing is known about the effects of diet and parasites on the red and green turacin and turacoverdin pigments of turaco feathers. Like melanin, turacin is synthesized from dietary components by turacos, so turacin may be like melanin and not sensitive to diet or parasites. Synthesis of turacin, however, requires substantial amounts of copper, a mineral that is typically not abundant in food. It seems quite reasonable that like carotenoid pigmentation, expression of red and green colors in turacos is linked to foraging success, but for a rare mineral rather than for the pigment per se.

with just a hint of carotenoid-based yellow, and strikingly different from the bright yellow feathers grown by males in a control group with no infection. However, the black patches on the crowns of these infected males grew in jet black and full-sized. In this study, the response of carotenoid and melanin pigmentation to the same infection was starkly different. Similarly, a strong effect of parasites on carotenoid pigmentation, but not on melanin pigmentation, was observed in a study of Great Tits.

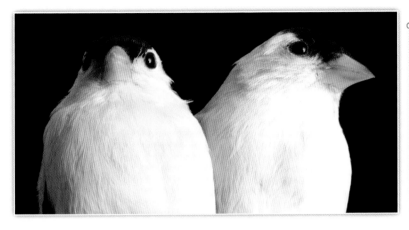

Two male **American Goldfinches** that were held in aviaries during molt. The bird on the left was maintained free of coccidial infection while the bird on the right was infected by coccidia during molt. Coccidiosis caused a loss of yellow carotenoid color of the feathers and bill but did not affect the black melanin color of the cap. *(captive)*

This set of studies is a small sample on which to make gross generalizations, but the information at hand suggests that, in contrast to carotenoid pigmentation and structural coloration, the color and size of black melanin patches do not signal a bird's health related to parasites. If melanin color is not dependent on diet and it does not vary with parasite load, what environmental conditions affect melanin?

SOCIAL STATUS

Expression of melanin coloration is tied to levels of circulating hormones, and specifically androgen hormones, the same hormones that are well known as performance-enhancing drugs taken by athletes. Male House Sparrows with experimentally elevated levels of testosterone during molt produce larger black patches. This sort of research is tricky to conduct because very high testosterone typically inhibits prebasic molt. Nevertheless, careful studies have found a relationship between circulating hormones and expression of black melanin. This relationship has not been found for carotenoid or structural coloration, but it also has not been studied exhaustively.

House Sparrow

If hormones are linked to aggressiveness and social status, and they are also linked to the size of black throat patches in House Sparrows, might social status affect the size of male throat patches? This idea has been tested only once. Captive House Sparrows were held during molt in groups of three, and their dominance rank was observed. The results were striking:

Males that held the alpha position in their cages grew larger black throat patches than males that held subordinate positions. Most significantly, social status at the time of molt was a much better predictor of the extent of black plumage than was the previous size of the black patch on the males. This experiment showed that the social status of the males can directly affect the size of a melanin ornament such as a throat patch. Hormones were not measured in this study, but presumably, subordinate status led to lower levels of circulating testosterone, and dominant status led to higher levels. It seems likely that differences in hormone levels caused the variation in the extent of black plumage.

NOT ONE THING OR THE OTHER

In this discussion of how environmental factors can affect plumage coloration, each class of environmental factors has been considered independently. Any wild bird, however, is beset by myriad challenges as it produces colorful bare parts and feathers. All birds play host to a range of parasites whether they are healthy or ill. All birds must forage for and ingest sufficient basic nutrition in addition to anything extra needed for color production. Most birds interact with other individuals of the same species, and they must cope with the ramifications of their social status. Many aspects of condition can simultaneously influence bird coloration, and one aspect can affect another aspect. A bird that becomes weakened by a parasite might forage less efficiently, reducing its overall nutrition and its intake of carotenoid pigments. Conversely, a bird that forages poorly may have less energy available to fend off infection by parasites. A wild male House Finch with pale yellow feather color resulting from deficient carotenoid pigments has probably done poorly in resisting parasites and in procuring good nutrition. For a

More than one environmental factor can simultaneously affect coloration, so no single or simple explanation can be given for why some birds are less or more colorful than others.

BIRDER'S NOTE

Unstable Leg Coloration ›› Bill and leg colors that result from carotenoid pigmentation and blood flow are susceptible to the negative effects of poor nutrition and parasites. Yellow legs, for instance, can become dull pink when carotenoid pigmentation is lost. Bare-part coloration should be used cautiously as a key criterion in identifying a rare bird.

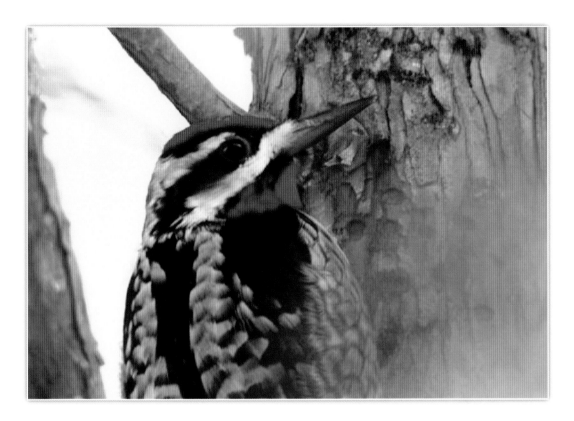

female House Finch choosing a mate, the particular circumstances that caused a male to grow yellow feathers may not matter. A redder male has met the combined challenges of feather pigmentation better than a pale male and is a fundamentally better choice as a mate.

PROCEED WITH CAUTION

Birders benefit from a basic understanding of how genes and environment interact to create variation in color and which traits would be expected to vary within a population of birds. Pigment access, nutrition, and parasites commonly affect color *quality* but generally have little effect on the color *patterns* of birds beyond making black patches a bit larger or smaller. For example, the white undertail spots of wood-warblers or the flank barring of dowitchers are not heavily influenced by the environment in which the bird grows its feathers. Genetically based color differences that are typical of a species are good field marks. Types of coloration likely to be altered by the environment, such as carotenoid-based color, should be avoided as the sole basis for identifying birds.

Carotenoid coloration can change depending on conditions during molt. If abundant carotenoids are ingested, carotenoid pigmentation can sometimes spill over to feathers not typically pigmented. With red on its cheek and nape, this sapsucker, photographed in the winter in Alabama, might be a drab Red-naped Sapsucker (a very rare bird for Alabama), a hybrid Red-naped Sapsucker and Yellow-bellied Sapsucker, or, more likely, a **Yellow-bellied Sapsucker** (a common winter bird) with spillover carotenoid coloration. (*Alabama, December*)

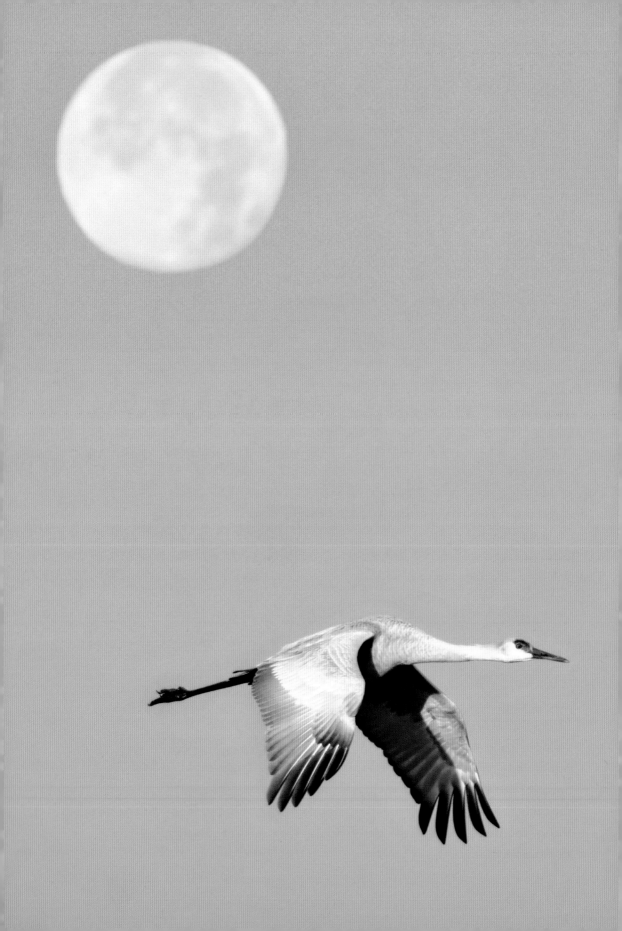

WARMING UP & WEARING DOWN

Great Frigatebird

♀

CHRISTMAS ISLAND RISES AS A GREEN EMERALD FROM THE boundless turquoise of the Pacific Ocean. Because it is volcanic and remote, it has no native rats, snakes, or lizards, making it a paradise for nesting seabirds of which the spectacular Great Frigatebird is among the most common. Frigatebirds are renowned fliers, soaring gracefully and effortlessly on wings that span nearly seven feet. The life of a Great Frigatebirds depends critically on its wings' being aerodynamic, which is why it was heart-wrenching for ornithologists Ralph and Elizabeth Schreiber when they found an individual in a frigatebird colony on Christmas Island with wing and tail feathers so degraded that it had lost the ability to fly. Even worse, it was a bird they knew. They had banded this albino individual 14 months earlier as a chick growing its aberrant white feathers. They had twice watched it fly over the colony, conspicuous in gleaming white where other frigatebirds were black. And now they found it grounded.

What had destroyed the plumage of this bird? Had it crashed into the vegetation that covered the island? Had it been attacked by another bird? The evidence suggested a more mundane destruction of the feathers. Air rushing past the white feathers had, bit by bit, worn them to nearly bare shafts. The demise of this poor bird was vindication of an idea proposed by Edward Burtt, a pioneer in research on

Most of the plumage of **Sandhill Cranes** has soft gray coloration. The primaries at the tips of the wings, however, have dark, nearly black melanin pigmentation. Such dark wing tips help reduce feather wear and are nearly ubiquitous among birds that fly long distances. *(New Mexico, December)*

This albino **Great Frigatebird** was found on Christmas Island in 1985 in a flightless condition due to extremely worn wing and tail feathers.

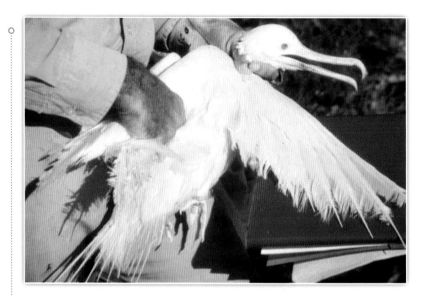

feather wear, that air particles alone can severely degrade feathers. Frigatebirds are denizens of the open skies. Their wings rarely brush against a solid object. The wear on this frigatebird's feathers showed that a bird does not have to crawl through tough, silica-rich grass or strike its wings against woody stems to abrade its plumage.

It was no coincidence that the only frigatebird in the colony with severely damaged feathers was also the only albino. Frigatebirds and other bird species that spend long hours flying each day are subject to feather wear from the wind constantly rushing over and around the wing. The fact that the bird with white wings suffered accelerated wear compared to normal Great Frigatebirds with melanin-rich dark wings gave strong support to the hypothesis that melanin functions to strengthen feathers.

This chapter explores the functions of bird coloration that are not related to visual signaling. Scientists who study the signaling properties of coloration can sometimes forget that feathers are more than easels for display of colors. Feathers are the tremendously versatile external covers that keep birds warm in the cold wind and cool

BIRDER'S NOTE

Buff Tips ›› Many familiar birds undergo subtle changes in coloration due to feather wear. Species such as House Finches and House Sparrows grow narrow buff tips on their chest and throat feathers in the fall that partly obscure ornamental coloration. These tips wear away by spring, revealing full coloration in time for breeding.

under a hot summer sun. Feather coloration affects how much solar radiation is absorbed or reflected and how much is trapped on the feathers' surface or allowed to penetrate to the body. Feathers also form birds' wings, but flight is only possible if feathers retain their shape and integrity. As the frigatebird anecdote illustrates, pigmentation can affect the rate at which feathers abrade and the likelihood that microbes will degrade feathers.

FEATHER WEAR AND TEAR

Laboratory experiments in which individual feathers are bombarded with tiny particles show that feathers with melanin are more resistant to abrasion than feathers lacking melanin. The pattern of melanin in the plumage of many bird species also supports the idea that melanin helps feathers resist abrasion: Wing tips are almost universally pigmented with melanin in birds that have an aerial lifestyle. On the Gulf Coast of the United States, birders encounter a diverse array of species with predominantly white or pale gray feathers including the American White Pelican, White Ibis, Northern Gannet, Ring-billed Gull, and Royal Tern. Although they are mostly white or pale gray, these birds have dark melanin pigmentation on their outermost primaries, forming black wing tips. The only birds in this region with white wing tips are herons such as Snowy Egrets and Great Egrets, which tend to fly only short distances, spending their days standing with their wings folded.

American White Pelican

How does the observation of black wing tips on white birds support the idea that melanin aids feathers in resisting abrasion? The tips of wings are subject to the most air turbulence and movement, hence the greatest abrasion by airborne particles. Deposition of dense melanin pigmentation specifically in feathered regions subject to greatest wear suggests that melanin protects feathers from abrasion.

The discovery that melanin protects and strengthens feathers means that a widespread pattern of feather coloration in birds is best explained not by any signaling function but by a mechanical function that aids survival. Current evidence suggests that carotenoids

and other nonmelanin pigments do not strengthen feathers, and that no birds concentrate carotenoid pigments at the tips of their wings further supports this view.

DAMAGE FROM BACTERIA

Bacteria are ubiquitous. They are found on the surface of the page of the book you are reading. They cover the surface of your body even if you are fastidious about hygiene. It was no surprise, therefore, when it was shown that feathers harbor a rich bacterial biota. What was new and interesting was the discovery a few years ago that many bacteria on the surface of feathers are capable of degrading feathers and using the feather tissue for food and energy. These feather-consuming bacteria are often called "feather-degrading" bacteria because their presence leads to a slow breakdown of the feather, which over months can severely damage the integrity of feathers. If you've ever pondered why there are so few feathers blowing around in the world—after all, billions of birds shed trillions of feathers once or twice each year—you now know that it is primarily because feathers are quickly broken down by feather-degrading bacteria.

As with any discovery in science, the observation that there are feather-degrading bacteria had to be put into context. How important is degradation due to bacteria, compared to wear due to turbulent air or wear due to dragging feathers over solid objects? The emerging answer is that it depends. The effects of feather-degrading bacteria depend on the natural history of the bird, on the climate

Different species of birds wear out their feathers under different circumstances. The **Grasshopper Sparrow** (left) spends its days squeezing between stems of abrasive grasses and by late summer has literally worn the feathers off of its face. **Turkey Vultures** (right) rarely brush against solid objects but they fly for many hours every day subjecting their feathers to abrasion from rushing air. As they feed on rotting carcasses, they are also exposed to many bacteria that may degrade feathers. (Alabama, August; Alabama, March)

FEATHER MICROBIOLOGY

The traditional technique that microbiologists use to study bacteria in any environment is to grow cultures. For studies of bacteria on feathers, a swab is taken from various places on a bird's plumage and placed in different growth media. Once a strain of bacteria grows in culture, it can be characterized and identified by the type of media on which it grows and by characteristics of the colony. This is traditional microbiology, and until recently it was the only means available to ornithologists trying to determine what kinds of bacteria occur on feathers. The problem with culturing bacteria, however, is that only a small subset of all bacteria will grow in culture. For years, microbiologists knew that they were undersampling the bacteria on feathers.

New genetic analyses have greatly expanded studies of feather bacteria. Instead of trying to grow the **bacteria** collected on a swab taken from feathers, DNA from the sampled bacteria can now be amplified and then identified in a molecular biology lab. In this way, without growing them in culture, a microbiologist can determine which bacteria are present. Testing a particular type of bacteria that degrades feathers requires that the bacterium be grown in culture, so traditional culture techniques and new molecular techniques both continue to play important roles in the study of feather bacteria.

Bacteria are tiny single-celled organisms, which are the most ubiquitous life forms on Earth.

and habitat in which it lives, and most crucially for the discussion of this chapter, on what pigments the bird has in its feathers.

Melanin appears to slow the rate of at which bacteria can break down feathers just as melanin slows the rate at which mechanical wear degrades feathers. Carotenoid and psittacofulvin pigments might also slow down the rate at which feathers are degraded by

bacteria, but this conclusion is not so certain. Overall, it seems that birds with dark plumage are more resistant to the damaging effects of bacteria than are paler birds.

Bacteria are ubiquitous, but they are not equally abundant everywhere. Bacteria need food and water to survive, so they are most abundant in moist, organic-rich environments like soil. They are much less common in a substrate like dry sand. Consequently, birds that nest or forage near moist, organic environments are exposed to many more bacteria than are birds that dwell in dry environments. If darker plumage protects birds from bacteria, and bacteria are most common in moist environments, then one might expect to see darker, more melanin-rich feathers on bird species living in humid environments. This predicted pattern—darker plumage in more humid environments—had been noted in the zoological literature long before ornithologists began studying feather bacteria. As a matter of fact, dark plumage and fur in humid environments

Feathers in media laced with bacteria. The feather on the left has suffered little or no decomposition, as indicated by the clear solution. The feather on the right has degraded substantially as indicated by the solution that is clouded with detached particles.

EXPERIMENTS WITH BACTERIA

To determine what effect a species of bacteria might have on feathers, microbiologists place feathers into a liquid broth with the bacterial species to be tested. If the species of bacteria degrades feathers, then the feather will show signs of decomposition and the broth will become cloudy with fine feather particles. Through this technique it has been determined that several of the bacteria found on the feathers of birds can rapidly degrade feathers under optimum conditions.

This experimental approach also allows ornithologists to determine what properties of feathers enable them to resist bacteria degradation. Melanin has emerged as the pigment most effective in protecting feathers from the damaging effects of microbes because feathers with melanic pigmentation are degraded more slowly than feathers lacking melanin. Tests have also been conducted with carotenoid and psittacofulvin pigments. Both psittacofulvin and carotenoids may help feathers resist bacterial degradation.

is such a widely recognized pattern that it has been elevated to the status of a zoological rule called "Gloger's rule."

Peregrine Falcon

Pacific Northwest *pealei*

tundra-breeding *tundrius*

The humid forests of the Pacific Northwest are famous for their dark birds, hosting the darkest sub-species in North America as diverse as Cackling Geese, Merlins, Peregrine Falcons, Western Screech-Owls, Song Sparrows, and Fox Sparrows. Song Sparrows are one of the most widespread birds in North America, inhabiting a wide range of climates from dry and hot to humid and moist. With some exceptions, there is correspondence between the darkness of Song Sparrow coloration and the humidity of their breeding environment—desert birds are pale, eastern birds are dark, and birds from the Pacific Northwest are darkest. Recent studies showed more bacteria on the feathers of Song Sparrows from humid forests than on Song Sparrows from desert scrub, consistent with the idea that the need to deal with bacterial degradation might shape the feather coloration of this species.

The problem with these correlational patterns is that it can be difficult to establish that a correlated effect is the cause of the pattern. Thermoregulation and back-ground matching (blending with lighter or darker backgrounds) are reasonable alternative explanations for the geographic patterns of feather pigmentation. Whether exposure to bacteria is the primary factor that determines body coloration of many birds remains to be convincingly demonstrated.

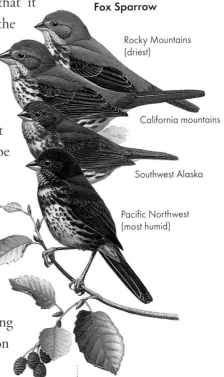

Fox Sparrow

Rocky Mountains (driest)

California mountains

Southwest Alaska

Pacific Northwest (most humid)

Most research on pigments and bacterial degrada-tion focuses on melanin, but some studies have shown that carotenoid and psittacofulvin can also inhibit bacterial growth on feathers. Patterns of carote-noid or psittacofulvin pigmentation do not follow Gloger's rule, however, and it seems likely that pigments other than melanin will prove *not* as effective in disrupting bacterial degradation. Studying the effects of pigments on the susceptibility of feathers to degradation by bacteria is an area of active research by ornithologists.

KEEPING COOL AND STAYING WARM

Everyone knows that it is wise to buy a light-colored automobile if you live in a hot, sunny environment and a dark car if you live in a cold climate—dark cars get hotter than light cars when they are parked in the sun. As outlined in the first chapter, black coloration results when all visible light is absorbed and white is achieved when visible light is reflected. Along with light comes heat energy, so dark cars heat up faster than light cars. Based on these experiences with automobiles, one might presume that birds would benefit by having light coloration in hot environments and dark coloration in cold environments. But human experience and intuition can be misleading when applied to feather pigmentation.

Contour feathers do not lie tightly against a bird's body. Instead, they ride above a downy layer, much like the nylon shell of a down jacket is suspended over the downy filling. This means that heat

Phainopeplas live in the hottest deserts of North America and spend the day perched in the open. Surprisingly, their dark plumage helps them stay cool. Most solar radiation is absorbed by the black plumage and radiated to the surrounding environment without reaching the body of the bird. (*November, California*)

absorbed by feathers is not necessarily transferred to the body. As a matter of fact, by absorbing bright sunlight, black contour feathers can shade the skin of birds from solar radiation, allowing wind to move heat away from the bird before it affects the bird's body temperature. In contrast, pale or white plumage allows some solar radiation to pass through contour feathers and reach the skin. As with sunlight shining through the windows of a car, radiation that passes through contour feathers tends to be trapped as heat between feathers and skin. Thus birds with black feathers can potentially stay cooler in hot environments, and birds with white feathers can potentially stay warmer in cold environments. The black plumage of desert birds like the Phainopepla and Chihauhaun Raven might reasonably be interpreted as an adaptation to promote **heat exchange**.

Black or dark plumage is rare among birds that winter in Arctic or Antarctic regions; light-colored and white plumages prevail in cold environments with periods of reduced exposure to daylight. The observation that birds living in cold and snowy environments are white is consistent with the idea that white feathers facilitate staying warm, but there are other factors at work as well. White plumage can make birds harder to spot in a snowy landscape, and camouflage is certainly a function of white feathers. But many Antarctic and oceanic birds that are at no risk from visual predators also tend to have white plumage, which supports a thermoregulatory role of white color. Penguins are an exception—most have large patches of black feathers—but their short feathers more readily transfer heat energy to their bodies.

Just as water flows downhill, heat energy transfers from warmer (higher energy) molecules to cooler (lower energy) molecules, enabling birds to move heat from the surface of their feathers.

AVOIDING GLARE

Birds are primarily visual animals. They rely on keen vision to find food, select mates, and avoid predators. Glare from bright sunlight can reduce visual acuity. Humans face the same problem, and athletes reduce glare by applying black paint or cloth patches under their eyes. Many bird species have dark feathering around their eyes that may reduce glare in the same manner. One of the most dramatic plumage patterns of birds that has been proposed to function in glare reduction is the prominent dark moustache of the Peregrine Falcon,

a bird of prey that hunts in the open air and must frequently contend with glare. While this seems like a plausible explanation for plumage patterns like the moustache of the Peregrine Falcon, reduction of glare by dark feathers remains to be tested in any species of bird.

Willow Flycatcher

The one trait on which coloration has been experimentally shown to reduce glare is the bill of Willow Flycatchers. When the dark upper mandibles of Willow Flycatchers were painted white, the birds spent more time foraging in the shade where glare would not hinder sight. Flycatchers used in this scientific study as "controls" with naturally dark upper mandibles spent more time out in the sun where they had to contend with glare, but where there were more insects. Many bird species have dark upper mandibles and paler lower mandibles, and glare reduction potentially explains this common pattern of avian coloration.

NO FUNCTION AT ALL

The biological fitness of a bird is typically assessed by the number of offspring or grandchildren produced. If a trait is neutral, individuals are equally fit regardless of what form of the trait they have.

A pervasive assumption of this book is that the coloration of birds matters. This is the working assumption of every scientist who studies coloration, and it is an assumption shared by most birders and naturalists. The external color of a bird does not seem like a **neutral trait**. Coloration determines how conspicuous or cryptic an individual is. It shapes interactions with parents, offspring, flock associates, competitors, and mates. It also affects feather wear and heat exchange. Nevertheless, there is compelling evidence that at least in one species of bird, it really doesn't matter what individuals look like.

As noted in chapter 6, Snow Geese come in two distinct color morphs, white and blue, which are quite different in appearance. Most of the feathers on the body of a white-morph bird are white and most of the feathers on the body of a blue-morph bird are dark.

Molt Limits ›› Unlike older birds, first-year birds of many songbird species retain some juvenal wing feathers as part of their first basic and first alternate plumages. Upon close inspection, especially in the hand during banding, these older juvenal feathers are distinct from feathers molted during the first prebasic molt and provide a useful means to distinguish first-year birds from adult birds.

It seems as if these big color differences between white and blue Snow Geese should have real consequences.

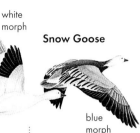

white morph

Snow Goose

blue morph

A team of biologists studied a population of Snow Geese at La Perouse Bay in northern Manitoba for more than 40 years. Despite amassing a huge amount of data that should have revealed the most subtle benefits of plumage coloration, they found no differences between the two plumage types in any aspect of survival or reproduction. In evolutionary terms, both morphs seemed to be equally fit. Plumage morphs in some species can signal different reproductive strategies that coexist within a population. The color morphs of Snow Geese, however, are not linked to behavioral strategies. Geese simply go through their lives with either dark or light plumage, and feather color seems to have no discernible effect on how successful a bird is. Note that white-morph birds have black wing tips, so there is apparently some natural selection on color pattern, but whether body feathers are dark or white seems to be a neutral trait in Snow Geese.

Even though the Snow Goose is an exception, the vast majority of evidence runs contrary to the idea that bird coloration has no function. Most coloration of most bird species seems to have been shaped by natural and sexual selection. Color does seem to matter for most species of birds.

MULTIPLE FUNCTIONS

Although this book covers topics one at a time and highlights classic examples, it is important to remember that a color display is not restricted to a single function. The black plumage of an American Crow will certainly affect how that individual thermoregulates, how vulnerable its plumage is to bacterial degradation, and how fast its feathers will abrade. But the black coloration also will affect how the bird appears to other crows as well as to predators and prey. Many forms of natural and sexual selection are likely to act on the coloration of all birds. There is great value in simplifying the complexities of life when working out general explanations for patterns in nature, but the realities are rarely so straightforward.

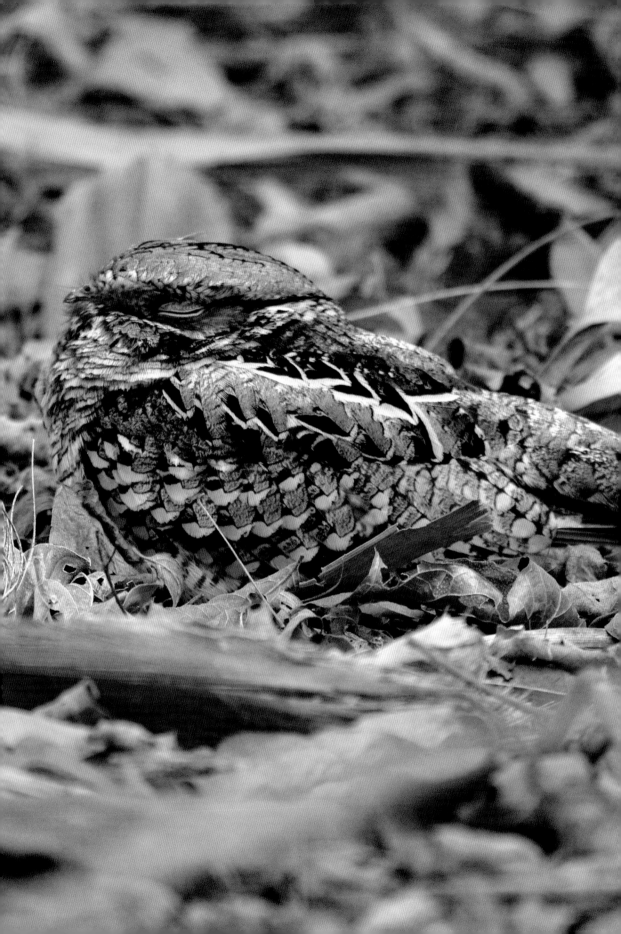

REVEALING OR CONCEALING

Aввотт Thayer was one of the most famous American painters of the late 19th century. He is renowned for his portraits of women and children, but among biologists he is better known for his theories about bird coloration and camouflage. Thayer thought that his knowledge of painting gave him a perspective on the colors of animals that no scientist could claim. In one of his books he wrote, "Nature has evolved actual art on the bodies of animals, and only an artist can read it."

Thayer made huge contributions to the scientific study of coloration. He was the first person to propose both disruptive coloration and countershading. Having developed fundamental theories for basic patterns of animal coloration, he should hold an honored place in the history of zoology. Instead, Thayer is more often the focus of ridicule and mockery. His tragic error was to doggedly force a single explanation—concealment—on all bird coloration, taking a sound and demonstrably correct theory and stretching it until it became ridiculous. So Thayer is remembered among biologists for suggesting that American Flamingos are pink to blend into the evening sky, and Blue Jays are blue so they can hide themselves in shady patches of snow.

It was none other than the Rough Rider himself, Theodore Roosevelt, after serving as president of the United States, who wrote

Blending in with the dry leaf litter of a south Texas refuge, this sleeping **Common Pauraque** relies on the camouflage provided by the complex color pattern on each feather of its body to avoid being captured by predators. *(Texas, March)*

This oil painting by Abbott Thayer was meant to show how the blue plumage of a **Blue Jay** could enable it to blend with blue-tinted snow in the winter. Thayer's theories of countershading and disruptive coloration revolutionized concepts of animal coloration, but his attempts to explain all feather coloration as camouflage have been discredited.

the most scathing critique of Thayer's terribly flawed explanations of bright ornamental color. Roosevelt pointed out, in less than kind terms, that flamingos appear black against a setting sun and that Blue Jays spend only the smallest fraction of their lives in anything close to a blue environment. Camouflage is clearly a benefit of drab and mottled coloration, but this concept cannot reasonably be extended to the bold and brilliant coloration of many birds. The tragedy of Thayer's legacy should be a lesson to all scientists: Even the most well-grounded and sound scientific principles can be overextended.

Color traits serve a diversity of functions related to making individual birds more or less conspicuous. Traits that make a bird easier to see are "honest" signals of presence; traits that make a bird harder to spot are "dishonest" signals of presence. Birds can also

have coloration that makes them look like something else, which is another form of concealment.

COUNTERSHADING

Knowledge of light, shadow, and depth perception led Abbott Thayer to the theory of countershading, undoubtedly his greatest discovery. To make a two-dimensional drawing appear to have three dimensions, an artist adds shading so that the top of the object facing the sun or lamp is lighter and the underside of the object is darker. Shading to add depth is among the first techniques that any artist learns. The simple act of shading transforms a child's two-dimensional drawing to a much more lifelike drawing that appears to have depth within the page.

According to the theory of countershading, an object can be made less conspicuous by giving it a color pattern that counters the normal shading created by overhead illumination. On a countershaded object, the top surface is darker and the underside is lighter. Our perception of an object's depth comes about from our experience with light and shadows. Through countershading, nature erases the patterns of shading that are familiar to a vertebrate brain. Without normal patterns of shading, an object appears more two-dimensional, and a two-dimensional bird is much harder to spot than a three-dimensional bird because it does not match a predator's search image.

Countershading is one of the most widespread patterns of plumage coloration. Among seabirds in basic plumage, a dark dorsal and a light ventral plumage is virtually ubiquitous. Groups as diverse as loons, grebes, ducks, alcids, shearwaters, petrels, albatrosses, cormorants, and penguins show this pattern. Hugely diverse species of shorebirds have evolved a remarkably similar pattern of countershading in

A search image is a pattern, such as the shape of a bird, held in the brain against with visual images are compared. Countershading and disruptive coloration work by obscuring the shape of a bird.

American Golden-Plover

basic ♂

alternate ♂

basic (nonbreeding) plumage with brown backs and tan undersides. This evolution of similar countershaded plumage makes many winter shorebirds a challenge for birders to identify.

Countershading is completely absent or even reversed in the plumages of some birds. Male Bobolinks in alternate (breeding) plumage in the spring and summer have light napes and rumps and dark bellies. Shorebird species such as American Golden-Plovers and Dunlin also have black bellies in alternate plumage. Bobolinks, American Golden-Plovers, Dunlin, and the vast majority of species that lose countershading when they are breeding molt into basic plumage after breeding and return to countershading.

BEING INVISIBLE

In the Harry Potter fantasy novels, Harry can wrap himself in a magic cloak and become invisible. Birds obviously don't have invisibility cloaks to hide behind, but some birds can be as hard to spot as Harry Potter scurrying down a hallway at Hogwarts under his cloak. Being cryptic is essential for most birds because they are small and virtually defenseless, and a host of predators, from spiders to tigers, like to eat birds.

The primary survival strategy for many species of birds is not to hide but rather to be very hard to catch. These birds have keen eyes, can fly very well, and constantly watch for danger. Because they do not need to hide to survive, birds that follow this strategy can have conspicuous coloration when it is advantageous. Other bird species evade predators primarily by not being detected. These birds typically match their background in coloration and pattern, making it hard for the eyes of predators to distinguish them from other objects in their environment.

BIRDER'S NOTE

Search-image Training ›› To avoid being seen, birds have evolved tricks of concealment, such as countershading and disruptive coloration, that take advantage of learned biases in the perceptions of humans and other predators. Birders can counteract these deceptions by concentrating and conducting focused sweeps for *bird shapes*. With practice, a birder can become much better at picking out "invisible" birds in foliage, marshes, and other avian hideouts.

Consider the Common Pauraque as an example (see page 138). Common Pauraques are medium-sized birds of south Texas and Mexico that hunt for flying insects during the night and sleep most of the day. At rest during the day, they are easy prey for a host of predators from Coatimundis to Gray Hawks. Where is a safe place for such a bird to sleep? For pauraques, the safest place is on the ground in leaf litter, because the color and pattern of their plumage matches almost perfectly the appearance of dead leaves on the ground. Having feathers that blend with fallen leaves is a feature of most woodland Caprimulgidae, the Common Pauraque's avian family, including Whip-poor-wills, Poor-wills, and Chuck-will's-widows, all of which sleep in leaf litter during the day. Common Nighthawks, another member of the Caprimulgidae, also sleep on the ground, but nighthawks have mottled gray rather than reddish brown feathers and so they seek out bare areas of gray pebbles or sand to roost.

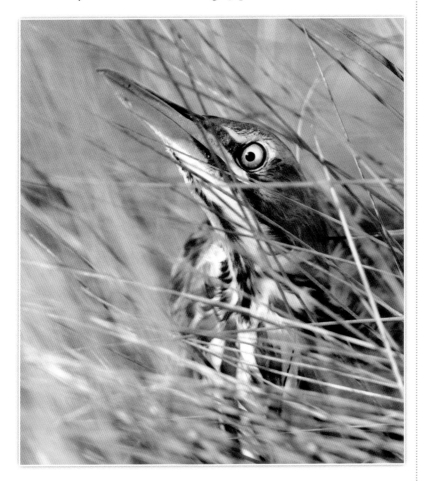

An **American Bittern** hiding in a marsh. The vertically streaked plumage of the bittern helps it blend with the vertical vegetation of its habitat. (Florida, November)

When they are not trying to be conspicuous, like this displaying male, **Lesser Prairie-Chickens** are very hard to spot. From a distance, the complex plumage pigment pattern within each feather creates an overall plumage pattern that blends with the prairies in which they live. *(Kansas, April)*

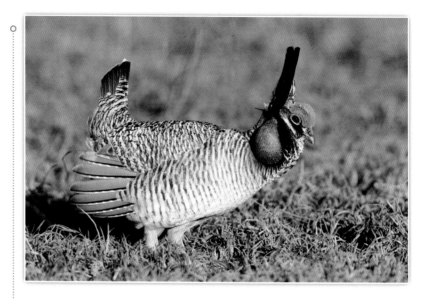

American Bitterns have streaked brown plumage that blends almost perfectly with the dry brown bases of cattails in the marshes they inhabit. The background match is best when the bittern's streaked plumage is held vertically, and this full effect is achieved only when a bittern points its bill skyward. When a bittern feels threatened by a predator and wants to hide, it will assume a posture with its streaked neck outstretched, and its bill pointed upward. In such a bill-up posture, bitterns blend remarkably well with the reeds in a marsh, and they will even sway slowly from side to side to mimic the movement of marsh grasses in the wind. Sedge Wrens and Marsh Wrens, which share marsh grasses with American Bitterns, also have streaked brown plumage that very nicely blends with the colors and patterns of a marsh, although these smaller birds do not adopt the extreme head-held-high behavior of bitterns.

Not all birds blend into their surroundings as perfectly as Common Pauraques and American Bitterns, but the plumage of many species of birds is a good match for the average color of their habitat. Philadelphia Vireos and many other forest birds have an olive green hue like the foliage in which they forage. Many North American sparrows that spend the winter in brown grass and the summer in brown woody debris have striped brown plumage that blends well with these habitats. Snowy Plovers are the color of dry sand. Semi-palmated Plovers are the color of wet sand or mud. Each blends with the portion of shoreline on which it spends the most time. It is

important to remember that the flashy and bold coloration that bird-ers enjoy observing is an exception to the general rule of **crypsis**. The coloration of most small birds blends well with their primary habitat, and the working assumption of ornithologists is that such coloration arose through natural selection for being hard to spot.

A pattern seen in many bird families is to grow brightly colored ornamental feathers for courtship and breeding and then to molt into a much drabber plumage for the nonbreeding period (see chapter 1). After breeding, bill, eye, and leg coloration often changes from colorful and striking to drab and inconspicuous. These general

> Crypsis is the capacity of an organism to avoid detection, such as by coloration and pattern that matches a background.

EXTREME COLOR CHANGE

Ptarmigan are grouse that live beyond the tree line, either at high elevations in mountains or in the far north. The tundra environment of ptarmigan undergoes a dramatic change in color as it cycles between seasons. In the winter, it is a stark world, with scarcely a rock or shrub to break the monotony of white. The plumage that best matches such a background is snowy white, with unpatterned feathers. In the summer, the snow retreats, revealing a dark and highly patterned landscape of tundra and rock. To blend with this background, birds need highly patterned dark brown feathers. The white plumage that blended so well with the winter environment is extremely conspicuous against the dark summer background. Conversely, a dark and mottled plumage that blends with a summer landscape makes a bird stand out against winter snow.

All three species of ptarmigan—Rock, White-tailed, and Willow—are ground-dwelling birds favored as prey of a host of predators including the Gyrfalcon over much of their northern ranges. Blending with the background is critical to the survival of ptarmigan, and so they have two complete molts per year, totally transforming in appearance from winter to summer.

White-tailed Ptarmigan

molting fall ♂

alternate ♂

alternate ♀

basic

Piping Plovers spend their days in the open, standing on uniform expanses of sand and mud. Against such a background, plain gray feathers with no bold patterns create the most camouflaged plumage. *(Alabama, October)*

patterns of color change strongly suggest that the bright colors of feathers, eyes, bills and legs are serving functions related to reproduction (such as attracting mates or fending off rivals). When such bright coloration is no longer needed for breeding, birds transition back to a cryptic coloration that enhances their survival.

Birds that live in environments with complex backgrounds, such as forest, woodland, grassland, and wetland, tend to have complex feather patterns. Highly patterned plumage blends with the background of vegetated habitats that are typically composed of complex jumbles of leaves, branches, and bark. For instance, each feather in the plumage of a Lesser Prairie-Chicken is black, tan, and brown. If a single feather is placed on a white sheet of paper, it appears to have bold and very conspicuous coloration. When the bold patterns of hundreds of prairie-chicken feathers are combined and viewed from a few feet away, the effect mimics the bold but small-scale patterns of black, tan, and brown on the short-grass prairie. The mottled plumage of a prairie-chicken blends into the average coloration of its grassland home much more effectively than any solid coloration would.

Blending with the background requires a different solution in more uniform habitats. In featureless environments, like sandy beaches or open water, uniform plumage coloration lacking pattern is least conspicuous. For instance, Piping Plovers have plain gray feathers, giving them a plain, unpatterned dorsal plumage. This plain, sand-colored plumage makes the plovers hard to spot against

beach sand. Large plumage patches of uniform coloration are characteristic of most birds that spend their time in habitats with uniform backgrounds such as snow, water, sand, or mud.

BOLDLY INVISIBLE

Some of the boldest and most striking color patterns of birds may actually make a bird harder for a predator to spot. Disruptive coloration is patterning that disrupts the eye's ability to trace the shape of an object. Dark bands or bars, such as the rings around the upper breast of many small plovers and coursers, can break up the body shapes of these birds, making them harder to pick out from their environment. Dark bands that divide a bird's body into segments are not the only patterns that can serve as disruptive coloration; any patch of bright or contrasting coloration on a bird's body can draw an observer's eye away from the body outline and help conceal the bird. The sort of color patterns that appear to be most effective in disruptive coloration are bold white patches on dark birds, such as the white shoulder and wing patch on the otherwise black plumage of breeding Lark Buntings, or dark patches on light birds, such as the black back and outer wing patches in the white plumage of breeding Snow Buntings.

The concept of disruptive coloration is old—first developed by Abbott Thayer and later refined by Hugh Cott, the foremost expert

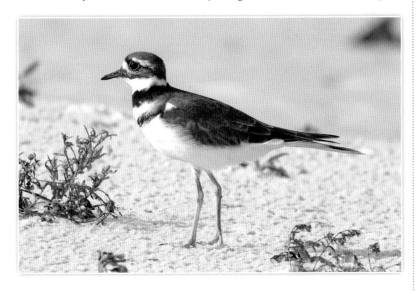

Although the black chest bands of a **Killdeer** seem bold and conspicuous once a bird has been spotted, these plumage elements disrupt perception of a bird shape and make Killdeer harder for a predator to spot. Note that the tan and white bands of the Piping Plover in the previous photograph serve the same purpose. (*Alabama, April*)

on animal coloration in the early and mid-20th century. Neverthe-less, the effectiveness of disruptive coloration in plumage has not been tested on birds since Thayer used his own paintings to show how the principle could work. However, there is little doubt that disruptive coloration can work because this principle of camou-flage has been widely tested and applied by militaries throughout the world.

EYES AND FALSE EYES

An old proverb tells us that "the eyes are the window of the soul." For a camouflaged bird, eyes can be the worst giveaway that they are parts of a living thing. As humans, we see life and vitality in the eyes of birds. Apparently, so do predators. If a bird cannot keep its eyes closed and concealed, as does a sleeping Common Pauraque, a common strategy is to hide black eyes in a black facial pattern. For instance, the Cedar Waxwing has jet black eyes that are centered in a black mask of feathers across its face. The skin around its eyes is also black. The overall effect makes it hard for a human to discern the eye of a waxwing. By making their eyes less conspicuous, waxwings make their whole existence a bit less conspicuous.

Many species of birds conceal their eyes in black plumage patches (see illustrations, page 152), but black on the face can serve functions other than concealing eyes. For example, the black mask of Common Yellowthroats is used as a signal in dominance interactions and when attracting mates. There is no reason to expect a plumage feature like a black mask to serve only one function. Black around the eyes might also reduce glare, and if such plumage features provide multiple benefits, they are that much more likely to evolve and be maintained.

A few birds use an alternative tactic for hid-ing eyes. These species have false eyes that draw attacks away from real eyes. Perhaps the clearest example of feather coloration that creates a false eye is found on the nape of small diurnal owls such as the Ferruginous Pygmy-Owl. Small owls are subject to very aggressive mobbing

Ferruginous Pygmy Owl

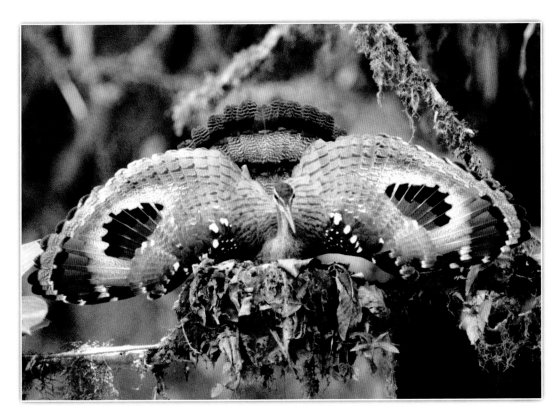

by small birds. The most aggressive of the songbird mobbers will actually strike an owl, and often these attacks are directed at the eyes—the most vulnerable part of the body. There is a great advantage, therefore, in drawing the attack of mobbing songbirds to the much less vulnerable back of the head. The eyespots on the nape of pygmy-owls apparently do just that.

Another possible example of feather coloration creating a false eye is the stunning wing display of the Sunbittern, an odd bird of the understory of tropical American forests that is about the size of a chicken. When the Sunbittern is threatened, it will turn toward the threat and in a rapid movement present the upper side of its spread wings. The coloration on each wing is striking, with bold patches of chestnut, golden, gray, and black arranged into a pattern that roughly resembles an eye—thus creating a gigantic set of eyes when the two wings are presented. It is claimed that this pattern startles and frightens would-be predators because of the resemblance to giant eyes. It could also be, however, that just the size and boldness of the wing display deters predators. Regardless of whether would-be predators perceive eyes in the display, the wing pattern of the Sunbittern is a good example of coloration used to startle and intimidate.

A **Sunbittern** displaying its wings and tail in a threat display. The stunning black, tan, and rufous display has been suggested to create the appearance of two gigantic eyes, meant to startle and intimidate predators and competitors. (Costa Rica, August)

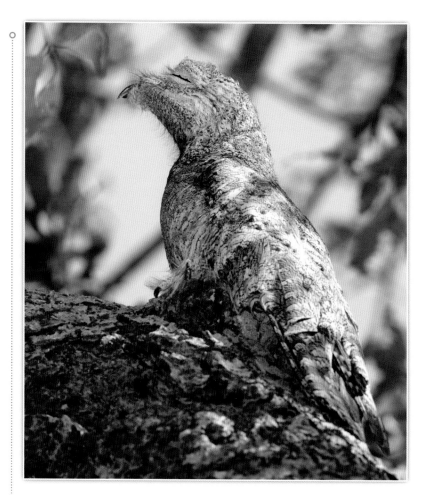

Great Potoos spend their days sleeping in the open on branches of trees, plainly visible to predators. Their shape and plumage coloration make them look like a dead snag on a tree. (*Brazil, August*)

LOOKING LIKE SOMETHING ELSE

Some birds hide not by being hard to discern, but by appearing not to be birds. The birds that best mimic inanimate objects are found in two groups of distantly related nightjars, the potoos in the Neotropics and the frogmouths in tropical Asia and Australia. Species in both of these groups hunt flying insects at night and rest during the day. Potoos and frogmouths use a strategy to hide during the day that differs from the similar Common Pauraque described above. They hide conspicuously in view. The strategy in both of these groups is to look exactly like an extension of the branch on which the bird sits. To make this deception work, potoos and frogmouths have a plumage color and pattern that closely resembles bark, and both assume an upright posture like a broken branch. Once they assume this broken-branch posture, they sit absolutely still through the daylight hours.

Potoos and frogmouths commit completely to their deceptive appearance. They will not flush when approached until they are nearly captured. When they nest, some species seek out a broken dead branch with a depression at its end and use the depression as their nest. In this way a frogmouth or potoo can incubate during the day while still looking like a broken-off branch.

Another possible example of a bird that hides in plain view is the Zone-tailed Hawk, a raptor of the desert Southwest and Mexico that hunts for small birds and mammals. In the size, shape, and pattern of its wings, a Zone-tailed Hawk looks a lot like the more abundant Turkey Vultures, which are carrion eaters, not hunters. Circling flocks of Turkey Vultures are common in the rocky desert areas inhabited by Zone-tailed Hawks, and these vultures pose no threat to mammals or other birds. A single Zone-tailed Hawk often joins a flock of Turkey Vultures, and it has been proposed that the hawk hides among the vultures to get close to prey undetected.

Zone-tailed Hawk

Turkey Vulture

juvenal

definitive

If adult Zone-tailed Hawks had a solid dark tail pattern like Turkey Vultures, rather than a boldly banded tail pattern, then the visual matching would be much more complete. The shape, size, and behavior of Zone-tailed Hawks are apparently enough like that of Turkey Vultures to make the deception work, although detailed documentation of Zone-tailed Hawks sneaking up on prey in flocks of Turkey Vultures is lacking.

CONSPICUOUS BY CHOICE

Highly camouflaged plumage like the mottled brown feathers of a Common Pauraque lie at one end of a continuum of plumage conspicuousness. At the opposite end are bold and conspicuous

BIRDER'S NOTE

Watch Your Step ›› Every birder has suffered the frustration of flushing a bird before getting a clear look at it. As this chapter documents, birds are very good at remaining unseen. To reduce the number of premature flushes, slow down and scan ahead.

McCown's Longspur

Fork-tailed Flycatcher

Variegated Flycatcher

White Wagtail

Mexican Chickadee

Eyes in black feather patches become less conspicuous as they are placed closer to the edge of the patches. From top to bottom, birds are ranked for most to least conspicuous eyes.

plumages that stand out against most backgrounds. The all-black plumages of crows and ravens and the all-white plumages of many herons and pelicans are familiar examples of conspicuous patterns. These solid, highly contrasting colors are difficult to conceal in any environment. Such bold and conspicuous coloration is best explained as signaling the presence of the bird. In other words, the function of these bold plumages is to make birds easier to spot.

Why would a bird want to signal its presence? Isn't it always better to hide? Announcing presence is typically a bad idea for small birds that have an array of predators. In general, signals of presence such as entirely black or white plumage are found on large birds with few predators that gain an advantage by foraging or roosting in large flocks. For these species, bold and conspicuous plumage seems to announce, "Here I am. Come join my group." Whole-plumage signals of presence are generally not found in small bird species, although white outer tail feathers that flash when a bird is fleeing are fairly common. These flashes displayed by fleeing birds likely function as signals directed at predators, saying, "You've been seen and I'm already fleeing from you. It is not worth your effort to try to chase me."

As an example of the potential advantages of being conspicuously colored, consider the American White Pelican. These large birds feed most efficiently when they work in tandem with other members of their species forming lines and driving fish into shallow water. For these birds, the payoff for being conspicuous is increased foraging success, which is achieved by attracting other pelicans to form larger fishing lines that trap more fish. White plumage is maximally conspicuous against the dark water of most fishing areas, hence it likely evolved as a signal of presence. Pelicans are huge birds, too large for any avian predators and inaccessible to most large mammalian predators. For the American White Pelican the benefits of attracting conspecifics adequately compensate for the risks of being conspicuous.

The black plumage of crows could function in a similar manner. American Crows roost in large flocks, especially in the winter, and the larger the roosting group, the safer it is for all assembled crows. A crow among ten is at much greater risk than a crow among ten thousand. It is advantageous to all crows to be visible as they fly to

roost, so large flocks will form. Black plumage is maximally contrasting and visible against most backgrounds including the sky, and black plumage may facilitate large aggregations.

WARNING COLORATION

The above explanation presumes that conspicuous coloration is directed at other individuals of the same species. Predators are an unintended receiver of the signal, and so only large, invulnerable species benefit by signaling presence through conspicuousness. Outside of birds, however, there is a whole class of coloration called warning coloration, which functions to make animals conspicuous to predators. Warning coloration is displayed by animals that are distasteful or poisonous or that can sting. Predators are either instinctively averse to such brightly colored prey or, after one or two bad experiences, they learn to avoid these animals. Bright coloration aids in tutoring predators to stay away. In this way, conspicuous warning coloration actually reduces the risk of injury from a predator. Warning coloration is used to explain the bright colors of many venomous snakes, stinging insects, and poisonous amphibians. Might some of the bright color displays of birds also be signals that birds are dangerous or unpalatable?

This idea was first taken up by Hugh Cott, who collected birds in Europe and Africa in the 1960s. Cott noted that flesh-eating flies

Warning coloration works best if it is bold and distinctive so predators remember it better.

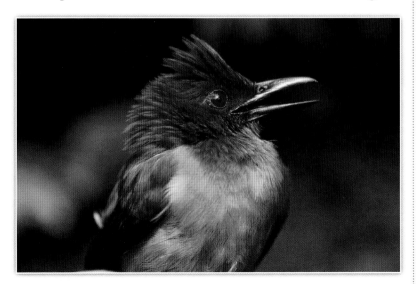

Indigenous people in New Guinea call the **Variable Pitohui** a rubbish bird, unfit for eating. Ornithologists discovered that it and other species of pitohui carry the same toxins in their skin and feathers that are found in the skin of poison dart frogs. The bright colors of pitohuis may serve as a warning signal that they are poisonous. (*Papua New Guinea, December*)

were attracted more readily to the carcasses of drably colored birds than brightly colored birds. Cott concluded that brightly colored birds were less palatable and that the bright plumage of these species was warning coloration. This data set was reanalyzed 30 years later using better statistical tests, and the pattern held up only for the portion of Cott's data that concerned African birds. There was no clear relationship between fly visitation and feather coloration for European species. Moreover, flesh-eating flies feed on dead animals; they pose no risk to living birds. Based on observations of the greatest bird killers in Europe and North America—the *Accipiter* hawks—there is no hint that more colorful birds are avoided because they are not tasty. Warning coloration seems an unlikely explanation for most of the bright color displays of most species of birds.

The plumage coloration of the pitohuis of New Guinea is the only well-supported example of warning coloration in birds. Several species of pitohuis have deadly toxins in their skin as well as colorful feathers that might deter predators. Most bright coloration in feathers is almost certainly not a warning signal directed at predators.

SCARING UP A MEAL

All of the adaptations used by birds to avoid detection by predators are also used by insects to avoid detection by birds. Birds counter insect crypsis by having keen vision with four dimensions of color perception. Nevertheless, the ability of birds to detect insect prey is greatly facilitated if the prey can be startled into moving. Foraging by startling prey, which is then chased down and eaten, is called "flush-pursuit," and species of birds that employ it frequently have bold patches of white or pale feathers on their wings or tail. The bold patches are flashed at foliage or grass where prey might be hiding.

What is the evidence that these wing and tail patches are effective at flushing prey? The best evidence comes from studies of *Myioborus* redstarts, which flash bold patches of white in their wings and tail as they forage for insects. In separate studies of Painted Redstarts and Slate-throated Redstarts, the white patches of a sample of birds were obscured with a black marker. These blackened birds had much-reduced prey capture rates compared to normal birds

Statistics are mathematical tools that help scientists decide what degree of difference among samples is more than that expected by chance alone.

that flashed white. In experiments, cutout models of redstarts with white in the wings similarly flushed more insects when moved adjacent to foliage than cutouts that were solid black.

Flush-pursuit foraging is not limited to *Myioborus* redstarts. Bold wing or tail patches are flashed during foraging by gnatcatchers, Australian fantails, *Myiobius* flycatchers, American Redstarts, and mockingbirds. The effectiveness of the wing flashes of these groups of birds has not been tested, but the experimental studies with *Myioborus* redstarts indicate that bold wing patterns can evolve as aids to foraging. It has been proposed that the bright yellow feet of several species of small egrets, including the Snowy Egret, startle small fish and invertebrates as the birds walk in shallow water, making prey more visible and easier to catch.

Painted Redstart
definitive

juvenal

Penguins in the genus *Spheniscus* may also use their plumage coloration to startle prey, but penguins do not use flush-pursuit like a redstart or startle hidden prey like an egret. Penguins can see the fish they need to catch easily enough because most of their potential meals swim around in enormous schools. Experiments with models show that the bold black and white markings of these penguins startle small fish, separating them from the school and facilitating capture.

SIGNALING BETWEEN OR WITHIN SPECIES

The colors and patterns discussed in this chapter are proposed to function primarily in interactions between different species, such as between predators and prey. In the remaining chapters, the focus will switch to colors and patterns that function as signals within species. As do humans, birds live social lives. The success or failure of most birds plays out through their interactions with birds of the same species—mates, potential mates, offspring, rivals, neighbors, flock mates, and so forth—more than in the occasional encounter with predators. An understanding of the bold and bright coloration of birds requires an appreciation for the daily social challenges faced by most birds and for how color displays can mediate such interactions.

STATEMENTS OF IDENTITY

P EOPLE ARE BETTER AT REMEMBERING FACES THAN NAMES, BUT from the perspective of computational difficulty the opposite should be true. A human brain should be able to remember names more easily and with greater accuracy than faces. Even the simplest computer can sort and recall with absolute accuracy vast lists of names, but only the most advanced computers can begin to recognize and remember humans based on facial characteristics. Why are people better at the more difficult task?

Recognizing individuals based on facial characteristics is an ancient skill, long predating humanity, whereas remembering names is only as old as language. We are better at recognizing faces because the brain centers needed for this task have been shaped by evolution for a very long time. Remembering names is an activity unique to humans, but recognizing faces and other idiosyncrasies of fellow members of a species is a skill humans share with many visually oriented vertebrates, including many birds.

Human faces seem designed to promote individual recognition. Even within the least diverse populations, faces are infinitely vari- able. It's interesting to speculate that human facial characteristics evolved to be variable specifically to aid in individual recognition. Fast and accurate recognition is beneficial both to the person being recognized and to the person doing the recognizing.

Whooper Swans, like Tundra Swans, have yellow patches at the bases of their bills that are variable in size and shape. Research on swans has shown that facial pattern is used as an aid to individual recognition. *(England, February)*

Birds, too, recognize other individual birds using idiosyncrasies of their appearances, and some features of avian plumage may exist primarily to foster such individual recognition. In a broader context, it is critically important for birds to be able to distinguish members of their own species from individuals of other species, and some plumage patterns seem to have evolved to aid in such species recognition. This chapter will review evidence that some plumage coloration and patterns serve as markers of individual or species identity.

REMEMBERING RIVALS

Ruddy Turnstones are social shorebirds. On their arctic breeding grounds, pairs of turnstones interact frequently with neighboring pairs. For the rest of the year, on rocky coasts throughout much of the world, Ruddy Turnstones exist in flocks. In prime wintering areas, there will be dozens of Ruddy Turnstones sharing each foraging patch and every pile of rocks. Resources are limited, and there is constant competition for the best foraging spots and

Human faces are infinitely variable. Pictured are four of my male graduate students, all of European descent, but each easily recognizable as unique in facial features. In the same way, the individual face and chest patterns of **Ruddy Turnstones** are unique and used by these birds in individual recognition. *(from one flock of birds, Florida, April)*

favored rocks on which to rest and preen. Relatively few birds may form a core flock that stays together throughout the winter. Disputes over feeding territory among these few dozen birds occur literally every daylight hour of every day. Birds from neighboring flocks are also encountered—some once a day, some once a week, some even less frequently.

Which individual turnstones get priority to resources is settled through physical contests; the strongest or most skilled combatant takes the prize. Once a winner and a loser have been established in a dyad of birds, it pays both contestants to remember each other. Each bird has perhaps a hundred individuals with whom it regularly competes, and repeatedly fighting the same fight with birds from this neighborhood wastes time, energy, and needlessly risks injury. How can such small birds with small brains remember so many individuals? The answer appears to be that they are aided by individual-specific patterns of plumage coloration.

Ruddy Turnstones display highly variable plumage coloration throughout the year, with irregular patches of gray, black, and white feathers across their heads and breasts. The size and configuration of these patches vary between individuals, but the variation does not correspond to age or sex. In contrast to what is observed in species like the House Sparrow and Great Tit (see chapter 13), the size of black patches does not relate to social status. If color variation in Ruddy Turnstones is unrelated to dominance, condition, age, or sex, why do turnstones have such a bold and variable plumage pattern? The variable plumage patterns of turnstones serve as **signals of individual identity**.

Experiments confirmed this hypothesis. On the breeding grounds, when fiberglass models that resembled neighbors were presented, the models elicited little aggression. When the same models were painted to resemble unfamiliar individuals, however, they were attacked aggressively. In winter flocks of turnstones, changing the pattern of

> Signals of identity need to be highly variable, but the colors that convey identity should not relate to dominance or attractiveness. In other words, the size or intensity of coloration should not link to the cost of its production.

BIRDER'S NOTE

**Show Me Your True Colors ›› ** Species with substantial individual variation in plumage pattern, such as Red-tailed Hawks in the West, can be very challenging to identify. A birder has to see through the variation to recognize the key traits that identify the bird, and skill at such tough identifications is only achieved through practice.

Red-billed Queleas show polymorphic variation in three patches of coloration producing eight combinations of traits. The sizes and shapes of color patches are also variable, and this variation in plumage coloration is used by queleas to recognize individuals in the large flocks in which they live. (Zimbabwe, March)

black and white on the breast plumage caused a bird to be attacked more by both dominant and subordinate flock mates, and it did not matter whether the patches of black coloration were enlarged or reduced. Changing the *pattern* of plumage coloration caused experimental birds to be treated like unfamiliar birds. These experiments underscore the value of variable plumage patterns that facilitate recognition. Time and energy that is not wasted on unnecessary fighting can be used for finding food or mates. Both the dominant and the subordinate birds benefit by recognizing each other and remembering their earlier engagements.

Male Red-billed Queleas illustrate a different way in which variable plumage color and pattern can facilitate individual recognition. The Red-billed Quelea is perhaps the most abundant terrestrial bird in the world. Queleas nest in central and southern Africa in vast colonies that can number in the tens of millions. These colonies often cover acres of savannah with each tree packed with hundreds of quelea nests. Within these masses of birds, individuals are incessantly competing for resources such as food, water, nest sites, preferred perches, and mates. Any given bird interacts with many dozens of neighbors each day. As in the turnstone example above, there are benefits if a bird can recall whom it has defeated and whom it has been defeated by. Perhaps it is not surprising that queleas show one of the most variable plumage patterns of any songbird.

In contrast to Ruddy Turnstones, which show continuous variation in the extent of black and white coloration, quealeas show **polymorphic variation** in color expression (see chapter 6 for an introduction to morphs in birds). The face of male quealeas can be black or white. The breast can be red or buff. The nape can also be red or buff. All of these traits are inherited independently of each other, which means that a bird can have any combination of face, breast, and nape coloration. As in the turnstone example, the color and pattern of plumage does not relate to age, physical condition, or dominance, which are the expected patterns if coloration was used to assess attractiveness or fighting ability. Polymorphic expression of these colored patches of feathers seems to exist to aid individual recognition.

Other examples of colors and patterns serving as aids in individual recognition include the yellow and black facial markings of Tundra Swans and the variable white cheek patch in Canada, Cackling, and Barnacle Geese. *Buteo* hawks such as Red-tailed Hawks and especially the Harlan's subspecies of the Red-tailed Hawk are well-known for their highly variable and idiosyncratic melanin pigmentation, and it seems likely that such variation functions as an aid to individual recognition. It may be that the plumage polymorphisms seen in some species of birds are maintained because having variable morphs within a population aids in individual recognition.

Red feather coloration in queleas shows polymorphic variation, but red bill coloration shows continuous variation related to health and condition.

RECOGNIZING OFFSPRING

In birds, variable plumage patterns seem to provide cues to individual recognition in four primary contexts: territoriality, aggressive competition, mate recognition, and parent-offspring recognition. Ruddy Turnstones and Red-billed Queleas are each excellent examples of

BIRDER'S NOTE

As Unique as Snowflakes ›› On first glance, all birds look alike (at least within the same age and sex class of a species). With careful study, it is often possible to find idiosyncrasies—a slight variation in pigmentation, a missing feather, even a behavioral mannerism—that allow an individual to be distinguished. Identifying individuals becomes key when a rare bird is reported in a number of locations and it is unclear whether or not the sightings concern the same bird.

species in which variable plumage is used in recognition during territorial and other aggressive interactions. In both species, variable plumage may also function in mate recognition, but that has yet to be demonstrated experimentally for these or any species of birds.

Recognition of offspring presents an important challenge to some birds. As eggs, nestlings, and fledglings, most birds are dependent on their parents. To avoid caring for unrelated offspring, birds of some species, especially colonial ones, need to recognize their offspring as they mature from eggs to fledglings, and some color displays seem to have evolved to aid in such offspring recognition.

For species that breed in widely spaced nests, there is essentially no chance that individuals will accidentally confuse their eggs, nestlings, or even fledglings with offspring from neighboring nests. In these species, there is no need for individual variation in coloraton of young, and they typically have plain, unpatterned eggs and weakly patterned juveniles, although there can be other functions of bold plumage patterns in juveniles. Most birds that nest in such situations have poor abilities to distinguish their own offspring from other young birds.

Royal Terns, in contrast, nest in dense colonies with each pair of terns tending its own sand scrape surrounded by the sand scrapes of many other terns. In a colony of densely packed and constantly shifting birds, there is a risk of confusing not just eggs but downy young as well. To help parents find and recognize their offspring in

Common Murres nest in crowded colonies with eggs laid in close proximity, creating the risk of eggs being confused. To make them easier to recognize, murres have eggs that are highly variable in color and pattern. (Oregon, May)

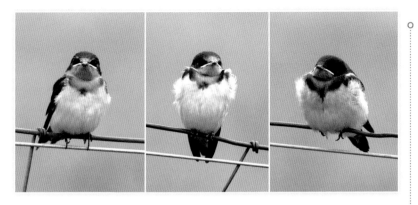

the crowded colonies, nestling Royal Terns have highly variable color expression. The down of tern nestlings varies from white to brown and from completely unspotted to heavily spotted. Leg and foot coloration of nestling Royal Terns also varies from pink and orange to black. All of these color traits are inherited independently, so chicks can be any combination of coloration and spottiness.

In some species of birds, the potential for mistaken identity doesn't occur until fledging, when offspring from many neighboring nests begin flying around at the same time. The result is the ultimate shuttle game as the nesting colony becomes a swirling mass of young birds constantly changing positions. In such circumstances there is potential for individuals to confuse their offspring with unrelated offspring. In many species of birds, vocalizations rather than coloration are used to identify fledglings. In species like the Barn Swallow and Cliff Swallow, however, fledglings have highly variable plumage patterns. Experiments manipulating the plumage pattern of Cliff Swallows demonstrate that parents use individually unique color patterns of plumage on the faces and heads to distinguish their own offspring from unrelated offspring.

SPECIES RECOGNITION

The need to recognize fellow birds extends beyond recognizing flock mates, neighbors, and offspring. It is also critical for birds to be able to recognize members of their own species. In studies of mate choice there is a tendency to jump immediately to tests of the most subtle discriminations that birds might make, such as assessing choice for small differences in the saturation of yellow feathers. Before such

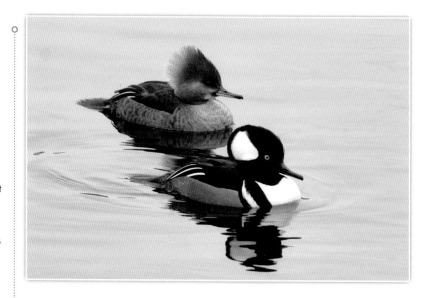

The elaborate plumages of many male birds, like the black, white, and rufous plumage of male **Hooded Mergansers,** is much more than is needed to simply signal species identity. A better explanation for such elaborate plumage is that it evolved through sexual selection. Once such distinctive male plumages exist, however, they are undoubtedly used by females to recognize males of their species. (Massachusetts, January)

After a century of being the dominant hypothesis for why birds are brightly colored, the species recognition hypothesis is now rarely invoked as an explanation for colorful plumage.

detailed discriminations by birds are possible, a more coarse-grained sorting is required. A bird has to find a potential mate of the appropriate sex and of the same species. "Has to" is perhaps too strong of a statement for this last requirement. Birds can and do mate with individuals outside of their own species. Hybrid matings sometimes result in no offspring or sterile offspring, but in many cases hybrid offspring are fertile. As a general statement, choosing a mate of a different species is the worst mate choice that a bird can make. It is almost always better in terms of offspring quality for a bird to choose a mate of its own species.

Might the colors and patterns of birds have evolved to aid in this critical decision? In other words, could the colors and patterns of birds have evolved as signals of species identity? Through the late 19th and most of the 20th century, zoologists believed that **species recognition** was the best explanation for the bold and colorful displays of birds. For almost a hundred years, signaling the identity of the species was the textbook explanation for ornamental coloration.

The literature on coloration created over the past 30 years, as encapsulated in this book, is a testament to how inadequate the species recognition hypothesis is as an explanation for the diversity, complexity, and showiness of avian color displays. A male Hooded Merganser does not need such bold and intricate feather ornamentation to signal that it is not a Red-breasted Merganser or a Wood Duck.

Female mate preference for color variation linked to male quality and female choice for color patterns that signal the identity of species should lead to different female behaviors. I had a chance to test for such different forms of mate choice in experiments with House Finches in 1994. Males in a subspecies of House Finches from southern Mexico, *Carpodacus mexicanus griscomi* (below, left), have much smaller patches of red plumage than do males from the familiar U.S. subspecies *Carpodacus mexicanus frontalis* (below, right). A variety of mate-choice studies in the lab and field showed that *frontalis* females prefer as mates males with large and highly saturated red coloration. For *frontalis* House Finches, bigger and brighter is better.

I wondered what *griscomi* females, from the small-patched subspecies, would think if I made their potential mates have red patches as big as *frontalis* males. I asked: Will female *griscomi* House Finches go for the biggest ornament, or will they go for a male with a subspecies-typical plumage pattern? When I gave them such a choice in experiments, female *griscomi* House Finches consistently chose the big patch of color. In other words, female *griscomi* House Finches chose males with a plumage pattern typical of another subspecies. In this example, the pattern of red coloration is not a signal of subspecies identity.

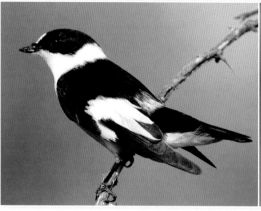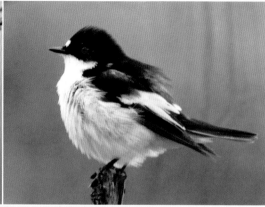

Collared (left) and **Pied** (right) **Flycatchers** both have broad ranges across Eurasia with regions hosting just one species as well as regions with both species. When the species co-occur, they are more distinct in coloration with more white in the plumage of Collared Flycatchers and less white in the plumage of Pied Flycatchers, as in the individuals shown here. Divergence in plumage pattern helps reduce mixed-species pairing. *(Cyprus, April; Norway, June)*

Moreover, plumage displays such as the breast coloration of House Finches and the cheek patches of Red-billed Queleas are far too variable in expression to serve as reliable and unambiguous signals of species identity. It has now been demonstrated through numerous studies that the colors of birds serve a host of functions that do not involve signaling species identity. The key question becomes not "does species recognition explain most bright avian coloration?" but rather "does the species recognition hypothesis explain *any* coloration in birds?"

Once elaborate color displays evolve within a species, they come to typify that species and are undoubtedly used in species recognition. I stated above that a male Hooded Merganser does not need such gaudy feathers to distinguish it from a Wood Duck, but given that males do have such a distinctive plumage pattern, female Hooded Mergansers certainly use this color pattern to recognize male Hooded Mergansers. The more pertinent question is whether there are color displays that seem to have evolved specifically as signals of species identity. Research suggests that a few color patterns in birds do serve primarily as signals of species identity.

Experiments confirm that the black-and-white plumages and the size of the white forehead spots of two closely related songbirds,

the Collared and the Pied Flycatcher, aid in species recognition. In Europe the Collared Flycatcher has a southeastern distribution, and the Pied Flycatcher has a northern and western distribution. There are broad areas where only one or the other species breeds, and there is also a large area in central Europe where the two flycatchers occur together in the same habitat. In the parts of Europe where only Pied Flycatchers or only Collared Flycatchers occur, males of the two species look very much alike, converging on a very similar black-and-white plumage pattern. In the area of overlap, however, male Pied Flycatchers are brownish instead of black and have small or no white forehead spots. Male Collared Flycatchers in this region of overlap show the opposite extreme of plumage coloration: They have enlarged white forehead patches and more white on their napes.

In mate-choice trials, females of both flycatcher species did a poor job of discriminating between male Collared and Pied Flycatchers from the look-alike populations. In contrast, when presented with males from the divergent populations, females of both species did a good job of discriminating between Collared and Pied Flycatcher males and choosing males of their own species. For these flycatchers, the black-and-white plumage coloration seemed to function as an important signal of species identity. The change in trait expression in relation to the need of females to distinguish between males in the zone of overlap lends strong support to the idea that this trait evolved to aid species recognition.

Another trait that may signal species identity is the speculum—the brightly colored secondary feathers—in the wings of ducks. The speculums of Mallards and their relatives in North America, Mottled Ducks and American Black Ducks, are simple blocks of structural coloration sometimes bordered by bars of black or white. Each species of duck has a unique combination of blue, green, or purple speculum coloration and black or white bars. Birders can distinguish flying ducks very quickly and at substantial distances by focusing on the typical speculum pattern. Various species of ducks live in large, mixed-species flocks in the winter where pairs form, so it seems reasonable that simple and unambiguous markers of species identity should evolve. The speculum of ducks

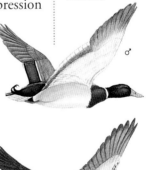

Mallard

American Black Duck

Male American Goldfinches have large patches of yellow in their plumage, and male Pine Siskins have small patches of yellow. I wondered whether goldfinches and siskins would be attracted to males with color ornamentation beyond what is ever observed in their species. Is bigger and redder always better? Specifically, my colleague Kevin McGraw and I tested the response of female American Goldfinches to males colored red, compared to their response to normal yellow males. We also tested the response of female Pine Siskins to male siskins with yellow breast plumage versus males with typical small yellow patches in their wings. Female goldfinches rejected the red males and female siskins rejected the males with yellow breast coloration. Females of both species showed strong preferences for birds with hue and patch size typical of their species.

Why did female *griscomi* House Finches respond to a super stimulus of red beyond what is shown by males in their subspecies (see previous sidebar, page 165), but American Goldfinches and Pine Siskins preferred ornamentation *within* the typical pattern of their species? These different responses could reflect whether the plumage manipulation was perceived as a change in degree or as a change in kind. The differences between medium and small patches of red breast coloration may be perceived by female House Finches as variation within subspecies-typical coloration, so the very large patch of red became a super stimulus. On the other hand, the jump from yellow to red coloration or from small yellow patches on the wings to large yellow patches on the breast may have caused females to perceive such males as no longer the same species.

may serve as clear, unambiguous signals of species identity, but this hypothesis has yet to be tested experimentally.

It is hard to know just how important selection for signals of species identity might be in the evolution of color patterns in birds. For instance, I know of no examples in North America that are equivalent to the Pied/Collared Flycatcher example in Europe. Any American or Canadian birder who has traveled or studied eastern and western field guides is aware that there are many east/west sister taxa in North America, such as Yellow-shafted and Red-shafted Flickers, Rose-breasted and Black-headed Grosbeaks, and Spotted and Eastern Towhees. These eastern and western populations are virtually identical in size, shape, and skeletal morphology, but they are distinctly different in coloration. Unlike what is seen in the Pied and Collared Flycatchers in Europe, however, there is no distinct change in morphology in any North American taxa in regions where the ranges of eastern and westerns species overlap. It seems that for these North American taxa, plumage differences arose when the populations were isolated and for reasons other than signaling species identity.

Distinctive plumage certainly is not essential for species isolation. Birders around the world know it is common to encounter distinct species that are very hard, if not impossible, to distinguish visually. These avian groups serve as a reminder that, while most birds are primarily visual animals, **sound** also plays a key role in recognition.

The focus of the next three chapters will turn to within-species assessments based on coloration, including choice of mates, estimates of fighting ability, and perceptions of strategy. In these discussions, individual and species recognition will rarely be mentioned, but recognition necessarily frames such assessments. Mate choice beyond the initial copulation works only if mates recognize each other in subsequent encounters. Signals of age and sex work only if the individuals are perceived to be of the same species. Why some species have highly variable plumage to aid recognition of individuals while others do not remains an open question. Very likely the number of individuals encountered and the predictability of the context in which individuals are encountered determines the value of special clues to individual identity.

As any "ear" birder knows, the sounds of most bird species are distinctive, and sounds are likely used in species recognition. A few birds, like Crested Auklets, use odor as a cue, and odor may aid species recognition.

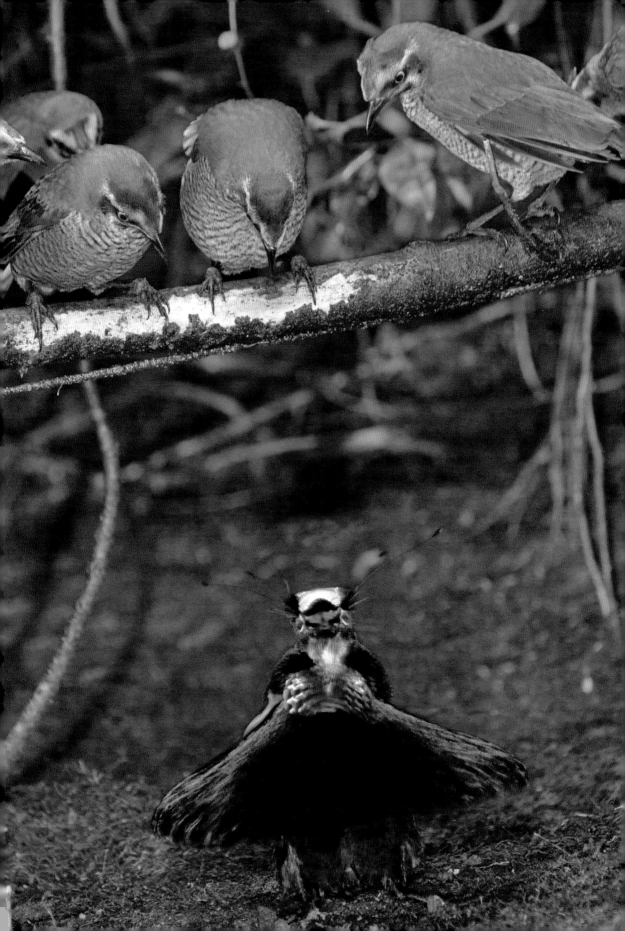

CHOOSING MATES

I N A LETTER TO A COLLEAGUE, CHARLES DARWIN ONCE WROTE, "The sight of a feather in a peacock's tail, whenever I gaze at it, makes me sick!" This seems like the sort of statement that an undergraduate student, tired of my ornithology lectures, may have penned. Why would one of the great natural historians of all time grow ill at the sight of the beautiful tail of a peacock? Just like modern birders, Darwin drew inspiration from observations of the natural world, especially birds. But when Darwin wrote his disparaging remarks about peacocks, he had just published his radical new theory of evolution by natural selection in *Origin of Species*. He was considering a wide range of observations of nature and assessing how well the idea of natural selection seemed to work. The peacock's tail threatened to undermine his theory.

Darwin was troubled by the fact that the tail of a peacock, like the red feathers of a House Finch, did not seem to promote the survival or reproductive ability of the bird. As a matter of fact, such ornamental traits seemed to *diminish* a male's chances for survival. A trait that reduced survival ran counter to the very premise of survival of the fittest. The cornerstone of Darwin's theory was that traits came to be and were maintained because they promoted the survival or reproductive capacity of an individual. If evolution by natural selection was right, how could there be a trait that *reduced*

A line of female **Carola's Parotias** assess the plumage and display of a male. Polygynous species that display on leks, such as the parotia, tend to be brightly colored and a single male—usually a brightly colored and highly ornamented male—can sire the offspring of multiple females. (*Papua New Guinea*)

survival? It was this quandary that caused Darwin to get queasy when he looked at a peacock's tail.

SEXUAL SELECTION

Sexual selection acts through two primary processes: mate choice and competition for mates. Parrots, such as these **Dusky Lories,** form strong pair bonds based on mutual choice. Lekking species, like these **Lesser Prairie-Chickens,** vigorously fight for position on the display arena, and victory in such competition leads to greater mating opportunities. *(captive; Kansas, April)*

To account for traits like elongated tails and to regain his love of pea-fowl, Darwin developed a corollary to evolution by natural selection. He proposed that such ornamental traits evolve and are maintained not because they promote survival and reproduction, but because they promote access to mates. He called this process sexual selection, and he invoked sexual selection to explain such traits as the tails of peacocks, the antlers of deer, and many of the "beautiful" feathers and the bare-part coloration of birds. Sexual selection is a very intuitive hypothesis because people play the same mating game. Just because a person is fertile and survives for many decades does not mean that he or she will have a lot of grandchildren. Attracting a mate plays a huge role in determining the propagation of one's genes.

Sexual selection can proceed by two distinctly different modes. First, males can compete among themselves for access to females.

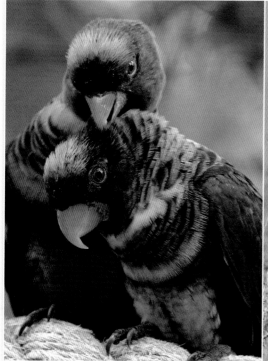
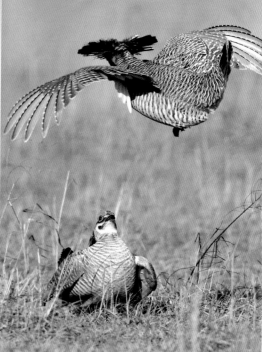

In birds, such contests over mates are often settled in fights with flailing wings, snapping bills, or slashing spurs, but they can also be settled through the display of colors that signal social status. Social signaling by means of color displays will be the topic of the next chapter. This chapter explores the second mode of sexual selection: using color displays to "charm" females.

Darwin's idea was that ornamental traits such as the long and elaborate tails of peacocks and the brightly colored feathers worn by male Painted Buntings enhance the attractiveness of males, thereby promoting sexual access to more females or more-desirable females and enabling greater reproductive success. For this idea to be correct, females must show a mating preference for males with more elaborate ornamental displays.

Painted Bunting

definitive ♂

Among all of Darwin's big explanations for how the natural world works, female mate choice for ornamental traits was the idea least accepted by his colleagues. As a matter of fact, the idea that color displays evolved through sexual selection was almost universally rejected by the scientific community for about 90 years after Darwin first proposed it. Alfred Russel Wallace's hypothesis that bright coloration served as a signal of species identity (see page 164) held sway for much of the 20th century. Humans were walking on the moon before most biologists began to take Darwin's ideas about mate choice seriously. Sexual selection acting through female choice finally gained wide acceptance as a reasonable explanation for ornamental traits like bird coloration when a series of behavioral studies confirmed that female fish and birds of some ornamented species prefer more colorful males. Sexual selection, and specifically the idea that female choice selects for bold and brilliant coloration, has now gained nearly universal acceptance among scientists. It is among the most intensely studied hypotheses in the fields of behavioral and evolutionary biology.

WHO CHOOSES WHAT?

Some of the most convincing studies showing that feather coloration can make males more attractive to females have focused on

the cardueline finches (family Fringillidae), the songbird family that includes such familiar species as goldfinches, rosefinches, and canaries. Cardueline finches commonly have vibrant red and yellow feather coloration that results from carotenoid pigmentation, and many species in this family of birds are numerous, easy to capture, and adapt well to cages. They also show abundant variation from one male to the next in expression of red and yellow colors. All of these factors combine to make cardueline finches particularly useful in studies of mate choice in relation to feather coloration.

House Finch

basic ♂

basic ♂

basic ♀

Much of my career as an ornithologist has been focused on studying female mate choice in response to red plumage coloration in the House Finch, the most abundant cardueline finch in North America. By conducting experiments with House Finches both in the wild and in captivity, I confirmed that a primary function of males' red/yellow plumage coloration is to attract mates. More than any other factor thus far examined, the redness of a male's feathers determines his success in pairing. I used experiments to show that female House Finches pay attention to more than just hue and saturation of feather pigmentation. They also assess the size of a male's color patch—bigger is sexier (see photograph, page 54, and sidebar, page 165).

If female House Finches respond to both the quality of pigmentation and the size of the color patch, which of these traits is more stimulating to them? I addressed this question by conducting mate-choice trials in which female House Finches were made to choose between size and saturation. They were presented with males that either had large, drab patches or small, saturated patches of red coloration. Females chose small, saturated patches.

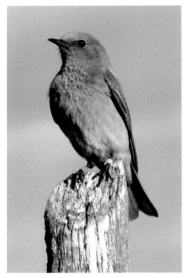

Most birds are monogamous and develop tight pair bonds. Mate choice in monogamous species focuses on finding a partner to nest with. But females also frequently copulate with males other than their mates, even among the many species of birds that form stable monogamous pair bonds. There is evidence to suggest that such **extra-pair copulations** involve a choice by females, just as they choose their social mates. Do females assess male coloration when mating outside the pair bond?

Matings outside the pair bond are called extra-pair copulations. Such mating leads to extra-pair fertilizations and extra-pair offspring.

In the most complete study of the effects of color on choice of extra-pair mates, researchers found that male Mountain Bluebirds (above) with the most brilliant blue color sired more extra-pair offspring. This observation suggests that female bluebirds chose brighter males to be their extra-pair mates. Overall, males with more brilliant blue gained significant reproductive output through extra-pair copulations compared to males with less saturated coloration. Studies with other species including Yellow Warblers, Collared Flycatchers, and Tree Swallows also found that success at extra-pair mating was related to melanin pigmentation or structural coloration.

These studies indicated that when push comes to shove, female House Finches choose color quality over patch size.

Female choice for the greater hue and saturation of yellow pigmentation has also been shown in experiments with American Goldfinches and Yellowhammers (a Eurasian bunting). In contrast, Eurasian Siskin females respond more to patch size than color quality, preferring males with larger patches of yellow carotenoid pigmentation on their wings.

MATE CHOICE FOR WHICH COLORS?

Experimental evidence confirms that females of some bird species, such as the House Finch, are attracted to brightly colored feathers. How broadly does such feather fancy extend? The feather coloration of House Finches and the other species mentioned above results from carotenoid pigmentation. Is it only red and yellow feathers pigmented by carotenoids that are used in mate attraction? What about melanin pigmentation, structural color, or scarcer forms of coloration? Do those color displays function in mate choice?

Bluethroat
alternate ♂

Choice for feather coloration is certainly not limited to red and yellow carotenoid pigmentation. Studies of structural blue and ultraviolet feather coloration in species such as the Blue Tit, European Starling, and Bluethroat provide clear evidence that females are attracted to more saturated color and to coloration with hue shifted more toward the ultraviolet. The direction of hue shift that females find "sexy" is interesting: a right shift, from yellow toward red, makes male House Finches and other species with carotenoid pigmentation more attractive. The opposite shift toward ultraviolet seems nearly universally attractive for males with blue and violet coloration. Red pigments are scarcer than yellow pigments, accounting for an attraction for redder displays, and shorter wavelength colors may require more precise microstructures than longer wavelengths in blue and violet feathers require. A male's ability to secure a scarce pigment or to produce a more precise feather structure may be a good signal of his quality as a mate.

White structural coloration is also sometimes the object of choice by females. In the Collared Flycatcher, a larger white forehead spot makes males more attractive to females. In the Black-capped Chickadee, females prefer males with the most reflective (brightest) white cheek patches. In Great Tits, females are attracted by males with the most immaculate plumage as defined by the sharpness of the boundary between the white cheek patch and the black of the crown and mantle.

Bold black melanin coloration of feathers is also commonly assessed by females. In the case of black plumage, it is usually the

size of the black patch of feathers rather than the blackness of the feathers within the patch that matters to females. Females have been shown to prefer larger black patches in such species as the House Sparrow, Great Tit, and Common Yellowthroat (but see sidebar, page 178). The black plumage of male **Pied Flycatchers** provides an important exception to the rule that melanin patch size matters more than feather blackness. In study populations in England and Scandinavia, male Pied Flycatchers have extensive melanin pigmentation across the plumage of their head, back, and tail, but this melanin pigmentation can vary from brown to black. Experiments manipulating the blackness of male plumage showed that females prefer to mate with males with blacker feathers.

Rufous and brown phaeomelanin coloration also seems to be used by some birds in assessing mates. When such colors are used in mate choice, females most often respond to color quality rather than patch size. In Barn Swallows, males with darker rust color on their breasts are more successful at pairing. When the breast color of some males was darkened, females produced more offspring with those males. In Mallards, females pay close attention to the reddish brown chest patch of males, but they don't seem to assess either the size of the patch or the quality of pigmentation. Instead, female Mallards assess whether the brown patch of a male is pristine and undamaged or is full of damaged feathers and bare patches. When male Mallards fight, they direct their attacks at their rival's brown chest plumage. Males that are poor fighters often have damaged breast patches; good fighters protect their breast plumage from damage.

FEMALES ARE NOT ALWAYS IMPRESSED

Not every study of birds with bright, ornamental coloration has found evidence for female choice for more colorful males. Male Blue Grosbeaks have brilliant blue feathers over most of their body. This blue is variable across males within populations, and expression of the blue is dependent on individual condition. These aspects of the coloration of Blue Grosbeaks sound much like descriptions of the red carotenoid color of House Finches, so when I undertook a study of female Blue Grosbeaks I expected them to behave like female finches

A dozen studies of mate choice in Pied Flycatchers have been published with some showing evidence for no choice based on coloration; others show females choosing darker males. Context plays a key role when females assess male plumage.

and choose brighter males. However, in aviary experiments in which students and I manipulated male plumage coloration with art markers, female grosbeaks showed no preference for more colorful males.

With my students, I have also conducted extensive research on Eastern Bluebirds, another species in which males display blue structural

FICKLE FEMALES

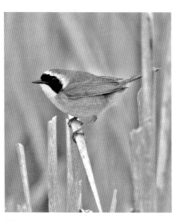

The Common Yellowthroat (left) is a secretive little bird dressed like a bandit going to a party, with a bright yellow coat and a bold black mask. Ornithologists Linda Whittingham, Peter Dunn, and their students studied this species for years in Wisconsin and showed in a variety of tests that females choose males with larger black masks but not brighter yellow breasts. In some ways these observations were unexpected, because yellow carotenoid coloration has often been shown to function in mate choice and black badges more typically function in social signaling. When Dunn and Whittingham repeated their study on yellowthroats in New York, the results were different. New York females did not select mates based on black mask size, but rather they chose mates based on the extent of yellow carotenoid coloration. Thus, studies by the same researchers using the same techniques on multiple ornaments of the same bird species at two locations in eastern North America provided different results concerning mate choice and coloration.

These Common Yellowthroat studies make the point that the behaviors of birds are often flexible over space and time. Females of a species might use male coloration as a key criterion in mate choice in one time and place but use a different trait in another context. Very likely these changes in female mate choice are caused by changes in the payoff to females assessing different male traits, but this is a difficult idea to test.

coloration that depends on their condition. In color-manipulation experiments in an aviary, we observed that nest-building females did not choose more colorful males as mates. To be certain that this was not just an artifact of captivity, we followed up with an experiment on wild birds. We removed the females of two neighboring males and used art markers to make one of the unpaired males more colorful and one less colorful. We then recorded which of the neighbors attracted a female first. We found no effect of plumage coloration on the mate choice of a newly arrived female. In studies of Common Rosefinches in Europe and Red-collared Widowbirds in Africa, researchers also reported that females did not use the bright red carotenoid col-oration of males as a basis for mate choice.

Why do females use color as a criterion in mate choice in species like the House Finch but apparently ignore it in Blue Grosbeaks and Eastern Bluebirds? In all species of birds, color is only one of a suite of ornamental traits displayed dur-ing courtship. Along with color, various species display with song, courtship dances, flight displays, and elongated or decorative feath-ers. Birds also use their color displays to signal dominance and to compete with other males for resources. Females might be indirectly selecting for male coloration by assessing the quality of resources defended by a male, if color is tied to resource defense. This appears to be the case in Blue Grosbeaks. Given the many criteria for mate selection, it is not surprising that some females prioritize behavioral displays or territory quality over coloration.

Blue Grosbeak
alternate ♂

BILL AND LEG COLORATION

Just as with feather color, the color of birds' bare parts, including bills, eye rings, legs, feet, and fleshy ornaments like wattles, can be used by females in assessing mates. Female choice for the coloration of a bare

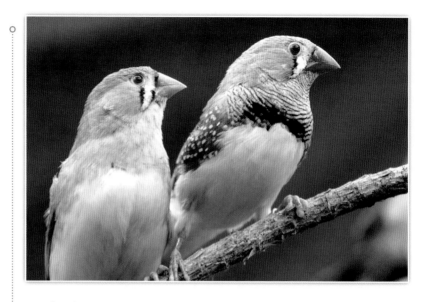

Both male (right) and female (left) **Zebra Finches** have carotenoid coloration of their bills and legs that reflects their health and condition and that is assessed during mate choice. Males also have bolder and brighter feather coloration, but the function of plumage color in Zebra Finches is unclear. *(captive)*

The orange cheek of male Zebra Finches is colored with phaeomelanin and may serve to enhance or amplify the orange color of the bill.

part has been studied most extensively in captive Zebra Finches, one of the most common cage birds in the world. Zebra Finches have complex and colorful plumage, but research on mate choice and coloration in this species focuses on red, carotenoid-based leg and bill color.

A long series of experimental studies has shown convincingly that females prefer males with more saturated and redder legs and bills. In some of the most creative experiments testing mate choice in **Zebra Finches**, ornithologists used colored plastic leg bands as a means to manipulate males' leg color. With this method, colors could be swapped among males between trials, so a male with blue leg bands in one trial became the male with red leg bands in another trial. Researchers observed that female Zebra Finches followed the red bands, preferring whichever male was wearing them. The response by female Zebra Finches to red plastic bands is perhaps not so different from the response of human males to red rouge on a woman's face. There's nothing inherently sexy about the artificial red pigment. But when the pigment is spread over a cheek, it creates a visual display similar to a healthy flow of blood. On male Zebra Finches, a red plastic leg band creates the impression of a "healthy" flush of carotenoid pigmentation.

A few field studies of bare-part color, including studies of the yellow bills of Eurasian Blackbirds and the bright blue feet of Blue-footed Boobies, demonstrated that females use the coloration of these traits as criteria in mate choice. Surprisingly, the brightness

of the large, scarlet red, inflatable throat pouches of Magnificant Frigatebirds, which are prominently displayed in courtship, is not assessed by females. The bare part coloration of most bird species, including such striking displays as the brilliantly colored bills of toucans, the blue and red wattles of tragopans, and the bright red skin on the heads of ground-hornbills, seem like traits that could function in female mate choice, but they remain unstudied.

MALES CHOOSE, TOO

In most species of birds, males perform the majority of sexual displays, and females seem most intent on assessment. For simplicity, therefore, I have focused on female mate choice and male color display. Of course, females of many species of birds are also brightly colored, and males as well as females often choose their mates carefully. As a general rule, when males are monogamous and invest in the care of offspring, they tend to be choosy about their mates.

Male choice for female coloration has been studied less extensively than female choice for male coloration. Many of the species

Barn Owls vary in breast coloration, from white to pale rust colored, and also in the number of black spots on the breast. In females, the number of black spots predicts the health and condition of individuals, and males prefer to mate with more-spotted females. (captive)

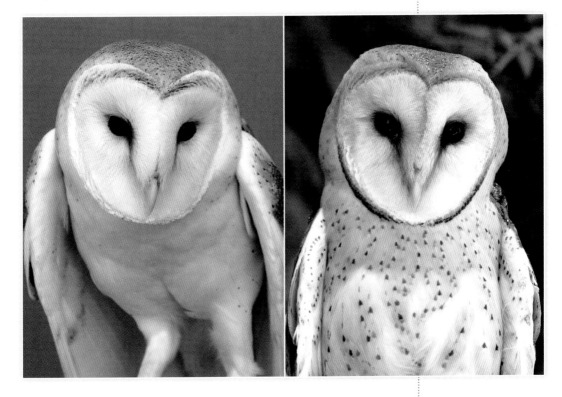

studied most extensively with regards to female choice for male color, including House Finches, Bluethroats, Blue Tits, and European Starlings, were also used in studies of male choice for female color. Generally, males choose females using the same plumage criteria used by females in choosing males. Studies of Barn Owls in Europe are an exception in that male mate choice and female ornamentation have been studied more than female mate choice. In these studies, male Barn Owls showed a preference for females with more black spots on their breast plumage.

One of the most poorly understood aspects of bird coloration remains the variation across species in the degree of female plumage coloration, hence sexual dichromatism. A simple explanation for variation in **color expression in females** is that female plumage brightness is proportional to the strength of male mate choice. When males use color to choose mates, we expect females to be brightly colored; when males do not assess the coloration of females, we expect females to be drab. Unfortunately, patterns across species do not entirely support this simple prediction. Male mate choice has been recorded in species in which females show little ornamentation, such as House Finches and Bluethroats, and absence of male choice has been noted in species in which females are brightly colored, such as the Turquoise-browed Motmot. The evolutionary forces that shape the overall color display of species is an area of active research in ornithology and is the topic of chapter 15.

LIMITS OF KNOWLEDGE

Most studies of female mate choice relative to male coloration have focused on the most common sources of color in birds: carotenoid, melanin, and structural color. The focus on these three forms of coloration was necessary and appropriate to build a basic understanding of the role of female mate choice in the evolution of color displays in birds. This focus, however, leaves whole classes of pigmentation unstudied.

With the exception of a single study, there is no information published about mate choice related to the less widespread pigment sources—psittacofulvins, turacins, pterins, or porphyrins. Given that

In groups like tanagers and orioles, tropical species tend to have females as brightly plumaged as males while temperate species tend to be dichromatic. More equal sexual selection on the two sexes in the tropics is one explanation for this pattern.

A male **House Finch** before (left) and after (right) being dyed red for a mate-choice experiment. *(captive)*

A degree of uncertainty is a common outcome when studying female choice relative to male coloration. When a female bird chooses a mate in a natural setting there are typically numerous variables at play that could affect mate choice and that are often correlated with plumage coloration. The most convincing way to demonstrate female choice for coloration is to conduct experiments in which a color display is *assigned* to a male by applying either a colorant or a color remover to its feathers. This approach randomizes all potential confounding effects so that if males with brighter coloration do better in attracting mates, the researcher can be confident that it is actually the color and not some correlated trait that has influenced the male's attractiveness.

There are two general approaches to color manipulation: remove the color patch entirely or alter the color within the natural range of variation. Entirely removing the colored patch is an extreme and unnatural manipulation, but it can be informative. If the color is removed entirely and there is no effect on mating success, then one can reasonably conclude that the color display was not an important criterion in female choice.

The better experiment is to change the coloration of males so that it is moved toward the extremes of natural variation. Such experiments sound simple, but they are often difficult to conduct because a large number of males have to be captured and manipulated before pairing has occurred. Experimental tests of female choice can be conducted using either wild or captive birds.

porphyrin pigments play an unknown role in coloration and are found only in drab brown feathers when they occur, it is not surprising that their role in mate choice has not been investigated. Turacin and turacoverdin, in contrast, produce stunning red and green feathers that look like the sort of ornamental traits that might be an object of mate choice. The function of the bright red and green colors has yet to be studied in any species of turaco, undoubtedly because turacos are scarce forest birds found only in Africa.

The lack of studies on the function of plumage coloration of parrots is something of an enigma. Many species of parrots are common in Latin America and Australia where many bird studies have been conducted, and parrots are among the most common cage birds. Nevertheless, the role of brilliant red, yellow, and green parrot coloration in mate choice has been studied only in the Burrowing Parrot, an uncommon South American species. Field research indicates that female Burrowing Parrots prefer males with larger red belly patches.

THE PAYOFF

Basing choice of a mate on color display seems like whimsical folly. Mate choice is serious business for female birds. The male that a female selects to sire her young and be her partner during nesting can have a huge impact on her reproductive success. For some birds, choosing a mate is a bigger decision than where to nest, when to nest, or how many eggs to lay. There must be a good reason that females use coloration to choose mates, and biologists have identified three payoffs that females might receive for choosing colorful males as mates: **material benefits**, genes for offspring survival, and genes that will make her sons sexy.

The most intuitive payoff is that females receive more material benefits from more colorful males. If coloration is a good predictor

Material benefits are resources that aid a female and her offspring, such as food, nest sites, and protection from predators.

of the quality of resources that a male can provide to a female, then it is to the female's benefit to assess coloration and to choose the most brightly colored male. Resources that benefit a female can be in the form of territory quality, including everything from the amount of food within the male's space to the nest sites that are available. In species in which males care for young, a typical pattern in birds, females can produce more offspring and offspring of higher quality if they pair with males that provide more care. Male plumage coloration has been shown to relate to male care of offspring in species such as the House Finch, Northern Cardinal, Eastern Bluebird, Pied Flycatcher, and House Sparrow. These studies focused on variation in a range of ornamental coloration types, including carotenoid, melanin, and structural coloration.

Is a payoff in the form of material benefits a universal explanation for why female birds choose mates based on coloration? It cannot be so because in a variety of birds, from Brown-headed Cowbird to Greater Sage-Grouse to Guianan Cock-of-the-rock, males provide no material benefits to females or their young. Males of these species simply copulate with females and fertilize eggs. They give females a set of genes for offspring, but nothing more. To complicate things further, the most fantastically colored of all birds tend to be species in which males provide no care, and in some of these species females

Like many birds, male **Northern Cardinals** provision dependent young. Male cardinals with brighter red feathers provide more food to offspring than do drabber males. (Alabama, May)

Afew species of birds create and use color displays that are not part of their bodies! For instance, White-winged Fairy-wrens in Australia present females with a blue flower during courtship, and the quality of the flower presented might affect mating success. In this example, a color display is assessed by a female during courtship, but the coloration exists completely beyond the body of the bird.

The prime examples of such coloration external to the body are the decorations used by several species of bowerbirds in Australia and New Guinea. Male bowerbirds build bowers that look a bit like large nests, but these structures are used exclusively to attract females and as places to copulate. Bowers are made of dry twigs and grass, but bowerbirds decorate their drab bowers with colorful objects from the environment. Male Satin Bowerbirds, which have beautiful iridescent blue coloration, almost always use blue objects to decorate the front of their bowers. Blue objects are rare in the woodlands inhabited by bowerbirds, and it takes time and skill to find a large collection of things that are blue. Male Satin Bowerbirds pile their hoard of blue objects at the front entrance to their bowers. Female bowerbirds assess the quality of the bower structure itself as well as the visual effect created by the display of blue objects in choosing their mates.

Like the Satin Bowerbird, the Vogelkop Bowerbird builds a bower from sticks and decorates it with colored objects from the environment. In contrast to the Satin Bowerbird's fixation on all things blue, Vogelkop Bowerbirds seem to value novelty, and virtually any object can turn up in a bower so long as the male thinks it adds to the effect. (New Guinea, February)

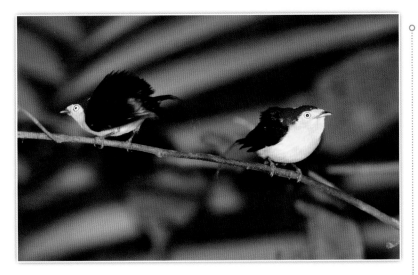

use expression of male coloration to choose mates. For females of these species, choosing mates based on ornament expression must involve payoffs other than the receipt of material resources.

Procuring genes that enhance the survival of offspring could be an important second form of payoff to females choosing mates based on coloration. Genes coding for traits as diverse as digestive efficiency and visual acuity could be the good genes linked to ornament expression, but biologists have focused mostly on genes for resistance to parasites as the good genes related to coloration. To many people, the word "parasite" evokes images of macroscopic invertebrates like ticks or tapeworms. Biologists, however, use the term "parasite" to mean any organism that lives on a host and is detrimental to that host; so parasites include a range of organisms from viruses and bacteria to the more familiar ticks and tapeworms.

There is extensive experimental evidence showing that parasites can depress the expression of some color displays in birds (see page 121). These studies show a link between parasitism and coloration, but they do not directly test the idea that genes for resistance to parasites are linked to coloration. Despite great interest in the concept that good genes may be linked to color display in birds, no study of birds has presented a convincing test of whether bird coloration signals genetic quality. Breakthroughs in DNA technology that enable scientists to identify specific genes for resistance to specific parasites should finally give ornithologists the proper tools to test this fascinating idea. For now, the hypothesis remains intriguing but untested.

A problem with the good-genes hypothesis is that evolutionary theory predicts that more fit genes should rapidly supplant less fit genes leaving no variation to be linked to bright feathers.

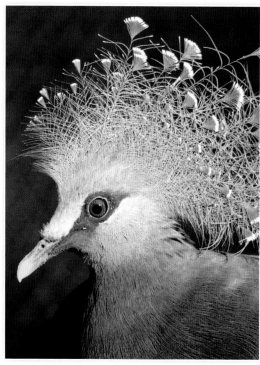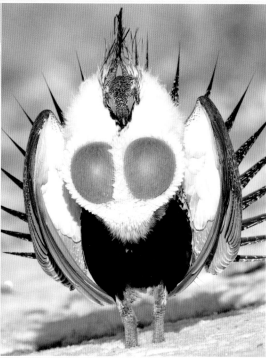

The sexy-son hypothesis proposes that the fantastic colors and ornaments displayed by some species of birds, like the **Victoria Crowned-Pigeon** and the **Greater Sage-Grouse,** are the consequence of arbitrary mate preferences by females. *(captive; Wyoming, March)*

The third possible benefit to females of choosing a highly orna-mented male is that offspring receive sexy genes if their mother mates with a sexy male. This hypothesis requires that there are genes that underlie variation in expression of the ornamental plumage trait. If colorful plumage makes offspring more attractive as mates when they mature, and if there is a genetic basis to the expression of coloration, then young sired by attractive males will inherit the attractive appearance and will be more successful at gaining mates. This is often called the sexy-son hypothesis.

An interesting implication of the sexy-son hypothesis is that there are few constraints on the sort of traits that can evolve. What-ever traits tickle the fancy of females and lead to increased mating success in males can be elaborated.

According to the sexy-son model, female choice could lead to feathers that are redder, eyes that are bluer, tails that are longer, tails that are shorter—or a million alternative forms of trait display. Some ornithologists consider this hypothesis to be a likely explanation for many of the ornate displays of birds because so many bizarre and seemingly arbitrary traits have evolved including combs, wattles, snoods, crests, racket tails, racket wings, and, of course, every color under the rainbow.

To an even greater degree than the good-genes hypothesis, the sexy-son hypothesis has proven challenging to test. The hypothesis clearly doesn't work for traits like the bill color of Zebra Finches or the breast color of House Finches because expression of these traits is determined largely by environmental factors such as diet and parasites. In these finches, the offspring of drab males and the offspring of bright males all have the same potential to show elaborate display of the color trait.

The **sexy-son hypothesis** stands the best chance of accurately describing why females choose males based on coloration in species with the most extravagant color displays—families such as hummingbirds, cotingas, manakins, and birds-of-paradise. In these groups, many complex and elaborate displays have evolved. In many of these groups, closely related species show incredible divergence of coloration. Such fast and extreme shifts in coloration suggest that the changes resulted from a process unconstrained by links between trait expression and condition or good genes; they seem more like traits that follow the fickle tastes of females. Like the good genes hypothesis, the sexy-son hypothesis is the focus of interest by many ornithologists; and, like the good-genes hypothesis, it has thus far eluded efforts to test it.

The outcome of the sexy-son hypothesis is often called arbitrary mate choice, because females can show a preference for any type of trait. Bizarre and arbitrary colors and patterns result.

WHY ARE BIRDS SO BEAUTIFUL?

When an ornithologist is asked why birds are so beautifully colored, the simple answer must be "because of female mate choice." All of the other functions of color explored in this book certainly account for much of the coloration within class Aves and even some colors that would be called bright and bold. But only female mate choice provides a satisfactory explanation for the magnificently extravagant colors seen in tanagers, cotingas, manakins, pitas, birds-of-paradise, and dozens of other groups. As shown in this chapter, mate choice also accounts for "lesser" ornamentation like the spots on a Barn Owl or the red bill of a Zebra Finch. With the fundamental importance of female choice established, the next chapter will take up the flip side of sexual selection—coloration that functions in contests for resources.

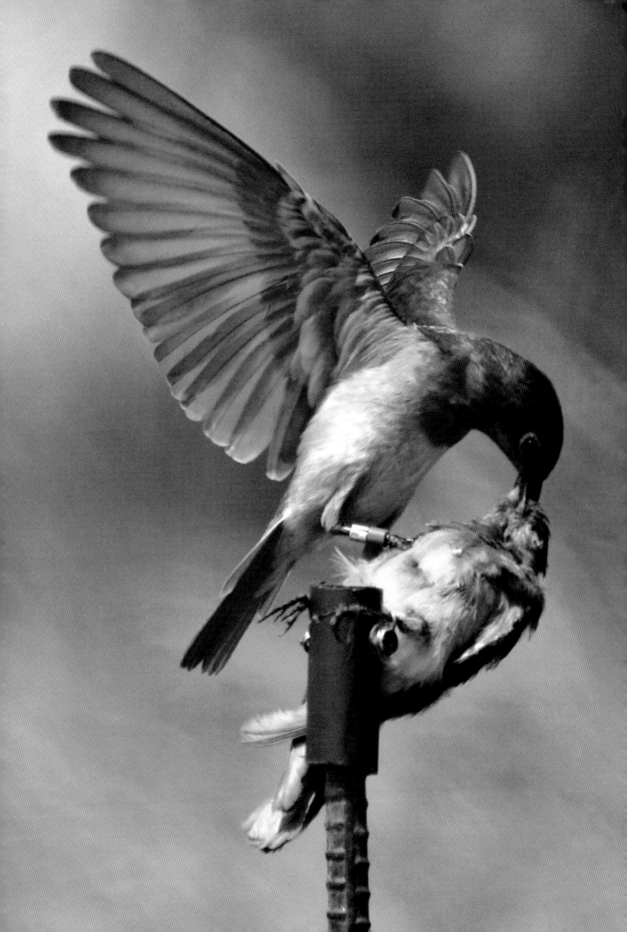

COLOR &
CONFRONTATION

R ECENTLY, I ATTENDED MY FIRST MIXED MARTIAL ARTS competition. This new fighting sport is a combination of boxing, wrestling, and kick boxing. The first two bouts were uneventful, each quickly turning into a wrestling match with no one suffering much damage. The third fight was different. I said "uh-oh" out loud as soon as the two contestants appeared. One fighter was huge and fit; the other was short, flabby, and pale. This fight looked like a mismatch from the outset, and it was.

I found what transpired hard to watch. In a matter of seconds under a barrage of fists and kicks, the pale flabby man was rendered unconscious. He ended up a crumpled mass on the mat as the winner danced around with his arms raised over his head.

The mismatch should never have happened, but it wasn't fatal or even a very serious mistake by the flabby fighter. Brutal as the fight was, the risks of permanent injury or death were slim—even in this barbaric sport there are strict rules about hitting an opponent once he gives up or loses the capacity to defend himself. The loser wasn't seriously hurt. He was taken home and put in a soft bed where he was safe from predators or other tough guys who might have wanted to finish him off.

Being overmatched in a fight is a much more serious matter for a bird. When a bird takes a beating in a fight, there *will* be predators

Male **Eastern Bluebirds** vigorously defend territories around their nest cavities. Placing a stuffed male with blue and orange coloration close to a male's nest box invariably results in an attack by the territory owner. *(Alabama, May)*

European Robins were the subject of a classic study by David Lack that showed that the reddish breast color, more than size, shape, or other coloration, evoked aggression from territorial males. (Scotland, October)

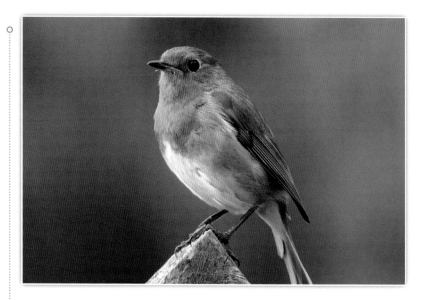

intent on eating it, and rival birds *will* press their advantage. Even if the bird doesn't die in the fight, it can certainly die as a consequence of a defeat. For birds, it is very important to avoid fighting superior opponents. A widespread function of plumage coloration is to signal fighting ability, so the sorts of mismatches that I witnessed do not occur. This chapter explores how color traits serve as signals of dominance and why such signals are so important to a bird's welfare.

SIGNALING STATUS

Birds live in a world of perpetual, often fierce, competition. In most cases the rules are simple: Take what you can for yourself, your mate, and your offspring. Take no pity on competitors. With rare exceptions, birds rise to the top of their groups—be that neighborhoods of territorial males or winter flocks—by brute force. Birds with the greatest power, stamina, and maneuverability defeat lesser individuals of their own species. **Status** refers to where among the ranks of individuals a bird falls. High-status birds lose few fights; low-status birds lose most of their fights.

Social status is a bird's position in the pecking order.

For nearly all birds, status can be a matter of life or death—or at least of reproductive success or failure. The greatest struggles occur among individuals of the same species and often among males of a given species. Individuals compete for limited resources that they need for survival and reproduction, including food, nest sites, places to roost, and

access to mates. Much of this competition is overt, settled through direct physical confrontations, but contests over resources can also be settled without direct fighting, through displays of coloration.

In many birds, color displays are clearly related to competition for resources. Bright and bold color displays frequently stimulate a strong aggressive response in rivals. A favorite example of plumage coloration triggering aggression concerns the reddish breast coloration of European Robins. More than 50 years ago the famed British zoologist David Lack observed that male robins viciously attacked a stuffed model placed within their territories. Lack wondered what specific features of the model stimulated aggression. He found his answer by placing a tuft of rusty breast feathers, devoid of head, wings, legs, and tail, in the territory of a male robin. The male attacked the tuft of colored feathers as if it were an entire bird. The rusty feathers alone were enough to evoke a strong aggressive response from a territorial male.

Why should plumage coloration stimulate such aggression in male birds? The answer seems to be that, in some species, specific aspects of plumage coloration function as status signals. Sievert Rowher first used the term "status signal" in a research paper in 1978 when he proposed the novel idea that the variable expression of melanin pigmentation in some sparrows that spend the winter in flocks in North America could serve as reliable signals of fighting ability. Rohwer's idea was that if two birds are competing for a desired resource and one of the potential combatants is clearly superior to the other combatant, then it is to the advantage of both the

This set of photographs of winter **Harris's Sparrows** was used by Sievert Rohwer in one of the first studies of the relationship between plumage color pattern and social status. Newly captured Harris's Sparrows were ranked for plumage pattern by matching them to the photographic series. Harris's Sparrows with more extensive black on their breasts and throats tended to be dominant to sparrows with less black.

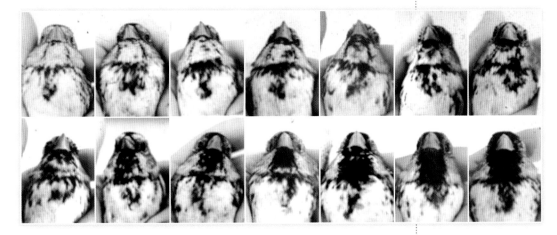

superior fighter and the inferior fighter to recognize the mismatch before a fight actually occurs. To enable birds to assess opponents before fighting, some birds display honest signals of fighting ability, and color displays frequently serve as such badges of status.

Rohwer developed his idea of status signaling for birds competing within a sex and age group. Such status signaling typically involves variation in the *quality* of an ornamental color display, such as the size of a black patch or the saturation of structural coloration. (Signaling different age or sex classes or totally different reproductive strategies typically involves variation in the *kind* of coloration that is displayed, such as orange breast feathers present or orange breast feathers absent, and such signals will be the topic of chapter 13.) Birds familiar to each other already know each other's fighting ability, and status signals do not add any useful information. Status signals are most valuable in situations in which unfamiliar birds are frequently encountered, as in wintering sparrow flocks or where breeding territories are being challenged. In these situations it is beneficial for contestants to be able to assess the status of new competitors without actually engaging in a fight. Through accurate signaling of status, dominant birds avoid wasting time and energy fighting weaker birds, and subordinate birds avoid fights with dominant birds who could do them harm.

Plumage coloration is used as a signal of dominance and fighting ability by sexually mature birds in two distinct contexts—in competition for mates and in contests for all other resources including food, preferred perches, position within a flock, and roost sites. Color displays that mediate competition for mates result from sexual selection, whereas color displays that function in contests for

COVERABLE BADGES

The color displays of adult males typically elicit strong aggression from territory-holding males. In many species, males need full expression of these displays if they are to have any chance of holding a territory, but there are circumstances in which it is beneficial for a male to hide his color displays and avoid aggression from rivals. If the display is on a restricted portion of plumage, a male can simply skulk and attempt to move unseen. Even better is to have a means to cover the bright color display that elicits aggression. One of the best examples of such a coverable badge is the red epaulet of male Red-winged Blackbirds (below). The bright red patch of feathers on the shoulders of male redwings elicits a strong aggressive response if it is displayed within the territory of another male. Male redwings, however, can cover the red portion of epaulets with black scapular feathers that lie above the epaulet.

The importance of being able to cover the red epaulet was dramatically demonstrated in a study in Ontario in which researchers caught territorial males and plucked the black feathers used to cover their epaulets. These males were forced to display their red epaulets constantly. Even before they moved off their territories, these perpetual displayers engaged in far more fights than unplucked males. When they tried to move off their territories they were subject to severe aggression from neighbors. For male Red-winged Blackbirds, it pays to be able to *not* signal aggression in some contexts.

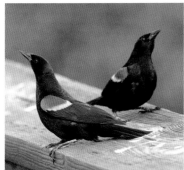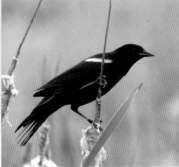

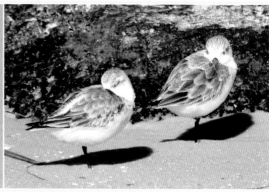

In the nonbreeding season, **Sanderlings** defend small patches of beach for feeding (left). When not feeding, they move and rest in tight flocks (right). For many birds, the need for both exclusive space and flock companions makes aggression in the nonbreeding season less severe and more specific to type of activity than aggression during the breeding season. *(both Florida, November)*

resources needed for survival result from natural selection. The same color displays typically serve as status signals in competition both for mates and for survival resources. Many aspects of these two forms of competition are the same, but there are key differences.

In competition for mating opportunities, the goal is usually to drive all competing individuals away and to keep them as far away as possible. In competition for food and other resources needed for survival, maintaining flock mates in close proximity is often crucial. The goal is typically to displace a competitor from a specific resource such as a food item but not to drive the competitor far away. The motivation for success in competition for mating opportunities is often much greater than in competition for other resources, so contests over reproductive opportunities are typically more intense and more likely to escalate into serious fights. For these reasons, competition for resources in the breeding and nonbreeding seasons are considered in separate sections in this chapter.

SOCIAL ORDER IN THE AVIAN WORLD

Birds within a flock inevitably establish dominance hierarchies, and people have appreciated this phenomenon for a long time. The term "pecking order" was introduced into the scientific literature by ethologists in the early 20th century, but from the dawn of agriculture farmers observed that hens in the barnyard held specific positions of dominance. Each hen pecks and displaces hens below her in the hierarchy and in turn each is pecked and displaced by hens above her. Scientists now call such pecking orders dominance hierarchies.

The same sort of dominance hierarchies exists in wild flocks of birds, and such hierarchies can be observed in free-living wild birds if

individuals are marked and watched closely. For instance, researchers in Ontario put colored bands on the legs of Black-capped Chickadees and observed them at feeding stations. Black-capped Chickadees live in stable flocks of about a dozen birds in the winter, and researchers found that there was a strict dominance hierarchy within each flock. Each chickadee holds a precise position in the flock such that it is displaced from seeds by all birds above it in the pecking order, and it displaces all birds below it in the pecking order. High-ranking chickadees, both male and female, tend to have blacker (less bright) throat patches and whiter (brighter) cheek patches.

Similar studies with both wild and captive flocks of several other bird species have established that, when they are living in groups during the nonbreeding season, individuals within the flocks form stable dominance hierarchies. Most of the color traits that have been shown to relate to dominance status within these winter flocks are bold patches of black melanin pigmentation. In Harris's Sparrows (see photograph, page 193), House Sparrows, and other species with black patches, it is the size of the patch, not the blackness of the patch, that predicts dominance status.

Just because color displays are associated with dominance does not mean that they are **status signals**. For a trait to be a status signal it has to be assessed by a rival bird, and it must change the manner in which the rival responds to the signaler. What evidence has been presented that plumage coloration is actually assessed and used to gauge behavior?

Testing for status signaling via plumage coloration is tricky. In some early studies, researchers placed males with different sized black badges together in a cage and then a few days or weeks later recorded which birds were dominant. Sure enough, in many of these studies males with larger badge sizes were dominant to birds with smaller black badges. The problem with this approach is that among a group of birds confined to a cage, true fighting ability will determine who is dominant and who is subordinate. A status signal is valuable only in the initial assessments by unfamiliar birds.

To test for true status signaling, it is necessary to carefully observe the response of a bird as it views the color display of a rival. In such experiments, unfamiliar birds have their ornamental coloration

Color is only useful as a signal of status and fighting ability in the initial assessment of a rival. Once birds physically interact, they know each other's true fighting ability.

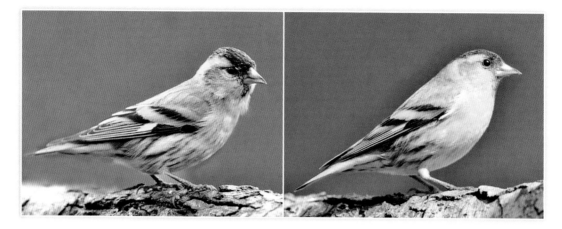

Eurasian Siskins show variable amounts of black on their crowns and throats, and birds with more black tend to be dominant to birds with less black. This plumage trait is a true signal of status, because siskins are more cautious when approaching unfamiliar birds with more black. *(both Scotland, April)*

altered, which typically entails making a patch of black feathers larger or smaller. With such manipulations, if there is a response to coloration, the researcher can be confident that the response is to coloration and not to some subtle difference in aggressiveness that is associated with the coloration.

Such experiments have demonstrated that black patches of melanin pigmentation are assessed and that larger patches of black elicit a more cautious and submissive approach. In other words, in these species, the size of melanin badges is a true signal of status. Some of the most thoroughly documented examples of patches of colored feathers functioning as badges of social status in winter flocks are the black bibs of House Sparrows, the black breast bands of Great Tits, and the black caps of Eurasian Siskins. On the male of each of these species, the patch of black coloration is conspicuously positioned so that it is displayed when a facing a rival bird, making it easy for rivals to discern differences in patch size.

Interestingly, similar dominance experiments have been conducted on House Finches and Northern Cardinals in which the hue and saturation of red carotenoid pigmentation rather than black melanin pigmentation was manipulated. In these species, carotenoid pigmentation was shown not to serve as a signal of social status.

CONTESTS FOR MATES

Many of the most familiar songbirds in North America and Eurasia change behavior dramatically between breeding and nonbreeding seasons. Males that live in social groups throughout the nonreproductive season become highly territorial with the onset of breeding. The territories held by these males are typically areas of exclusive use.

SIGNAL HONESTY

Key questions related to status signaling are: What maintains honesty in such signaling systems? Wouldn't subordinate birds benefit by falsely signaling high status? What prevents such dishonest signaling? It seems that the honesty of a signal within an age and sex class is maintained either by having a trait that is so challenging to produce that it is not possible to cheat or through social mediation, which is the periodic testing for cheaters. Under the first hypothesis, a large or brilliant color display can only be produced if a male is healthy and has access to good nutrition, so it is not possible for a male in poor condition to produce such a trait. If health and vigor are also related to dominance, then dominance will be reliably associated with larger patches and brighter colors.

Alternatively, a badge of status can be cheap to produce but costly to wear around. In humans, language can fill this role: Talk is cheap but bragging about your fighting ability will eventually land you in a real fight. Because dominant birds regularly test the fighting ability of other high-signaling birds, individuals that dishonestly signal high status end up in fights with superior fighters and risk injury. If birds signal their status honestly, they avoid such mismatched contests.

The honesty of carotenoid and structural color displays is reinforced by the high cost of producing these traits. Because melanin badges are less expensive to produce, they must be periodically tested if signaling is to remain honest. Even so, melanin badges are beneficial because, in the long term, they reduce the number of fights in which birds must engage.

Social mediation is a check on dishonest signaling. Subordinate males that signal high status will occasionally be challenged and have to fight true dominant males. The costs of such occasional fights are sufficient to stop dishonest signaling.

Females and sometimes young males are admitted, but all males that are perceived as rivals for potential mates are violently driven out.

For species of birds that defend territories, reproductive success hinges on **territory ownership**. In most of these species, a male without a territory has little chance of breeding, and a male that loses its territory has little chance of gaining a new territory. A territory is a resource of value beyond anything else in the lives of these birds. A bird that might give up access to a feeding location or a favored perch with no resistance in the winter may fight to the death to defend his breeding territory.

Defense of breeding territory explains why the European Robin studied by David Lack attacked a tuft of rusty feathers. The territorial robin recognized the red breast feathers as a sexually mature rival male challenging it for its territory and mate. In his studies of the European Robin, Lack recounted another anecdote in which a rival male came into the territory of a mated male and badly injured the male. By winning the fight, the intruder captured both the male's territory and his female. The loser robin was never seen again and was assumed to have died. For a bird defending its territory, the stakes are so high and the motivation to succeed is so great that subtle differences in the coloration of an intruding male might not matter. Among territorial males, only signals of sex and age typically mitigate aggression. Territorial males are committed to defending their resources against rival adult males at any cost.

Focusing on the aggressive behavior of territory-holding adult males presents a misleading impression of how plumage coloration might function in contests for breeding opportunities. Each territorial adult is a winner. These birds are holding territories because they claimed and defended their space from the onset of the breeding

BIRDER'S NOTE

Rebels Without a Cause ›› During spring migration, males of many species sing frequently and aggressively chase rival males. Such conspicuous behavior is one reason that spring migration is so enjoyable for birders. But what are these males fighting over? Most individuals linger a day or two at a stopover site and then continue north. Such aggressive behavior is best explained as a maladaptive consequence of the need to be ready for a fight upon arrival on the breeding grounds.

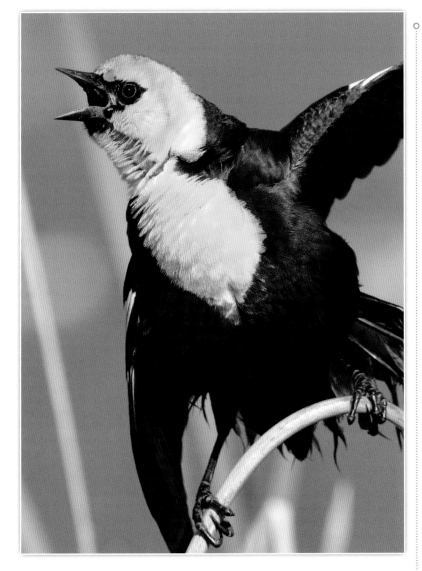

Male **Yellow-headed Blackbirds** flaunt their bright colors as they sing and display on their territories. For most territorial birds, color plays a central role in staking out and holding a territory. *(Wyoming, June)*

season. Once in this position, territorial birds might do little assessment and fight any intruder. In the struggles to partition breeding resources, however, there is still great potential for status signaling. It is during the period in which territories are being established that color can play a key role in signaling status and permitting birds to avoid mismatches.

During the establishment of territories, males assess which rivals to challenge for ownership of a territory and which to acquiesce to. Color displays often play a role in these dominance interactions, just as they do in mitigating aggression in winter flocks. My colleague Lynn Siefferman and I conducted an experiment with the

nesting boxes of Eastern Bluebirds that illustrates this point. When we initiated our long-term study of bluebirds on agricultural lands near Auburn University in the late 1990s, there was expansive habitat for Eastern Bluebirds but very few nest boxes or natural cavities for nesting. Without a cavity, bluebirds cannot reproduce, so nesting cavities form the core of male bluebirds' territories.

In late winter we put up nesting boxes at low density throughout this habitat that had been devoid of boxes. Male bluebirds rapidly claimed the boxes, and we caught each of these box owners, measured their plumage color, and released them. We then erected a set of additional boxes, filling in the gaps between our original box placements. Most of these boxes erected later were also occupied, and we caught each of these second-wave settlers and measured their color. We found that the early-settling birds had brighter structural coloration than birds that occupied the second set of boxes. We interpreted this difference to mean that brighter plumage coloration aided these original settlers in competition for boxes. It seems likely that drabber males acquiesced to the more brightly plumaged dominant males and then competed with other drab males for secondary resources. Experiments with male Eastern Bluebirds confirmed that blue structural coloration is used as a signal of status during the breeding season.

Eastern Bluebird

♂

In other studies, researchers altered the appearance of territorial males and then observed what change in behavior resulted. If color is used as a signal of status, then making a territorial male less colorful should cause it to be challenged more by nonterritorial males. This response to color manipulation has been observed in several species of birds. Paradoxically, making males more colorful can also cause them to be subject to more aggressions from other dominant males, presumably because brighter coloration is perceived as a signal of heightened aggression posing more of a threat (see sidebar, page 199). Taken together, these studies show that plumage coloration does serve as a signal of status among breeding males, allowing nonterritorial males to assess which territorial males might be successfully challenged and allowing territorial males to gauge the level of threat that an intruding or neighboring male poses.

WHAT COLORS SIGNAL STATUS?

In both nonbreeding and breeding contexts, black melanin pigmentation is the color trait that is most often associated with dominance and resource-holding potential. The blackness of feather patches has rarely been studied, but in Black-capped Chickadees, the darkness of black feathers predicts dominance. Brown and rust phaeomelanin has been studied in the context of social status much less than black eumelanin, but the darkness of rusty breast coloration relates to dominance status in Eastern and Western Bluebirds.

Black-capped Chickadee

Based on just a few studies, carotenoid coloration seems often not to function as a signal of status in the nonbreeding season. For instance, yellow and red carotenoid-based coloration in the House Finch and Northern Cardinal, two species that have been thoroughly studied, has been shown not to signal social status. However, red and yellow carotenoid pigmentation clearly plays a role in aggressive interactions during territorial contests and competition for females, because males of many red species respond aggressively to red males or even to red feathers placed within their territories. A detailed study of the Red-collared Widowbird, an African songbird in which males have jet-black plumage with a striking red collar, provides an excellent demonstration of carotenoid pigmentation serving as a signal of social status in a breeding context. Both the color quality and patch size of the red collar is used as a signal of dominance, but female widowbirds do not use red coloration as a criterion in mate choice.

As with studies of carotenoid coloration, the results from studies of the role of structural coloration as a signal of social status have been mixed. Experimental plumage manipulation of the blue/UV coloration of Blue Tits showed that structural coloration is not used as a signal of status. However, a similar manipulation of the blue/UV coloration of Bluethroats revealed that blue coloration can signal dominance, as did a study of the lavender color of captive Gouldian Finches. In Eastern Bluebirds (described above) blue structural coloration predicted success at procuring nest boxes, which are the most highly contested resource for bluebirds.

Male **Lark Buntings**
in definitive plumage
are striking birds with
a bold black and white
color pattern (right).
Before they intrude on a
neighbor's territory, they
pull underlying brown
feathers over their
black feathers and hide
their white wing patch,
transforming into birds
that are much less
flashy (left). *(both
Colorado, May)*

Male Lark Buntings are striking birds with jet-black body plumage and large white patches on the wings. In general, males with blacker plumage and larger white wing patches (below, right) win contests over resources compared to males with grayer body plumage and smaller wing patches (below, left). Unlike most birds, Lark Buntings can rapidly reduce the boldness of their color display by covering some of their black plumage with brown feathers that typically lie under the black feathers. Males can also cover their white wing patches.

Whether or not male Lark Buntings display their full ornamentation or partially conceal it depends on their reproductive tactic. Males invest their time and energy either in establishing territories and attracting a mate or in pursuing extra-pair matings. Territorial males use their full ornament display to win a territory and attract a female. In contrast, males that pursue extra-pair matings assume a cryptic gray plumage with their white wing patches concealed. Such extra-pair matings often occur among Lark Buntings when groups of males invade the territory of another male and form a "mob" around the female. These mobbing males invariably hide their wing patches and reduce their black coloration with gray feathers, probably to deflect the aggression of the territorial male.

These are not either-or strategies. The same male may defend his territory and his mate using his full ornamental coloration and later in the same day join a mob of males, conceal his black coloration, and pursue extra-pair matings. Sometimes it pays to be sexy and dominant and sometimes is pays to be drab and sneaky.

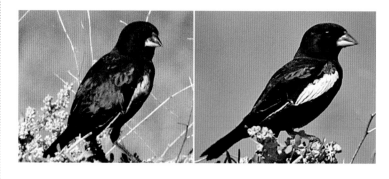

The pattern emerging is that carotenoid pigmentation and structural coloration can sometimes signal dominance, but that status signaling is typically the function of black melanin patches. Black patches do not seem to be intrinsically difficult to create, since patch size is not affected by parasites or nutrition. Rather, black patch size seems to be adjusted according to the social status of the individual. Because expression of black plumage patches is linked to **testosterone**, the male steroid hormone that controls aggression, it makes sense that black badges would be reliable signals of fighting ability and dominance. Carotenoid and structural coloration are typically condition-dependent traits that are physiologically challenging to create and that reflect the overall health and nutrition of males. Because health and nutrition might link to fighting ability, these traits might also be useful signals in assessing competitors, but they are fundamentally different sorts of signals than is melanin pigmentation.

Testosterone has been called a two-edged sword because, while it enhances production of ornaments like bright colors, it depresses the immune system.

THE TWO FACES OF SEXUAL SELECTION

The coloration of birds can promote access to mates either by making males attractive to females or by aiding males in aggressive interactions with other males. If the conclusion of the previous chapter was that ornate plumage is best explained as a consequence of female mate choice, the conclusion from this chapter is that bold black patches are best explained as signals of status used in contests for resources. Both of these statements are gross generalizations. A wide range of coloration can function either in mate choice or status signaling, and of course, these two functions are not mutually exclusive. The same color displays can serve both functions, and such dual functions of a single color display have been found in many studies of bird coloration. Mate choice and male-male competition are so tightly linked in many bird species that it is often difficult for scientists to test these two forms of sexual selection independently.

SIGNALING STRATEGY

I N 1936 G. K. NOBLE, A HERPETOLOGIST AT THE AMERICAN Museum of Natural History with an interest in animal coloration, conducted a simple experiment in his backyard in Englewood, New Jersey. He captured the female of a pair of Northern ("Yellow-shafted") Flickers that were starting to nest in a large elm tree and glued a black spot to the side of the bird's face before releasing it.

Male and female flickers are almost identical in plumage color and pattern, but male flickers have a bold black mark running from the gape to below the cheek—often called a moustache—whereas females have a plain gray face. By gluing a patch of black on the face of the female, Noble gave her the appearance of a male. He wondered if the male flicker would still be able to recognize its mate. As he reported in the ornithological journal *The Auk*, he did not: "With a start he drew back and recovering his balance, lunged viciously forward. Then began a long drive which lasted nearly two hours and a half. Along the branches back to the trunk, up to the nest hole and again out on the branches the male mercilessly pursued the moustached female." When Noble removed the black moustache from the female a couple of exhausting hours later, the male immediately abandoned all aggression and began treating the female again as his mate.

It is hard to imagine a more definitive demonstration that bird coloration can serve as a signal of the sex of an individual.

Northern Flicker "Yellow-Shafted"

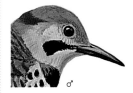

♂

♀

Male **Ruffs** come in three plumage morphs that are linked to behavioral strategies. Dark morph males, such as this displaying individual, are socially dominant to other morphs and defend positions within the display arena. *(Sweden)*

A reproductive strategy is a behavioral and physiological pattern aimed at winning reproductive success. Strategies can be transient, such as subadult plumages linked to subordinant behavior, or they can last a lifetime, as in plumage morphs of Ruffs. Sex is the most fundamental reproductive strategy.

Noble's backyard experiment introduces the concept of color displays that are signals of reproductive strategies. Signals of reproductive strategy are distinctly different from plumage traits used by females to assess the quality of potential mates and from signals that reflect fighting ability. Those latter traits show continuous variation. The signals of reproductive strategy discussed in this chapter show discrete color variation related to the reproductive strategies that they signal. These signals distinguish males from females, young birds from older birds, and in few rare cases, individuals who follow different lifetime reproductive strategies.

SEXUAL IDENTITY

Why do birds need to signal their sex with a trait like a black moustache? Isn't sexual identity obvious to members of a species? Based on the flicker study, we have to conclude that it is not. Most species of birds lack external genitalia—the cloaca of a male is identical to the cloaca of a female. In many species including the Northern Flicker, males and females do not differ appreciably in size. If plumage color and pattern are the same over most of the surface of the body, what signals of sexual identity are left? Certainly behaviors such as song can give away the sex of an individual, but sex-specific behaviors are not constantly on display. A simple visual signal that says "I am a male" or "I am a female" solves the problem.

Both sexes benefit from signals of sex. In a typical avian mating system in which females do the choosing and males do the displaying, males certainly want females to know that they are available as mates. Conversely, if there is male aggression, females do not want to be mistaken for a rival male—just look at the fate of Noble's female flicker when she was erroneously recognized as a male. Because signaling sex is beneficial to both males and females, it is not surprising that unambiguous markers of sexual identity have evolved in the plumage of species like the Northern Flicker. An interesting but unresolved question is why many other species of birds have no apparent visual signals of their sex.

Relatively few color displays in birds are likely to be explained *exclusively* as signals of sexual identity. Sexual dichromatism involving

bold, bright, or complex plumage coloration, such as the brilliant male and drab gray female plumage colors of Wood Ducks, undoubtedly makes the sexes easy to distinguish. Such gaudy and complex coloration, however, is much more than the minimum needed for individuals to signal their sex unambiguously.

When sexual dichromatism involves complex traits, the need for conveying sexual identity cannot be the primary explanation for the ornate plumage of males. The best explanation for complex and gaudy color displays is that they function as signals of condition or attractiveness. If a trait exists exclusively to signal sexual identity, it is expected to be simple, unambiguous, invariant, and cheap to produce. The black moustache of male flickers meets these criteria. The small patches of red feathers on the heads of males but not females in many species of woodpeckers, the different amounts of white in the wings and tails of male and female Common Nighthawks, and the black cap of male Blackcaps versus the brown cap of the female Blackcaps also seem like traits that may have evolved as indicators of sexual identity. In these examples the plumage differences between the sexes are simple and unambiguous. None of these plumage traits, except the flicker moustache, has been tested to show that it functions in sex recognition.

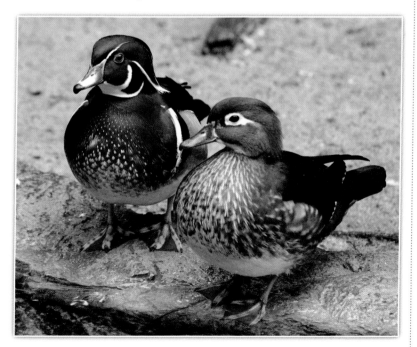

The striking plumage of male **Wood Ducks** may be used by females to recognize males, but such complex and costly plumage displays likely evolved through sexual selection. *(Florida, April)*

○ SEXUAL IMMATURITY

Another reproductive state that can be conveyed through coloration and color patterns is sexual immaturity. Between natal down and acquisition of their first basic plumage a few months after hatching, birds grow a juvenal plumage that is often distinct in color or pattern from the plumages of older birds. The coloration of bare parts, particularly eyes and bills, also sometimes differs in young birds. When newly independent young birds are recruited into a population during the spring and summer, the population will have two discrete age groups—young, naive, sexually immature birds and birds that have been alive for at least a year. Distinctive coloration commonly distinguishes such inexperienced from more experienced individuals.

That color can signal sexual immaturity was demonstrated in a simple color-manipulation experiment done with Purplish-backed Jays. In several of the New World jays like the Brown Jay, young, sexually immature birds grow definitive plumage but still have bright yellow bills that are distinct from the black bills of adults. In the late 1960s, ornithologist William Hardy purchased some Purplish-backed Jays (then called Beechy's Jays) from a dealer in Tepic, Mexico, and transported them to his lab in Los Angeles, California. For a time he caged two of these birds as a pair, while in an adjoining cage he kept a lone adult male. Hardy reported that the paired male spent at least half of each day banging on the cage in the direction of the lone male and generally acting aggressively toward it. When he painted the black bill of the lone jay yellow, giving it the appearance of a sexually immature juvenile, the paired male abruptly ceased all aggression toward it. As with Noble's experiment on flickers, Hardy's experiment represents a single, unreplicated observation, but it

Brown Jay

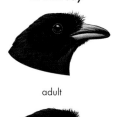

adult

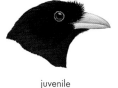

juvenile

is hard to argue with such unambiguous results. Juvenile bill color brings about reduced aggression in these jays likely because it serves as a signal of sexual immaturity.

Juvenal plumage is female-like in many dichromatic species. What is the advantage of having juvenal plumage like that of a female? Why not have a distinctive juvenile appearance? Compared to the plumage of adult males, the plumage of adult females is usually simpler, less conspicuous, and less costly to produce. Also in most species, males are the aggressive sex, and their aggression is usually directed toward other males, not females. By resembling females, young birds avoid the costs of bright and conspicuous male plumage and take advantage of a predisposition of adult males to be nonaggressive toward females.

Because they are sexually immature, birds in juvenal plumage pose no threat of cuckolding or usurping the territory of older males. As with signals of sex, signals of age are potentially beneficial to both the sender (young bird) and the receiver (adult bird). Older birds benefit by not wasting time and energy chasing or fighting with birds that pose no real threat to their reproductive effort. Juveniles benefit by avoiding aggression from older, more experienced birds.

Brown Pelicans
in juvenal plumage (perched left panel; flying right panel) have pale belly feathers and other subtle but distinct color differences from pelicans in definitive plumage (flying left; perched right). Juvenal plumage serves as a signal of immaturity and subordinate status. In this case, the juvenile gives up its perch to an adult without resistance. *(Alabama, October)*

Models of **Eastern Bluebirds,** constructed by stuffing dead birds, were used to test the function of spotty juvenal plumage. Breast patches were swapped between trials as shown in the two panels.

To test the effect of breast spots in the juvenal plumage of Eastern Bluebirds, Russell Ligon presented territorial males with stuffed male bluebirds that had removable breast patches. One of the breast patches was plain orange with no spotting and one was a typical spotted breast of a juvenile bluebird. By making the breast patches removable and interchangeable, he was able to control for potential effects created by the models themselves. With this design he could decisively answer the question: Does the distinctive juvenal plumage of young bluebirds deter aggression from adult males? The answer from the experiment was a clear yes. Territorial males attacked orange-breasted models much more aggressively than spotty-breasted models.

DELAYED PLUMAGE MATURATION

In many species of birds, plumage immaturity extends beyond the period of juvenal plumage. Males, and occasionally females, of these species do not attain full coloration until after their first potential breeding season. In contrast to the developmentally immature birds in juvenal plumage, individuals in subadult plumage typically *are* sexually mature. These younger birds are signaling an alternate reproductive strategy through their subadult plumage color and pattern. In most cases, the reproductive strategy of subadult males is to be less aggressive and more submissive, thereby avoiding aggression from older, more experienced males but also losing reproductive opportunities.

Delayed plumage maturation has been studied primarily in songbirds, but it is a conspicuous feature of birds in many orders and families including pelicans, herons, storks, spoonbills, large waterfowl,

birds of prey, gulls, skimmers, penguins, and alcids, among others. Most species go through one potential breeding season in subadult plumage, but in some species individuals may pass through several breeding seasons in less-than-definitive coloration. The champions of slow plumage development are the large albatrosses. Wandering Albatrosses, for instance, can take up to 20 years to achieve unblemished white breast plumage, but individuals often begin breeding around age 10 with some brown in their breast plumage.

Most birders, I think, dismiss subadult plumages as simply part of the developmental progression toward full maturity. Just as a male human *can't* jump from 4 pounds at birth to 180 pounds at adulthood without transitioning through a 70-pound body size, it might be argued that a male Rose-breasted Grosbeak *has to* transition through subadult plumage with a pale red breast and brown-and-black wing coloration to reach the bright red and jet black plumage coloration of a full adult male. But this analogy doesn't hold up. There are no strict developmental constraints on a male Rose-breasted Grosbeak that preclude it from growing definitive plumage by its first spring. Other closely related species of approximately equal body size, such as the Northern Cardinal and the Eastern Towhee, reach definitive plumage by their first spring. The subadult plumage of first-spring male Rose-breasted Grosbeaks is a strategic signal, not the result of a developmental constraint.

The strategy of subadult males signaled through subadult plumage is basically to take on fewer risks and invest less in reproductive

In definitive plumage, **Black-headed Grosbeaks** are highly sexually dichromatic; males (left) have bold black, white, and orange coloration while females (center) are brown and buff. Males in subadult plumage (right) have a variable mix of male and female color patches. Such subadult plumage is a signal of subordinate status by inexperienced first-year males. *(all California; April, May, and May)*

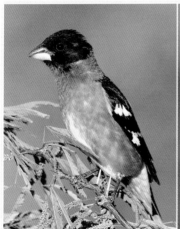
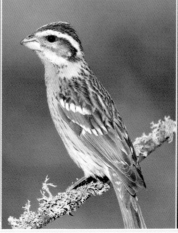
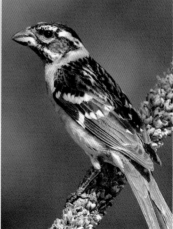

effort and, instead, to invest more in survival and maintenance. Males in subadult plumage are almost always subordinate to older, more experienced males. These young males compete among themselves for the resources that remain once the most preferred resources are divided among older males. By wearing a relatively drab subadult plumage, young males also eliminate the costs of producing ornamental coloration, as in acquiring scarce carotenoid pigments, and the costs of being conspicuous to predators. Strategies related to delayed plumage maturation typically persist for one or a few years as young birds gain experience in reproductive competition, although as mentioned above, large albatrosses can take 20 years for full plumage development.

In many migratory species of songbirds with subadult plumage such as Black-headed Grosbeaks and American Redstarts, young males arrive on their breeding grounds approximately two weeks later than males in definitive plumage. Arrival in late spring is another part of young males' strategies to invest in survival over reproduction. A later arrival usually means better weather and more food. By delaying their migration, these males also avoid the most ferocious fighting as older males carve out territories. Of course, this also means that by the time subadult males arrive, the best territories are taken.

By signaling their youth and inexperience, young males avoid direct competition with older males who have the advantage. In so doing, young males increase their chances of surviving to the next breeding season when they will be older, more experienced, and able to compete more effectively for breeding opportunities. In many species, males in subadult plumage hold no territories and instead drift around a breeding area. Such nonterritorial males are called "floaters" by ornithologists. Floaters use their first year in the

Rabble-rousers ›› Even though subadult males typically follow a strategy of low investment in reproduction, in many species they are the most conspicuous individuals for much of the summer. Once older males are occupied with nesting, subadults take the opportunity to display. Many beginning birders are confused by the odd yellow orioles (subadult Orchard Orioles) or the "female" American Redstarts that sing so conspicuously through the hot months of the summer.

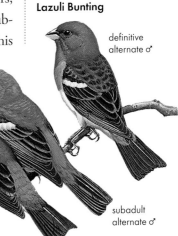

Purple Martins nest in colonies and older males (upper left) control access to their own cavity as well as neighboring cavities. These older males drive away rival males in definitive plumage but encourage yearling males in subadult plumage (third from left) to settle next to them. The older males cuckold these subadult males, fathering as many as half of the young in their neighbors' nests. (Alabama, May)

breeding area to learn about the neighborhood of territorial males. Again using American Redstarts and Black-headed Grosbeaks as examples, some subadult males succeed in establishing territories, which are almost always in positions peripheral to the territories of older males in definitive plumage, and other males exist as floaters. Overall, whether they hold territories or not, subadult males have lower reproductive success than males in definitive plumage.

In other species, males in subadult plumage have an interesting arrangement with older males in definitive plumage. Experienced Purple Martin and Lazuli Bunting males tolerate subadult males as close neighbors even as they aggressively chase away older males in definitive plumage. It turns out that the tolerance by these older males is not a case of charity. The older males cuckold their younger neighbors, fathering as many as 50 percent of the young in the nests of these subadult males but never being cuckolded by their young neighbors. This seems like a terrible case of avian extortion, but it is really more a case of mutualism. Without the tolerance of older, experienced males, breeding opportunities for the inexperienced subadult males are almost nil. These young and inexperienced males essentially trade the paternity of some offspring in their nests in exchange for a chance to breed.

In many species of dichromatic songbirds, such as Purple Finches and American Redstarts, all males in

Lazuli Bunting

definitive alternate ♂

subadult alternate ♂

♀

subadult plumage resemble adult females. In other species, such as Indigo Buntings and Black-headed Grosbeaks, males in subadult plumage span a range of appearances from like females to like definitive males. In these latter species, the males in brighter plumage tend to adopt a more aggressive reproductive strategy more like that of older males. Subadult males in drabber, more female-like plumage tend to adopt a submissive reproductive strategy. So even within the subadult strategy, there is variation in the aggression levels of males.

Within passerine birds, delayed plumage maturation is a phenomenon observed primarily in species with sexually dichromatic plumage, and it is almost always a reproductive strategy restricted to males. One important exception in North America occurs in the Tree Swallow, a species that is sexually monochromatic such that both males and females have bright iridescent blue-green coloration. Female, but not male, Tree Swallows have a dull subadult plumage that seems to be related to severe competition among females for nesting cavities.

With low chances of procuring a cavity and breeding in their first year, female Tree Swallows seem to adopt the same strategy as young *males* in other species of songbirds, reducing their investment in reproduction in favor of increased survival during their first year.

Generalities presented in the previous sections regarding juvenal and subadult plumages work best for songbirds and other smaller birds. For these species, juvenal plumage coincides with sexual immaturity. By the time these small-bodied birds reach their first breeding season after molting out of juvenal plumage, they typically have functional reproductive organs, hence subadult plumage can be viewed as an alternate reproductive strategy. In contrast, sexual immaturity in some large birds such as eagles and albatrosses can persist for years after juvenal plumage is lost. For many of these species, sexual immaturity is signaled by a sequence of subadult plumages.

Even though large-bodied birds may not develop functional reproductive systems for years after hatching, it is still valid to view subadult plumages in these species as a signal of an alternative (delayed) reproductive strategy. Actual physical delay of development of

Tree Swallow

definitive

definitive

subadult ♀

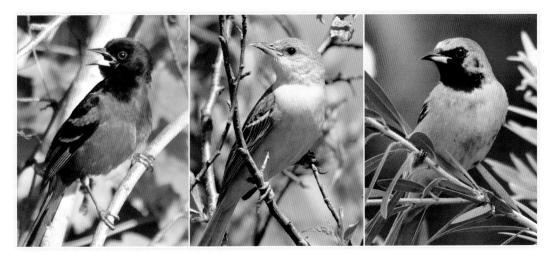

reproductive organs is really just an extreme form of delayed invest-
ment in reproduction. These large-bodied birds simply delay devel-
opment of gonads and plumage until they gain sufficient experience
to have a reasonable opportunity to compete as breeders.

STRATEGIES THAT LAST A LIFETIME

In most species of birds, there is a common reproductive strategy
pursued by all sexually mature individuals of the same sex. For
instance, males of many species defend territories, and each male in
a population aspires to attain a high-quality territory that will allow
it to attract the best female or to have an opportunity to mate with
multiple females. Some males of the same species might be more
brightly colored than other males or might have larger patches of
color, and this variation might relate to success in gaining a high-
quality territory. Whatever the particular variation on the theme, all
individuals are engaged in the same contest.

 In a small subset of bird species, sexually mature individuals of
the same sex pursue fundamentally different strategies for reproduc-
tion throughout their lifetimes. Alternative, lifelong reproductive
strategies are relatively common in insects and fish, but they are
rare in birds. In the two cases where alternative lifetime reproduc-
tive strategies have been documented in birds, they are signaled by
plumage coloration.

 The best avian example of alternative lifelong reproductive strate-
gies is found in the Ruff, a species of shorebird that breeds in north-
ern Eurasia and migrates throughout Eurasia and Africa. Birders in

Orchard Orioles have
the most distinctive
subadult plumage of
any songbird in North
America. Males in
definitive plumage (left)
have coloration that
is completely different
from females (middle).
Yearling males, with their
black throat patches,
are distinct from both
females and older males.
Such a distinctive, age-
specific plumage is best
explained as a signal
of inexperience and
subordinate status to
older males. *(Alabama,
April; Kansas, May;
Alabama, April)*

North America get a taste of the eccentricities of this species in their field guides, most of which show a few pictures of Ruffs because the species is a regular vagrant in North America. Invariably these field guides illustrate female Ruffs, which are drab brown and look something like a cross between a yellowlegs and a Pectoral Sandpiper. Female Ruffs are so distinct from males that they get their own name: Reeves. Typically, field guides illustrate a couple of males in breeding plumage: one that appears to have a dark mane like a lion, which is the male's ruff, and then, oddly, a male with a ruff that is white. Along with their mane-like ruffs, males also have odd tufts of feathers on their heads that also can be light or dark. Why should individuals within a species of shorebird be so variable in coloration?

It has taken decades for ornithologists to figure out what's up with Ruffs. First, Ruffs breed on what are known as **leks**—display courts where females come to choose a mate and copulate. Male Ruffs contribute nothing to the reproductive effort following fertilization, so males spend all of their time during the mating season on their display courts trying to attract and copulate with females. A handful of other bird species such as the Greater Sage-Grouse in North America, Great Bustard in Europe, and Guianan Cock-of-the-rock in the Neotropics follow the same sort of lekking behavior. But among lekking species, only the Ruff has males that follow different lifetime reproductive strategies.

Male Ruffs follow one of three distinct reproductive strategies: a dominant and aggressive strategy, a subordinate and passive strategy, and a "sneaker" strategy. Males with dark ruffs or dark head tufts are the dominant males. Males with white ruffs and white or rusty head tufts are satellites. Males in female-like plumage and with small body size are sneakers. These plumage types and associated strategies are genetically determined, fixed at the moment of conception. In Ruffs, dominant and satellite males conspicuously and unambiguously signal their lifetime reproductive strategy through their plumage coloration. Sneaker males also follow their own lifetime strategy that links to plumage coloration, but they are anything but conspicuous about their intent.

How can such a system work? Wouldn't one strategy be better than alternative strategies and, over time, become the only strategy?

Species display on leks when males abandon all care of offspring. Instead of defending resources needed for nesting and food gathering, males defend small areas on display courts where females come to assess males and copulate.

The fact that most bird species do not have discrete, lifetime reproductive strategies suggests that in most cases a single best strategy does supplant all other strategies. In the Ruff, however, multiple strategies persist and co-exist because each provides a different avenue for reproductive success.

The aggressive strategy of males with dark ruffs constitutes the most common reproductive strategy. These males fight vigorously among themselves for the best positions on the lek, and females tend to mate with the males that hold these favored lekking positions. Hence, matings are not spread evenly among dark males. A few dark-morph males fertilize many females, while most dark-morph males leave no descendants at all.

Males with white ruffs and head tufts play the role of satellites, meaning that they do not attempt to defend a particular spot on the lek. White-morph males are not aggressive and always submit to dark-morph males. White-morph males actually form mutualistic displays with dominant males. Many dominant, dark-morph males tolerate a white-morph male on their territories—often right in the heart of the lek—and the two males will display together with ritualized satellite-dominant displays. Studies show that dark-morph males with white-morph males on their territories are more attractive to females than dominant males without satellites. Despite their

Male **Ruffs** have three morphs of color and plumage elaborateness: female-like (left), white (middle), and dark (right). Each color morph is genetically linked to a behavioral strategy. Female mimics act like females until they get an opportunity to copulate with a real female. Dark-morph birds are socially dominant and fight to hold places on the leks. White-morph males are satellites and move about, sometimes teaming with dark males to attract females. (captive)

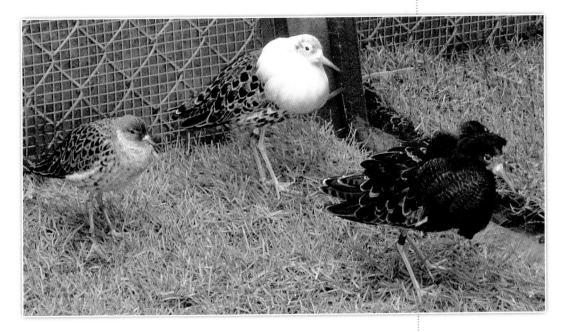

Male Ruffs that are not female mimics come in two discrete plumage morphs: dark and white. But within these two morphs, males are tremendously variable. Dark-morph males are not all chocolate brown. They vary in hue from golden and rust to brown and black. They can even have white ruffs, so long as they have dark head tufts. White-morph males all have a mostly white ruff, but they can have white, black, brown, or rufous plumage on the head and body. As if such dark-brown-to-white variation wasn't enough, males show a dizzying array of spots, bars, and stripes within the dark-and-white background plumages. There is more variation in the plumage of a dozen male Ruffs than is observed across most families of shorebirds. This diversity of colors and patterns is enough to leave a birder scratching his or her head.

If Ruffs signal their key reproductive strategy in the darkness of their ruff and head-tuft feathers, then why do they have such a variable pattern of spots and bars? It turns out that Ruffs signal two very different things with their plumage. The dominant color morph—white versus dark—is a signal of reproductive strategy as described in the text. In addition, the highly variable colors and patterns of males serve as signals of individual identity. This two-tier signaling system benefits Ruffs in their incessant interactions on the leks.

passive behavior and subordinate role, white-morph males are about as successful at fertilizing females as dark-morph males.

The dark/white polymorphism is stable because both white and dark morphs achieve equal reproductive success when 15 percent of the males have white ruffs. If white-morph males became more

frequent, their strategy would become less successful because there would be too many satellites on leks. If they became less frequent, then the satellite strategy would become more successful and white-morph males would increase. The balance point is 15 percent white-morph males.

Perhaps the most fascinating reproductive strategy employed by male Ruffs is the sneaker strategy. Sneaker males lack a ruff and have plumage coloration that is exactly like the plumage of Reeves. As a matter of fact, these sneaker males are so cryptic that they were overlooked by ornithologists through nearly 90 years of studies on Ruffs. The sneaker strategy was described only in 2006. Sneaker males not only look like females but act like females. They are smaller than ornamented males and their cryptic appearance and behavior deceive dominant males most of the time and allow sneaker males to penetrate unchallenged right to the heart of the lek.

Sneaker males do whatever it takes to keep dark-morph males from copulating with females and to gain mating opportunities for themselves. When a dominant male approaches a receptive female, a sneaker male tries to insert itself between the pair or will crouch like a female to entice the dominant to mount him rather than the female. Following such a ruse, females will sometimes copulate with the sneaker. About one percent of male Ruffs are sneaker males.

Ruffs are the only birds with a sneaker morph, but such sneaker male strategies are relatively common in fish. Bluegill sunfish, for instance, have a sneaker male strategy that functions remarkably like the sneaker male morph in the Ruff.

WHITE-THROATED SPARROWS

The White-throated Sparrow is familiar to most birders as an abundant breeder across the Canadian Shield and a widespread and common winter resident in the eastern United States. It is the only bird species other than the Ruff that has been shown to have a plumage polymorphism linked to alternative lifetime reproductive strategies. The breeding strategy of White-throated Sparrows, however, is completely different and simpler than that of Ruffs. White-throated Sparrows are not strongly sexually dichromatic, and they do not display on leks. Instead, White-throated Sparrows form monogamous pair bonds, and pairs defend territories.

Male and female White-throated Sparrows both come in two distinctive plumage color morphs. Either they have tan-and-brown head

stripes with dingy throats—the tan morph—or they have bold black-and-white head stripes with bold white throats—the white morph.

In both males and females, white-morph birds are more aggressive and less parental than tan-morph birds. White birds dominate tan birds in contests over access to food in the winter and preferred breeding territories in the summer. As in the Ruff, these color morphs and associated behavioral patterns are genetically determined, lifelong reproductive strategies.

If white-morph birds dominate tan-morph birds in contests over food resources and territories, then why do tan-morph birds persist? The simple answer is that tan-morph birds are much more attentive parents. By far the most successful White-throated Sparrow pairs are mixed-morph pairs composed of a tan-morph and a white-morph bird. White-white pairs spend too much of their time singing and fighting with neighbors. They do not invest enough of their time and energy in the care of offspring and, consequently, they produce few young. Tan-tan pairs, in contrast, are unable to hold sufficient resources for successful breeding, and these highly parental pairs also have low reproductive success. Mixed pairs strike the right balance between energy channeled to parental duties and energy used to defend resources. Strong disassortative mating—that is, a strong preference to mate with the alternative morph—maintains these two distinct reproductive strategies within the population.

THE ORIGINS OF COLOR DIVERSITY

Hundreds of bird species display plumage polymorphisms, usually with dark and light plumage types occurring within the same population. Except in the cases of the Ruff and the White-throated Sparrow,

however, color morphs in birds are not linked to different behavioral strategies. In other species that have been studied, such as Parasitic Jeagers, Reddish Egrets, and Snow Geese, individuals of different color morphs follow the same reproductive strategy. Color polymorphisms seem to be maintained in these species because they aid in individual recognition and perhaps because different color morphs represent different, but equally successful, means to deal with challenges imposed by natural selection such as camouflage or thermoregulation.

In the previous six chapters, the focus has been on a diverse range of functions for both pigmentary and structural coloration—from antibacterial protection to signals of complex reproductive strategy. Understanding the pigments or structures that produce coloration and the value of various color displays for birds provides a critical baseline for understanding why birds look the way they do. But studies of functions in single species, even when they are as fascinating as the lifetime reproductive strategies of Ruffs, leave the really big questions unresolved.

Why do male House Finches display with red carotenoid pigments while Eastern Bluebirds display with blue structural coloration? Why haven't species converged on the same sexual display, in the same way so many species have converged on countershading as a solution for being less visible? Why do some species have red only on their heads, such as Red-faced Warblers, while others show red only on their wings, such as Red-winged Blackbirds? In the last chapter, we will turn to the big questions about why specific types and patterns of coloration have evolved.

Both male and female **White-throated Sparrows** come in two color morphs: tan-striped (left) or white striped (right). Tan-striped birds are non-aggressive and attentive parents. White-striped birds are aggressive, socially dominant, and poor parents. (Virginia, January; Virginia, December)

THE EVOLUTION OF COLOR

Ornithologist Kevin Omland, a professor at the University of Maryland–Baltimore County, encourages his colleagues to engage in "tree thinking." Omland is not advocating conservation of mid-Atlantic forests or a means to achieve a perfectly landscaped yard. Rather, he is teaching the proper perspective from which to investigate the evolution of avian colors and patterns.

Omland's trees are phylogenies—branching diagrams that depict hypotheses for the evolutionary relationships of birds. Phylogenies must necessarily be hypotheses rather than statements of certainty because no human was around to witness the events surrounding the speciation of any bird. Instead, scientists are left to deduce the evolutionary history of birds using logic and reason, and phylogenetic trees are the hypotheses that result from such deductive reasoning.

To study the evolution of avian coloration, scientists focus on the patterns of change in coloration across groups of birds. This approach is called the comparative method because, instead of studying how colors work within a single species, scientists compare color expression among species, genera, families, and orders of birds. Color researchers use this technique to study the factors that led to the evolution of different types of color displays in birds and to try to explain why birds are colored the way they are.

A male **Scott's Oriole** in definitive plumage. Scott's Orioles show the "Baltimore Oriole" plumage pattern, also shared with Orchard Oriole, with a black hood and tail. Complex plumage patterns repeatedly disappear and reappear over evolutionary time, and orioles with the same plumage pattern are often not closely related. (California, April)

Ornithologists study the evolution of coloration in two different ways. First, the patterns of changes in a trait can be mapped directly onto the branches of a phylogeny (see sidebar, page 230). This approach allows scientists to study whether changes in different traits tend to occur together, hence whether coloration and other factors might be causally related. Alternatively, scientists look at the association between coloration and variables like habitat or mating system. The goal in comparative studies is to deduce the circumstances, in terms of both social and the physical environments, that led to the evolution of different coloration.

HOW BIRDS GOT RED FEATHERS

Carotenoid pigments produce most of the bright red, orange, and yellow coloration of the bills, legs, and feathers of birds. There are few alternative sources of red and yellow color in birds, and these alternative sources are restricted to specific orders of birds, notably psittacofulvins in parrots and turacin in turacos. Anyone with even passing knowledge of birds will know that some birds have red pigmentation, either on their bills and legs or in their feathers and that some birds do not. Some entire orders of birds lack carotenoid pigmentation, and in other orders carotenoid pigmentation is widespread. Is it possible to understand the distribution of carotenoid coloration across groups of birds?

Use of carotenoid pigments as colorants is widespread in vertebrates, with many brightly colored fish, amphibians, and reptiles showing red and yellow carotenoid pigmentation. It seems likely, therefore, that use of carotenoid pigmentation is an **ancestral trait** in birds as well. As predicted, carotenoid pigmentation of bare parts,

In the language of phylogenetics, a primitive or ancestral trait is a trait found in ancestors, so it is the trait at the base of the phylogenetic tree. A derived trait is a new form of the trait that evolved from the primitive trait.

BIRDER'S NOTE

Species Blending ›› Speciation is a dynamic process, and divergence and coalescence of populations is a natural phenomenon. Recent human activity is now speeding up the rate of convergence of populations and causing a loss of diversity. For instance, non-migratory Mallards have been moved by people into the ranges of American Black Ducks, Mottled Ducks, and "Mexican Ducks," and hybridization of these species with Mallards is causing loss of species-typical plumage patterns in the native ducks.

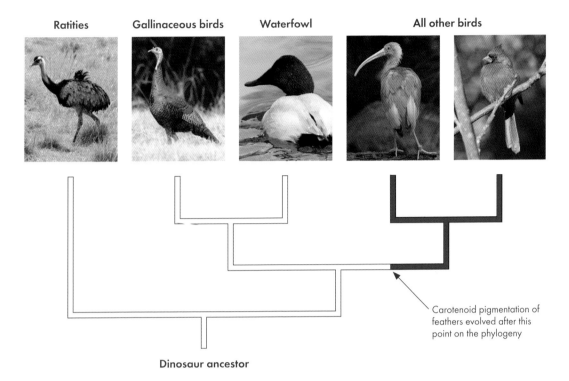

Ratities | **Gallinaceous birds** | **Waterfowl** | **All other birds**

Carotenoid pigmentation of feathers evolved after this point on the phylogeny

Dinosaur ancestor

including bills and legs, is inferred to have been present in the most primitive groups of birds. This deduction means that whether or not species of birds show carotenoid coloration of legs and bills is not a matter of phylogenetic constraint. A phylogenetic constraint is a barrier to the evolution of a trait imposed by the evolutionary history of a species. In this case, the mechanisms for carotenoid pigmentation are available to all birds, and bird species are *not* constrained in the evolution of red bills or legs by absence of the physiological machinery needed for such color displays.

Among living vertebrates, feathers are unique to birds, and getting carotenoid pigments into feathers takes special adaptations compared to getting carotenoid pigments into skin. It turns out that the use of carotenoid pigments in feathers is *not* an ancestral trait within birds. I can make such a speculation about the coloration of animals that went extinct many tens of millions of years ago by tracing the patterns of use of carotenoids in feathers on a phylogeny of birds.

In the flightless ratites (ostriches and their relatives) and tinamous (a neotropical group), which constitute the first lineage to split off from the rest of class Aves, carotenoid pigmentation of feathers is absent.

A phylogeny of some major groups within class Aves showing the distribution of carotenoid pigmentation of feathers. Carotenoid pigmentation of feathers does not appear as a common trait until after the split between ducks/gallinaceous birds and all other birds. *(August, Brazil; Alabama, November; Ohio, December; captive; Alabama, April)*

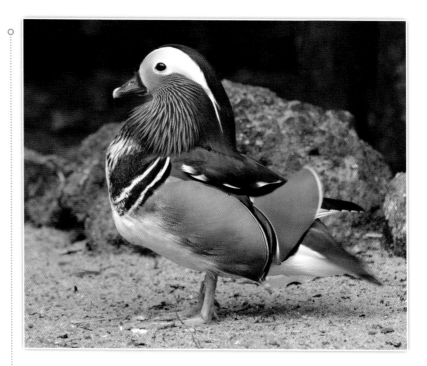

Male ducks of many species, like this male **Mandarin Duck,** have beautiful colors and ornaments. Many species have red, orange, or yellow bills and legs colored with carotenoids, but no duck has red, orange, or yellow carotenoid-based plumage coloration. Carotenoid coloration of feathers evolved in birds after the duck lineage split. *(captive)*

Carotenoid pigmentation of feathers also appears to be lacking in the next two groups of birds to split off, the duck-like birds (order Anseriformes) and the gallinaceous birds (order Galliformes). Carotenoid pigmentation of feathers does not appear in birds until after the duck-like birds and the chicken-like birds split off from the lineage that would give rise to all other orders of birds (see page 227).

From this comparative study, we can answer the question: Why do many species of ducks have red and yellow legs and bills but no species of duck has bright red or yellow feathers? A reasonable answer to this question, following the simple comparative analysis described above, is that no mechanism for creating bright red feather coloration was ever available to species in the duck lineage. In contrast, carotenoid pigmentation of bare parts is an ancestral trait, shared by all birds.

COMPLEX COLOR PATTERNS

Color *patterns* can also be studied by mapping traits onto a phylogeny. One of the most striking aspects of avian coloration is that the same complex patterns of coloration appear on distantly related species. For instance, the Eastern Meadowlark in North America and the Yellow-

PARSIMONY

For some traits, like the shape of the shells of mollusks, the history of change in the trait is evident in the fossil record. For a trait like red coloration, however, there is no record in fossils. The pattern of change in the trait over evolutionary time has to be deduced. One of the primary tools used by biologists to study the evolution of a trait such as coloration is the reconstruction of changes in the trait across a phylogeny.

The central principle that underlies **character state reconstructions** as well as the drawing of phylogenetic trees is parsimony—the simplest hypothesis is assumed to be the correct hypothesis unless there is compelling evidence to the contrary. In terms of assigning coloration to the ancestors of modern birds, ornithologists start with what can be observed—the coloration of living birds—and work backwards down the phylogentic tree. In evolutionary terms, the simplest hypothesis is the hypothesis that requires the fewest number of evolutionary changes. To deduce what ancestral birds looked like, an evolutionary biologist starts with the appearance of existing species or groups of species and works backwards in time down the phylogeny assigning the most likely appearance to each ancestral taxon. As each branching point in the tree is reached, each of which represents a common ancestor, the researcher asks: What color state of the ancestor would require the fewest evolutionary changes to produce the colors that we see in living birds? Sometimes there is no simplest ancestral state—two alternate appearances of the ancestor can lead to equally simple evolutionary paths. In such cases, that part of the tree is left unresolved. There is usually a single state of ancestral coloration that produces the simplest evolutionary path (see next page).

Character state reconstruction is using simple rules of logic to assign traits to ancestors.

throated Longclaw in Africa have strikingly similar plumage color and pattern with a bright yellow breast broken by a black V across the chest. Long-tailed Widowbirds, another African grassland bird, have red epaulets with yellow lower borders, just like Red-winged Blackbirds. In both of these examples, despite being strikingly similar in plumage pattern, the species are distantly related. These birds did not

Scientists follow simple rules of parsimony to reconstruct the colors of avian ancestors (see previous page).

Step 1. Indicate the character state, such as plumage coloration, for living taxa that make up the phylogeny.

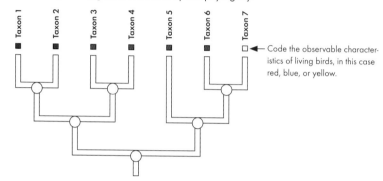

Code the observable characteristics of living birds, in this case red, blue, or yellow.

Step 2. Use parsimony to assign most likely character states to the immediate ancestors of living taxa.

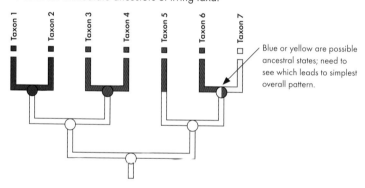

Blue or yellow are possible ancestral states; need to see which leads to simplest overall pattern.

Step 3. Finish by assigning a character state to all ansestors following parsimony: minimizing number of evolutionary changes that occur.

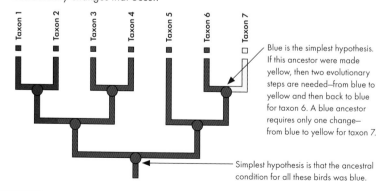

Blue is the simplest hypothesis. If this ancestor were made yellow, then two evolutionary steps are needed—from blue to yellow and then back to blue for taxon 6. A blue ancestor requires only one change—from blue to yellow for taxon 7.

Simplest hypothesis is that the ancestral condition for all these birds was blue.

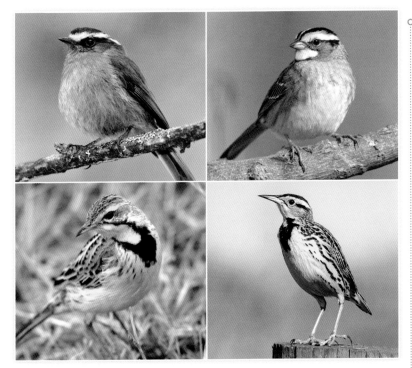

Distantly related birds sometimes show remarkable convergence in plumage color and pattern. The **Crowned Chat-tyrant** (top left), a tyrant flycatcher, has crown stripes and yellow lores like a **White-throated Sparrow** (top right), an emberizid sparrow. The **Yellow-throated Longclaw** (lower left), a pipit, has a yellow and black plumage pattern nearly identical to an **Eastern Meadowlark** (lower right), a New World blackbird. (*Ecuador, May; Michigan, April; Kenya, September; Florida, March*)

inherit their shared appearance from a recent common ancestor; it seems very likely that it evolved independently in each species.

The independent evolution of the same trait in different species is called convergent evolution. When convergent evolution results in a simple patterns with an obvious function—such as countershading, which has evolved independently many times in birds—such repeated evolution is not hard to explain. Given the infinite possible combinations of black and yellow pigmentation spread across the surface of a bird and the apparent arbitrariness of the meadowlark pattern, it is far from obvious why the specific black-and-yellow pattern of a meadowlark would evolve twice. Although there is no convincing explanation for why meadowlarks and longclaws

A phylogeny of New World orioles. When the color patterns of males are mapped onto the phylogeny, it becomes apparent that many species with the same pattern of black and orange/yellow, such as **Scott's, Baltimore,** and **Orchard Orioles,** are not each other's closest relatives. One explanation for the repeated evolution of complex color patterns is that sets of genes for these patterns are turned on and off, sometimes remaining deactivated for millions of years.

Orchard

Hooded

Spot-breasted

Altamira

Baltimore

Scott's

converged on the same black and yellow pattern, comparative studies have provided insight into the convergent evolution of complex color patterns in other groups of birds.

Kevin Omland, the advocate of tree thinking at the opening of this chapter, and his students used a comparative approach to study the evolution of complex color patterns within the New World orioles, a group within the songbird family Icteridae. All orioles are orange and black or yellow and black, but the distribution of black and orange/yellow feathers in different oriole species varies greatly. Despite the complexity of the pattern and the number of possible combinations of color patches, the same arrangement of black and orange/yellow appears repeatedly in different species. For

instance, the "Baltimore Oriole pattern," with all-black hood and back, occurs not just in Baltimore Orioles but also in Orchard and Scott's Orioles. The "Altamira Oriole pattern," with an orange head and black bib and eye patch, is seen not just in Altamira Orioles but also in Hooded and Spot-breasted Orioles.

The assumption among ornithologists had long been that the orioles most similar in pattern were each other's closest relatives, such that the similarity of pattern could be attributed to common inheritance from a recent shared ancestor. Omland's application of tree thinking to the problem showed that this assumption about relatedness and similarity of pattern was wrong. Orioles with the same pattern of black and yellow/orange were not each other's closest relatives. Some species with the Baltimore Oriole pattern were more closely related to species with the Altamira Oriole pattern than they were to other species with the Baltimore Oriole pattern. The pattern of coloration in orioles is another example of convergent evolution.

Once again we are left wondering: How could such complex plumage patterns evolve independently more than once? In contrast to the meadowlark/longclaw example above, convergence in oriole color patterns can be explained using new insights about genetic evolution. Omland's observations indicate that complex plumage patterns can appear, disappear, and reappear in lineages across evolutionary time by switching on and off **integrated sets of genes**. Ornithologists are just beginning to understand how genes code for complex plumage patterns, but the reappearance of a complex color pattern that has been lost in a lineage of birds suggests that sets of genes that code for complex plumage patterns, like the black-and-orange pattern of orioles, can be turned off without being destroyed. Such deactivation means that reactivation of the entire plumage pattern can occur when a simple mutation turns the stored pattern back

Integrated sets of genes are genes that are linked and inherited together. Such integration means that the entire set of genes can be turned on or turned off together.

BIRDER'S NOTE

More Like Kissing Cousins ›› Some species long thought to be sister taxa—each other's closest relatives—due to similarity of coloration or propensity to hybridize turn out not to be so closely related. For instance, evidence suggests that the Lazuli Bunting is more closely related to the Blue Grosbeak than to the Indigo Bunting, which was long thought to be the Lazuli Bunting's sister species.

Evolutionary analyses indicate that sexual dichromatism in ducks, such as in **Mallards** (left), is the ancestral state and that monochromatism, as in **Mottled Ducks** (right), evolved from dichromatism. Such loss of dichromatism has occurred repeatedly in isolated populations of Mallards, giving rise also to American Black Duck, Hawaiian Duck, and "Mexican" Duck. *(Massachusetts, January; Florida, March)*

on, and complex plumage patterns can appear suddenly in species of birds with no immediate ancestor sharing such a pattern.

Such activation and deactivation of complex plumage traits is a process much different from that proposed in the alternative hypothesis, which is that identical plumage patterns evolved independently, bit by bit, through evolution acting on each component of the color pattern. This latter hypothesis seems far-fetched in the oriole example, but it is currently the best explanation for the convergence in coloration of *distantly* related species like the Eastern Meadowlark and Yellow-throated Longclaw.

THE ORIGIN OF SEXUAL DICHROMATISM

People, including many ornithologists, tend to think of evolution as progressing from less complex states to more complex states and, with respect to plumage coloration, from drab to bright and from monochromatic to dichromatic. In some cases the concept of progressive evolution is accurate—for instance carotenoid pigmentation of feathers has evolved from absent to present. But evolution can also lead to loss of coloration or simplified color expression. Over evolutionary time, traits can be lost as well as gained, and less-complex plumages can evolve from more-complex plumages. These considerations become especially relevant with respect to the evolution of sexual dichromatism.

There long had been a bias among researchers to think of the evolution of sexual dichromatism as driven by changes in male coloration. Whether it was stated explicitly or not, many researchers assumed that the ancestor of dichromatic birds was monochromatic and that dichromatism evolved as males evolved brighter plumage. For the taxa that have been studied to date, this view of the evolution of dichromatism is not always accurate.

In most dabbling ducks, males are either brightly colored and females are drab or both sexes are drab. Sexual dichromatism with bright males and drab females appears to be the ancestral condition of the group, and sexual monochromatism has evolved from sexual dichromatism numerous times. This reconstruction suggests that the color variation among these dabbling ducks results from the *loss* of bright coloration in males.

AGENTS OF CHANGE

The previous sections detailed how the evolution of coloration and color patterns can be explained by tracing changes in characters such as carotenoid feather pigmentation across the branches of a phylogeny. Another approach to studying the evolution of coloration is to look for *patterns of association* between coloration and the factors that might cause evolutionary changes in coloration. The logic behind such analyses is simple. If a color trait is consistently associated with an external factor that might reasonably affect the

Across all birds as well as within specific families and orders of birds, mating system is related to plumage color. Within birds-of-paradise (family Paradisaeidae), polygynous species such as the **Red Bird-of-paradise** (right) are much more brightly colored than monogamous species, such as the **Curl-crested Manucode** (left). (Indonesia; Papua New Guinea)

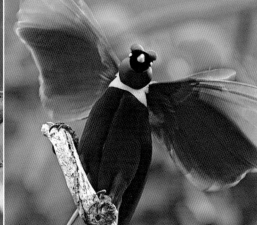

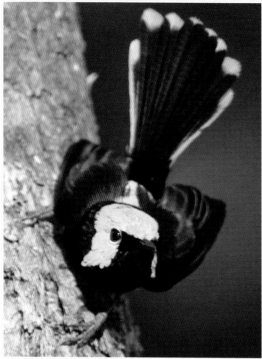

The extent of extra-pair matings observed within a species is a good predictor of plumage coloration. Species with low levels of extra-pair mating, such as the **Striated Grasswren** (right), tend to be less colorful than species with more extra-pair mating, such as the **Lovely Fairywren** (left). *(both Australia, June)*

evolution of the trait, such as habitat or mating system, then finding such a pattern of association with coloration potentially provides insight into why coloration evolved the way that it did. The trick is to find the factors that are causally linked rather than coincidentally linked to color change.

Ornithologists generally accept the hypothesis that mating systems affect the evolution of male plumage brightness and the degree of sexual dichromatism. In polygynous mating systems, the force of selection on males to be attractive to females should be greater than in monogamous mating systems, thus leading to more elaborate male ornamentation and greater dichromatism in polygynous species. However, it is also widely recognized that there are many exceptions to this general pattern. In particular, in many socially monogamous songbirds, males are brightly colored. Mating system alone does not seem adequate to account for the action of sexual selection on plumage coloration. What is being missed?

A key missing element in comparisons of mating system and coloration turns out to be extra-pair matings (see page 175). The social mating system of birds is sometimes a poor indicator of how many females the most attractive males really mate with. Attractive males of many birds will have a social mate, but then they will also mate with several

other females in their neighborhood. Even though the social mating system of a species might be correctly classified as monogamous, extra-pair matings can dramatically alter the benefits to males of having colorful plumage. For instance, both Indigo Buntings and House Finches form monogamous pairs, but 35 percent of the offspring in the nests of Indigo Buntings results from extra-pair mating while only about 8 percent of House Finch young result from mating outside the pair.

When new analyses were conducted comparing plumage coloration and sexual dichromatism to the amount of extra-pair matings in bird species, extra-pair matings were shown to have a strong effect favoring colorful males. So it is not just the mating system but the access to multiple females that is the best predictor of male plumage coloration and sexual dichromatism.

HABITAT AND COLORATION

Individual birds move about their home ranges so as to display their coloration at a time and place that most accentuates their color displays. Most birds do not move out of their preferred habitats, however, because that is where they are adapted to find food and shelter. These specific habitats have different light environments, and some color displays are more effective in one lighting situation compared to another. For instance, in shaded environments, red produces a more effective display, whereas in open habitats with direct sunlight, blue is shown to best effect. Is it possible that over evolutionary time, species of birds have evolved color displays that are most effective under the lighting conditions in which they spend most of their time?

Sacred Kingfisher

Two comparative studies have tested whether light environment predicts the coloration of birds. One study looked at coloration in relation to where birds dwell within a neotropical rainforest, and the other looked at coloration relative to gross habitat types (open or shaded) among some Australian birds. Both studies found an effect of light environment on coloration. In the Australian study, open-country birds had plumage with bluer color than birds that lived in shaded habitats. This is not to say that all open-country birds are blue, just that there are more blue species in open habitats than you'd expect

by chance. In the rainforest study, researchers found that compared to species that dwell on the ground, canopy species had more green in their feathers. Ground-dwelling birds tended to be brown. Both of these color shifts were as predicted, given the light environment and background of the canopy versus the forest-floor environments. These studies provide evidence that plumage coloration can evolve to accentuate display within the available lighting conditions.

THE BIG PICTURE

In one of the most original journal articles published in recent years, Mark Riegner did what no ornithologist studying bird coloration had done before: He stepped back and assessed the gross plumage patterns that occur across all birds. Instead of focusing within specific bird taxa or worrying about which pigment type was creating which color display, Riegner looked for general patterns of coloration across all birds related to body size. He found an interesting pattern that seemed general to birds.

In going from the largest birds like ostriches, though medium-sized birds like hawks and gallinaceous birds, to the smallest, songbird-sized birds, plumage patterns tend to vary in standard ways. The largest birds tended to have a few large patches of color and to show reverse countershading with light plumage above and dark below; mid-sized birds tended toward plumages that transitioned from boldly patterned black and white, to barred, to spotted, to streaked as size decreased; and the smallest, songbird-sized birds were countershaded. There are many exceptions to this trajectory. Nevertheless, with this general framework in mind, it is remarkable to flip through the pages of any field guide from any region of the world and see the general pattern hold up pretty well.

The reason why these general patterns of coloration related to size are repeated over and over in different groups of birds has yet to be explained. These patterns could reflect a response to natural selection acting on birds according to body size independent of details of their ecology. Alternatively, these patterns could arise from some general developmental constraint on production of color pattern related to body size.

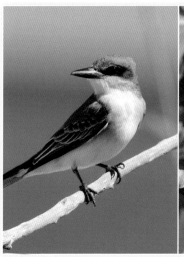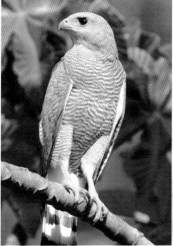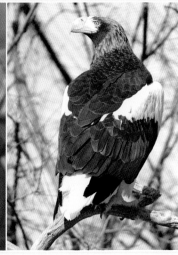

UNIFYING CONCEPT

Evolution by natural and sexual selection provides the context within which ornithologists interpret the color and patterns of animals. In this chapter, evolution of coloration is the explicit topic. But even when it is not discussed explicitly, evolution runs as an undercurrent in every chapter. As soon as one moves beyond basic descriptions of what is, the only viable scientific framework for interpreting the colors of birds is evolution by natural and sexual selection.

Ornithologists have made tremendous strides toward a comprehensive understanding of the coloration of birds, and those discoveries fill the pages of this book. Despite such advances, most of the really big questions regarding why birds look the way they do remain to be completely answered. But we are hardly in a period of stagnation. Each month the ornithological, behavioral, and evolutionary journals are peppered with reports of exciting new studies on the coloration of birds. Advances in molecular biology and the decoding of DNA are sweeping all disciplines of biology forward, including research on avian coloration. We live in an exciting age of scientific discovery that will include an increasing understanding of why birds look the way they do.

A general pattern across all birds is for small species, such as the **Gray Kingbird** (left), to be countershaded; medium-sized species, such as the **Gray Hawk** (middle), to have spots or bars; and the largest species, such as the **Steller's Sea-Eagle** (right), to have large patches of bold colors, often with reversed countershading. *(Florida, April; Ecuador, April; captive)*

T HE MAGNIFICENT AND VARIED COLORS OF BIRDS PLAY a large role in drawing so many us to a lifetime of birding. Avian coloration produces the visual experiences that lure us out of bed and into the wild before dawn with binoculars, scopes, and cameras at the ready. It is the starting point and central focus of what birders do—identify birds.

One of the primary skills that separate a top birder from a beginner is the ability to interpret variation in bird coloration. Simply memorizing typical patterns of variation is not the same as understanding the mechanisms that give rise to the variation and the reason that all birds of a species do not look alike. Few realms of study improve the competence of a birder more than learning about avian coloration. The birder who understands coloration is prepared to interpret the wonderful complexities of appearance displayed by birds.

Sex, age, and season are the bases for most color variation within a species, so mastery of plumage sequences and seasonal transitions is basic knowledge for most birders. Where a novice sees a flock of unidentifiable gulls, the skilled and patient birder might identify three species with two or three age groups for each of the species. No bird will go unidentified. It is only through mastery of plumage variation that unusual birds will be regularly found and correctly identified. Field guides and "how to" birder guides, such as the *National Geographic Field Guide to the Birds of North America*

Male **Prothonotary Warblers** have beautiful yellow plumage from carotenoid pigments and blue structural coloration. (Florida, April)

and *National Geographic Birding Essentials* provide detailed information about what various species look like, but birders who take the time to *understand* color in relation to molt cycles and developmental processes gain new insight into why birds look the way they do. Such knowledgeable birders are prepared to interpret plumage variation beyond that which can be illustrated in a field guide.

In a similar way, a grasp of the effects of genetics and the environment on different types of coloration helps make sense of color variation. For instance the same backyard feeder might host a white Steller's Jay and a yellow male House Finch. Both birds have atypical plumage color, but the mechanisms that caused the unusual coloration of the two species are completely different. While the jay's feathers betray a genetic mutation blocking a physiological pathway, the finch is simply at the lower end of a continuum of color dictated by environmental circumstances during feather growth. The avid birder invests so much in developing and honing identification skills that a need to understand such variation becomes fundamental.

Another realm of ornithology into which birders are necessarily drawn is taxonomy, and specifically species and subspecies designations. Decisions about the distinctiveness of bird populations dictate what does and does not go on a bird list. The genetics of coloration play a central role in the taxonomic decisions made every year by the American Ornithologists' Union Committee on Classification and Nomenclature. Through a grasp of how environmental and genetic factors create geographic variation in avian appearances, a birder can better understand why species are added or removed from the checklist.

For those who enjoy a bit less listing and a bit more watching, I hope that this book was especially enlightening. With an understanding of basic principles of coloration, watching a flock of waxwings feeding on honeysuckle fruits takes on new significance. Are the waxwings choosing particular fruits to ingest carotenoid pigments for feather coloration? Will these fruits cause the waxwings to grow tails with orange tips? Is there competition for the fruits and, if so, does color play a role in mediating contests? Will the feather colors produced with carotenoids from the fruits affect success at attracting mates six months in the future? Once a bird watcher

understands the basics of bird coloration, many previously inexplicable bird behaviors begin to make sense.

Research on bird coloration is in full blossom: It is neither in its infancy nor near a final resolution. Much to the chagrin of my editor, I ended many chapters of this book with statements like "never been tested," "remains to be studied," and "we don't know." I suppose a reader could come away from the book feeling that the scientific community understands little about the colors of birds, but I don't find that to be a fair assessment.

In recent decades, scientists studying the colors of birds have made tremendous advances on numerous research fronts. For any color or pattern of coloration in any species of bird, an ornithologist could provide reasonable explanations for the mechanism by which the color is produced and how the color or pattern functions, and he or she could support these explanations by pointing to studies in at least a few species of birds. No doubt, with our less-than-complete knowledge, some of these explanations would be deficient or even wrong, but scientists have built a broad and stable platform from which to launch future investigations.

The big question related to bird coloration, or to any aspect of biology for that matter, is: Why are things the way they are? Why are Baltimore Orioles orange, and Blue Grosbeaks blue? Why do Long-tailed Manakins take five years to reach definitive plumage while slightly larger House Finches have full adult plumage six months after hatching? Why do male American Black Ducks look similar to females, but male Mallards look nothing like female Mallards?

Understandably, these questions have proven the most challenging for scientists to answer. They rest heavily on a century of studies of production and function. Progress in answering these big questions is necessarily slow, but there is forward momentum. As the base of knowledge expands, so does the opportunity for answering broad questions about why birds look the way they do.

For those of us fortunate enough to know the allure of birds, there is no activity more fulfilling than a day spent birding. Having the knowledge to interpret the sights and sounds of birds makes birding all the more enjoyable, and toward that end I hope that this book has enabled bird enthusiasts of all kinds to better appreciate the avian world.

SOURCES

Most of the information in this book comes from papers cited in *Bird Coloration, Volume 1: Mechanisms and Measurement* and *Bird Coloration, Volume 2: Function and Evolution,* both edited by G. E. Hill and K. J. McGraw and both published in 2006 by Harvard University Press. In the list of references below I refer to the appropriate chapter or chapters in *Bird Coloration,* abbreviated as BCV1 and BCV2, and then any additional papers from which I drew information but that are not listed in the *Bird Coloration* volumes.

The common names of birds used in this book follow the *Checklist of North American Birds,* 7th edition, and its supplements by the North American Classification Committee of the American Ornithologists' Union for birds of North America. For birds not found in North America, common bird names follows J. F. Clements, *The Clements Checklist of Birds of the World,* 6th edition (Ithaca, New York: Cornell University Press, 2007).

Chapter 1: F. B. Gill, *Ornithology,* 3rd ed. (New York: W. H. Freeman and Company, 2007).

Chapter 2: BCV1 chapters 1 and 4.

Chapter 3: BCV1 chapters 2 and 3.

Chapter 4: BCV1 chapters 5, 6, 8, and 9.

Chapter 5: BCV1 chapter 7; M. D. Shawkey and G. E. Hill, "Significance of a basal melanin layer to production of non-iridescent structural plumage color: Evidence from an amelanotic Steller's Jay *(Cyanocitta stelleri),*" *Journal of Experimental Biology* 209 (2006):1245-50.

Chapter 6: BCV1 chapters 10 and 11. T. Birkhead, *A Brand New Bird* (New York: Basic Books, 2003).

Chapter 7: BCV1 chapter 12; BCV2 chapter 6. C. Isaksson and S. Andersson, "Carotenoid diet and nestling provisioning in urban and rural great tits Parus major," *Journal of Avian Biology* 38 (2006):564-72.

Chapter 8: BCV1 chapter 11; BCV2 chapter 1. R. W. Schreiber, E. A. Schreiber, A. M. Peele, et al., "Pattern of damage to albino Great Frigatebird flight feathers supports hypothesis of abrasion by airborne particles," *Condor* 108 (2006):736–41.

Chapter 9: BCV2 chapter 1 and 2.

Chapter 10: BCV2 chapters 2, 4, and 5; G. E. Hill and K. J. McGraw, "Correlated changes in male plumage coloration and female mate choice in cardueline finches," *Animal Behaviour* 67 (2004):27-35.

Chapter 11: BCV1 chapter 9; BCV2 chapters 4, 6, and 7; S. L. Balenger, L. S. Johnson, and B. S. Masters, "Sexual selection in a socially monogamous bird: Male color predicts paternity success in the mountain bluebird, *Sialia currucoides*," *Behavioral Ecology and Sociobiology* 63 (2009):403-11; O. D. Peter, J. C. Garvin, L. A. Whittingham, et al., "Carotenoid and melanin-based ornaments signal similar aspects of male quality in two populations of the common yellowthroat," *Functional Ecology,* in press; M. Liu, L. Siefferman, H. L. Mays, et al., "A field test of female mate preference for plumage coloration in eastern bluebirds," *Animal Behaviour,* in press; R. J. Safran, C. R. Neuman, K. J. McGraw, et al., "Dynamic paternity allocation as a function of male plumage color in barn swallows," *Science* 309 (2005):2210-12.

Chapter 12: BCV2 chapter 3; K. J. Metz and P. J. Weatherhead, "Seeing red: Uncovering coverable badges in red-winged blackbirds," *Animal Behaviour* 43 (1992):223-29; D. L. Lack, *The Life of the Robin* (London: H. F. & G. Witherby, 1943); O. Vedder, P. Korsten, M. J. L. Magrath, et al., "Ultraviolet plumage does not signal social status in free-living Blue Tits: An experimental test," *Behavioral Ecology* 19 (2008):410-16; S. R. Pryke and S. C. Griffith, "Red dominates black: Agonistic signalling among head morphs in the colour polymorphic Gouldian finch," *Proceedings of the Royal Society* B 273 (2006):949-57; A. S. Chaine and B. E. Lyon, "Intrasexual selection on multiple plumage ornaments in the Lark Bunting," *Animal Behaviour* 76 (2008):657-67.

Chapter 13: BCV2 chapters 2 and 3; J. W. Hardy, "Behavior and its evolution in neotropical jays *(Cissilopha)*," *Bird-banding* 45 (1974):253-68; R. A. Ligon and G. E. Hill, "Do adult eastern bluebirds *Sialia sialis* recognize juvenile-specific traits?" *Animal Behaviour,* in press; E. S. Morton, L. Forman, and M. Braun, "Extra-pair fertilizations and the evolution of colonial breeding in purple martins," *Auk* 107 (1990):275-83.

Chapter 14: BCV2 chapters 8, 9, and 10; M. F. Riegner, "Parallel evolution of plumage pattern and coloration in birds: Implications for defining avian morphospace," *Condor* 110 (2008):599-614.

ABOUT THE AUTHOR

GEOFFREY E. HILL IS AN ORNITHOLOGIST AND PROFESSOR OF BIOLOGY at Auburn University. He is co-editor of two scholarly volumes on bird coloration as well as author of two books, *A Red Bird in a Brown Bag* and *Ivorybill Hunters*. He has published more than 170 journal articles on the behavior, evolution, and conservation of birds, with more than half on bird coloration.

ACKNOWLEDGMENTS

I RECEIVED INSIGHTFUL AND TREMENDOUSLY HELPFUL FEEDBACK ON various chapters from Wendy Hood, Kristen Navara, Kevin McGraw, Matt Shawkey, Scott Santos, James Dale, Lynn Siefferman, Stephanie Doucet, Kevin Omland, Paul Nolan, Andrew Stoehr, Richard Prum, Edward Burtt, Jr., Christopher Hoffman, Herman Mays, Jr., David Lank, Peter Prescott, and the members of my lab group in 2008 and 2009. Jonathan Alderfer and Paul Hess read the entire manuscript and made many significant suggestions for improving the book. Feathers photographed for the book were borrowed from the Auburn University Natural History Museum and Learning Center and from the Smithsonian Institution National Museum of Natural History, courtesy of Gary Graves and James Dean. My wife, Wendy Hood, and my children, Trevor and Savannah, provided support and encouragement as I wrote and edited. My mother, Sally Hill, proofread the entire book. My team of cooperating photographers, who are named in the illustration credits and are all wonderful birders and naturalists, endured endless requests for improbable images and, with their magnificent photographs, made this book beautiful and fun. Adrian Coakley helped select and edit hundreds of photographs, and Cameron Zotter and Melissa Farris created a beautiful layout. My editor, Garrett Brown, did a masterful job of keeping the project on time, on point, and within stringent page limits. The Department of Biological Sciences and College of Science and Mathematics at Auburn University gave me the time needed to complete this project. This book would not have been possible if not for the devotion and dedication of generations of graduate students and faculty who created the studies on which my accounts are based. This book is dedicated to the researchers whose studies I summarize in these pages.

All interior photos by Geoffery Hill unless otherwise noted:
1, David Quinn; 2-3, Jozsef Szentpetri; 4, Glenn Bartley; 6, E.J. Peiker; 8, Octavio Campos Salles; 11, David Quinn; 12, Brandon Holden; 13, H. Douglas Pratt; 14 (UP), Thomas R. Schultz; 14 (LO), Thomas R. Schultz; 16 (LE), Bob Steele; 16 (RT), Bob Steele; 17, H. Douglas Pratt; 18, Killian Mullarney; 19, Neil Losin; 21 (UP), Doug Backlund; 24 (UP), Diane Pierce; 24 (LO), Peter Burke; 26 (UP), Michael O'Brien; 26 (LO), H. Douglas Pratt; 28, Donald L. Malick; 30 (RT), Bob Steele; 31 (LE), Bob Steele; 31 (RT), Bob Steele; 32, Maxis Gamez; 36, Brandon Holden; 38, Ralph C. Eagle, Jr./Photo Researchers, Inc.; 39, David Quinn; 40, Peter Burke; 42 (LE), Bjørn Rørslett; 42 (RT), Bjørn Rørslett; 43 (LE), Staffan Andersson; 43 (RT), Staffan Andersson; 45, Glenn Bartley; 46, Glenn Bartley; 50, Doug Backlund; 51 (UP), Stephanie Doucet; 51 (LO), Bob Steele; 53 (RT), Diane Pierce; 53 (LE), H. Douglas Pratt; 56, Wendy R. Hood; 57, Chuck Ripper; 59, David Quinn; 60 (LO), Diane Pierce; 61, Thomas R. Schultz; 62 (UP RT), Brandon Holden; 62 (LO LE), Brandon Holden; 63 (UP LE), Judd Patterson; 63 (UP RT), Glenn Bartley; 63 (LO LE), Glenn Bartley; 63 (LO RT), Brandon Holden; 65 (UP LE), Glenn Bartley; 65 (UP RT), Brandon Holden; 65 (LO LE), Brandon Holden; 65 (LO RT), Brandon Holden; 68 (LE), Mark Jones/Minden Pictures; 68 (RT), John Cancalosi; 69 (RT), Bob Steele; 73, Donald L. Malick; /4, Donald L. Malick; 75, Jack Rodgers; 76, Glenn Bartley; 78, John P. O'Neill; 79 (LE), Mathew D. Shawkey; 79 (LO CTR), Mathew D. Shawkey; 83 (UP LE), Jack Rodgers; 83 (UP RT), Glenn Bartley; 83 (LO LE), Brandon Holden; 83 (LO RT), Glenn Bartley; 84 (LE), Glenn Bartley; 84 (RT), Glenn Bartley; 84 (LO), Glenn Bartley; 85 (UP), Jonathan Alderfer; 85 (LO), Cynthia J. House; 86 (UP LE), Judd Patterson; 86 (UP RT), Glenn Bartley; 86 (LO LE), Bob Steele; 86 (LO RT), Glenn Bartley; 88 (A), Peter Burke; 88 (C), H. Douglas Pratt; 88 (D), Mathew D. Shawkey; 90, Maxis Gamez; 92 (LE), Gerhard Hofmann & Fernanda Scheffer; 92 (CTR), Casey J. Tucker; 93 (RT), N. John Schmitt; 94, Thomas R. Schultz; 98, Sarah Pryke; 99 (UP LE), Brandon Holden; 99 (UP RT), Brandon Holden; 99 (LO LE), Brandon Holden; 99 (LO RT), Brandon Holden; 100, H. Douglas Pratt; 102 (LE), Graham Catley; 102 (RT), Graham Catley; 106, Thomas R. Schultz; 107 (LE), Alejandro Sanchez; 107 (RT), Neil Losin; 108, Kent Pendleton; 109, N. John Schmitt; 110, Günes Aybay; 114, David Quinn; 115, Christopher Furlong/Getty Images; 118, Chris Hellier/CORBIS; 120 (LE), Bruno Faivre; 120 (RT), Stéphane Garnier; 121, Kent Pendleton; 123 (LO), N. John Schmitt; 125, Scott Rose; 126, Maxis Gamez; 127, Thomas R. Schultz; 128, Elizabeth Schreiber; 129, H. Jon Janosik; 131, Matthew D. Shawkey; 133 (UP LE), Donald L. Malick; 133 (UP RT), Donald L. Malick; 133 (LO), Diane Pierce; 134, Neil Losin; 136, David Beadle; 137, Cynthia J. House; 140, Abbott Henderson Thayer/CORBIS; 142 (LE), Jonathan Alderfer; 142 (RT), Jonathan Alderfer; 143, Judd Patterson; 144 (RT), Judd Patterson; 145 (UP), Kent Pendleton; 145 (LO), Kent Pendleton; 148, Thomas R. Schultz; 149, Michael and Patricia Fogden/Minden Pictures/National Geographic Stock; 150, Neil Losin; 151, N. John Schmitt; 152 (A), Diane Pierce; 152 (B), H. Douglas Pratt; 152 (C), Peter Burke; 152 (D), H. Douglas Pratt; 152 (E), Michael O'Brien; 153, Jack Dumbacher/VIREO; 155, H. Douglas Pratt; 156, Sue Tranter; 160, Kim Wolhuter; 162 (LE), Casey J. Tucker; 162 (RT), Judd Patterson; 166 (LE), Graham Catley; 166 (RT), Graham Catley; 167 (LO), Cynthia J. House; 170, Tim Laman/National Geographic Stock; 172 (RT), Judd Patterson; 173, Diane Pierce; 174 (UP), Diane Pierce; 174 (LO), Diane Pierce; 175, L. Scott Johnson; 176, David Quinn; 178, Bryan Holliday; 179, Diane Pierce; 186, Konrad Wothe/Minden Pictures/National Geographic Stock; 187, Michael And Patricia Fogden/Minden Pictures/National Geographic Stock; 188 (RT), Neil Losin; 193, Sievert Rohwer; 198 (LE), John Anderson; 198 (RT), John Anderson; 201, Judd Patterson; 202, H. Douglas Pratt; 203, Michael O'Brien; 204 (LE), Alexis Chaine; 204 (RT), Alexis Chaine; 206, Roger Wilmshurst/CORBIS; 207 (UP), Donald L. Malick; 210, H. Douglas Pratt; 212 (LE), Russell A. Ligon; 212 (RT), Russell A. Ligon; 213 (LE), Bob Steele; 213 (CTR), Bob Steele; 213 (RT), Bob Steele; 215 (LO), Diane Pierce; 216, H. Douglas Pratt; 217 (CTR), Bob Gress; 219, David B. Lank; 220 (LE), David B. Lank; 220 (CTR), David B. Lank; 220 (RT), David B. Lank; 223 (LE), Neil Losin; 223 (RT), Neil Losin; 224, Bob Steele; 227 (A), Neil Losin; 231 (UP LE), Glenn Bartley; 231 (UP RT), Bryan Holliday; 231 (LO LE), Bill Gozansky/VIREO; 231 (LO RT), Bryan Holliday; 234 (RT), Robert Royse; 235 (LE), Tim Laman; 235 (RT), Tim Laman; 236 (LE), Bob Steele; 236 (RT), George Reynard/VIREO; 237, David Quinn; 239 (CTR), Glenn Bartley; 241, Bryan Holliday.

National Geographic Bird Coloration
Geoffrey E. Hill

Published by the National Geographic Society
John M. Fahey, Jr., *President and Chief Executive Officer*
Gilbert M. Grosvenor, *Chairman of the Board*
Tim T. Kelly, *President, Global Media Group*
John Q. Griffin, *Executive Vice President; President, Publishing*
Nina D. Hoffman, *Executive Vice President;*
 President, Book Publishing Group

Prepared by the Book Division
Barbara Brownell Grogan, *Vice President and Editor in Chief*
Marianne R. Koszorus, *Director of Design*
Susan Tyler Hitchcock, *Senior Editor*
Carl Mehler, *Director of Maps*
R. Gary Colbert, *Production Director*
Jennifer A. Thornton, *Managing Editor*
Meredith C. Wilcox, *Administrative Director, Illustrations*

Staff for This Book
Jonathan Alderfer, *Chief Consultant of Birding Program*
Garrett Brown, *Editor*
Melissa Farris, *Art Director*
Cameron Zotter, *Designer*
Adrian Coakley, *Illustrations Editor*
Robert Waymouth, *Illustrations Specialist*
Paul Hess, *Copy Editor*
Jennifer Conrad Seidel, *Proofreader*

Manufacturing and Quality Management
Christopher A. Liedel, *Chief Financial Officer*
Phillip L. Schlosser, *Vice President*
Chris Brown, *Technical Director*
Nicole Elliott, *Manager*
Rachel Faulise, *Manager*

For more information, please call 1-800-NGS LINE (647-5463) or write to the following address:

National Geographic Society
1145 17th Street N.W.
Washington, D.C. 20036-4688 U.S.A.

Visit us online at www.nationalgeographic.com

For information about special discounts for bulk purchases, please contact National Geographic Books Special Sales: ngspecsales@ngs.org

For rights or permissions inquiries, please contact National Geographic Books Subsidiary Rights: ngbookrights@ngs.org

Library of Congress Cataloging-in-Publication Data

Hill, Geoffrey E. (Geoffrey Edward)
 National Geographic bird coloration / by Geoffrey E. Hill. – 1st ed.
 p. cm.
 Includes index.
 ISBN 978-1-4262-0571-2 (hardcover : alk. paper)
 1. Birds–Color. I. National Geographic Society (U.S.) II. Title.
 QL673.H55 2009
 598.147′2–dc22
 2009036773

ISBN: 978-1-4262-0571-2

Printed in China

09/RRDS/1